ONE SQUARE MILE

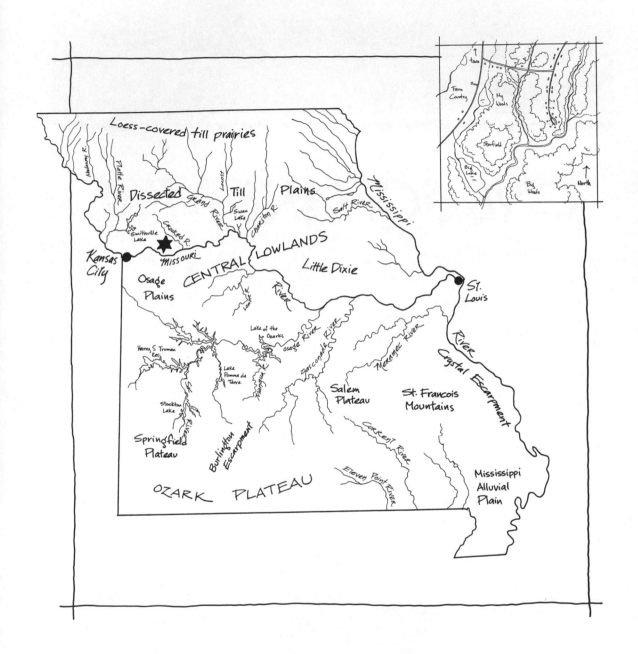

AMERICA IN MICROCOSM

ONE SQUARE MILE
An Artist's Journal of America's Heartland

CATHY JOHNSON

Walker and Company New York

To Harris, who supports me in everything

First published in the United States of America in 1993
by Walker Publishing Company, Inc.

Published simultaneously in Canada by Thomas Allen & Son
Canada, Limited, Markham, Ontario

Library of Congress Cataloging-in-Publication Data
Johnson, Cathy (Cathy A.)
One square mile: an artist's journal of America's heartland / Cathy Johnson
p. cm.—(America in microcosm)
Includes bibliographical references and index.
ISBN 0-8027-7393-1
1. Johnson, Cathy (Cathy A.)—Psychology. 2. Nature (Aesthetics). 3. Missouri in art.
I. Title. II. Series.
NC139.J593A2 1993
743' .83'09778—dc20 92-14673
CIP

The quotation on page v is from *Maine Memories*, © Elizabeth Coatsworth Beston; reprinted by
permission of The Countryman Press, Inc.

Book design by Georg Brewer
Printed in the United States of America

2 4 6 8 10 9 7 5 3 1

And if Americans are to become really at home in America
it must be through the devotion of many people to many
small, deeply loved places. The field by the sea, the single
mountain peak seen from a man's door, the island of trees
and farm buildings in the western wheat, must be sung and
painted and praised until each takes on the gentleness of
the thing long loved, and becomes an unconscious part of
us and we of it.

—Elizabeth Coatsworth

Contents

Acknowledgments

There is no way to adequately express my gratitude to all who helped with this book. Some are named in Appendix A; others remain nameless, a voice on the end of the phone line. And if I have forgotten a name—and I surely have, in the course of a year and more of work on this book—please know you are appreciated nonetheless.

The women at the Excelsior Springs Branch of Mid-Continent Public Library (especially Marian Hurtubise, who goes far out of her way) were always helpful, as were the men and women at the Missouri Department of Conservation and the Missouri Department of Natural Resources.

My friends and veterinarians, Ed Piepergerdes and Pete Rucker, and Pete's family, Nancy, Andy, and Leslie, helped me in many ways, allowing me to sketch the creatures that found their way into their care and offering insight into behavior—as did George Hiser, conservation agent for the State of Missouri.

Wendy McDougal brought me new things to see and draw, and kept my perspective youthful. Linda Ellis of the Missouri Native Plant Society was always willing to visit the land, take my rapid-fire phone calls, look at my plant samples, and help identify specimens—or find someone who could. The staff at the Martha Lafite Thompson Nature Sanctuary and Patrice Dunn in particular were always ready to field questions. Dr. Richard Gentile, professor of geology at the University of Missouri at Kansas City, walked the land with me and filled me in on ancient history.

The generous help of Tom R. Johnson, J. Richard Heitzman, and Joe Francka was much appreciated in checking my lists, as was that of Jerri Davis.

My editor, Mary Kennan Herbert, was always there with suggestions and direction, and Art Director Georg Brewer offered valuable input during the entire process of book production.

Fellow writer-artists Richard Gayton, Clare Walker Leslie, Hannah Hinchman, and Ann Zwinger were a resource not to be taken lightly; their emotional support and ideas were invaluable to this project.

As always, my dear Harris kept me in one piece through the often difficult, always demanding process of making a book.

And last, I offer thanks to the land itself.

Introduction

edge of morning consciousness and wakes me to a sound of leaving. I like living where three blocks away is the edge of town, a river, wildlife and landscape.

That's not so unusual; even in the largest city, *someone* lives three blocks from plowed ground or forest or mountains. But here, "downtown" is only three blocks in the opposite direction. The town is not really so small; it's just grown in the other direction, reaching amoebically on the western edge toward Kansas City, 25 miles away. For the most part, though, reach is still a long way from grasp, and even on the western border there's a wide swath of emptiness. We won't be a suburb of the city for many years yet.

I am at home here. I have spent fifteen years getting to know the place.

And one thing I know is that it is still town. There is still too much noise; there are still too many cars, though one may not pass on the state highway half a block away for

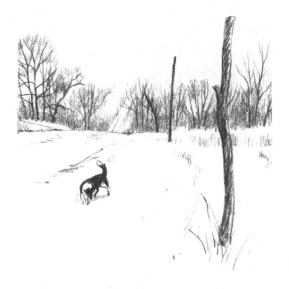

WOODS AND ROAD IN MIST; COLORED PENCIL

I like living in a town of a size so small that occasionally you must inch along the main drag behind a haywagon or tractor, where a good quarter of the people you pass wave in greeting. I like living where the whistle of a freight train still lifts the

twenty minutes and more on a hot summer afternoon and there are only three stoplights in the whole city.

I discovered my "one square mile" a few years ago, wandering by accident upon this nearby place that has become a second home as well as a place to study and work—and a place to run when I have had enough and then some.

My husband, Harris, and I bought these eighteen acres with just this sort of in-depth exploration in mind. The land has a wonderful variety of distinct habitats, lacking only swamp and mountain to make it complete. There are edge habitats, old meadows, mowed areas, aging forests and young ones, a manmade pond near the road, and a mysterious little limestone-bedded creek that mutters to itself nine months of the year— when it isn't dry or frozen. There is also a range of some one hundred feet vertically, which affects the microclimate and those things that thrive here. The creatures that are attracted to these varying conditions are endlessly interesting and a pleasure to draw.

As an artist-writer-naturalist, I find opportunities for both verbal and visual observation; my subject matter is the natural world, which provides inspiration and a source of constant challenge. If I don't learn here, I have no one but myself to blame. If I can't find peace, it is not to be found anywhere.

The divisions between ecosystems are nowhere near as neat as the chapters in this book might suggest. Things grow where they're not supposed to—perhaps with less vigor than they'd have where you expect them, but they grow in these odd places nonetheless. Animals and birds move from ecosystem to ecosystem according to design or need. Hunger draws a forest dweller into the open; a sudden pressing need for shelter leads another creature into deep brush, and it stays for a while. I've tried to reflect that out-of-place-ness in my sketches, drawing what I see where I find it, not necessarily where it is supposed to be. This is life, messy and lusty and exciting as it is, not a field guide to habitat.

It was frustrating, at times, working on this book. The necessity of sharing mainly the visual sometimes felt limiting, constricting; there is so much more to experience in nature than those things I was able

to capture on paper. There was so much more I wanted to say—but to express the inexpressible is an exercise in frustration in itself. My hope is that the sketches and drawings included here will inspire you to get out onto your *own* square mile. Once there, once present to the land itself, the visual will lead inevitably to the audible, the sensual, the cognitive—and perhaps the spiritual. My Blackfoot ancestors would be pleased.

There are far too *many* things present on a square mile to cover in a single volume; the intent of this book is to offer a hint, an introduction— an invitation. At the end of the book (see Appendix B) is a rough catalog of things I have found (or might find) here: the vertebrates, invertebrates, flowers, mushrooms, trees, rocks, and fossils to be seen in this quadrant of Missouri, given the microclimes, habitats, and eco- systems present. In this mile are forests and meadows, creeks and ponds and lakes, yards and gardens, gravel roads and small state high- ways; it goes without saying that the life forms and the geology that informs them must be varied beyond the scope of a single book. Appendix B hints further at that diversity—but again, it only offers hints.

Many experts have been of help here, either visiting this square mile or checking my lists, adding or subtracting species. The Bib- liography is specific to my area, insofar as I could make it, but that is intended to show you the wide range of information available pertaining to a single state. There will be as much or more information for your particular area, if you dig for it.

My acreage is the nucleus of this square mile—in my mind, at least; to the north and east and west are a patchwork of homes and farms, lakes and ponds, gravel roads and small county highways. To the south are deeper woods, and a dozen small tributaries that join with our creek to form the larger stream—which in turn rendezvous with the Missouri some ten miles south of here. Limestone outcroppings underpin all of this, the pale, rocky remains of an inland sea some 300 million years old, and bits of remnant prairies mark the way it once must have been. It is all home.

Part I

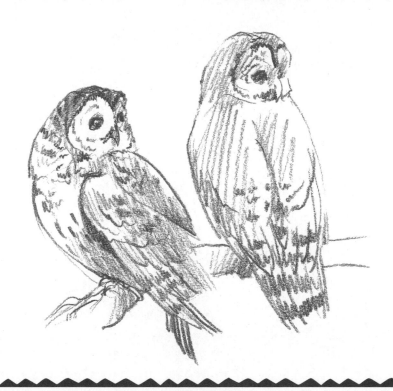

The Woods

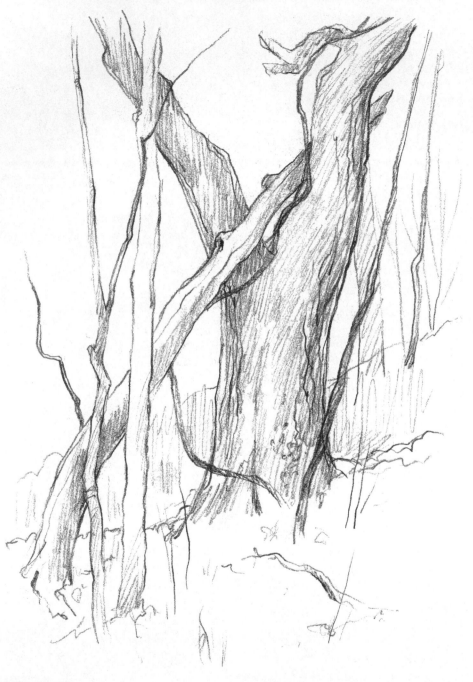

Mixed woods; pencil

I begin with the woods because that is what makes this place special. Much of this square mile is blanketed in timber of various types and conditions. Here are young forests, with hardly a tree over three inches in diameter, up against old growth that has stood since presettlement times. Here are cutover woodlots, managed with a kind of casual unprofessional air. Here are dense stands of oak and hickory, leavened by locust and maple, walnut and Osage orange, and lit up, along the drainage of the creek beds, by the pale, reaching limbs of sycamore. The forest is delightfully varied; old and new growth, large and small, smooth and rough, straight and crooked and curved—dead and alive.

The understory is as varied, a crazy quilt of redbud, gray dogwood, wild plum, buckeye, and pawpaw. Wild vines cling to almost every tree, and in the autumn theirs are among the first leaves to turn. Mushrooms and mosses, wildflowers and lichen—no matter where I look, there is something worth study.

The birds and mammals that find cover here are a constant pleasure to watch, disappearing seemingly at will when they've been watched quite *enough*, thank you. Nocturnal creatures, like whip-poor-wills and little brown bats, add mystery far deeper than that of the daylight hours.

A fallen tree has been hung up in the crotch of a big oak for as long as I've known the place, slowly decaying from the bottom up. All around the two so intertwined, young saplings have grown up until

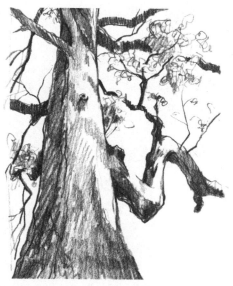

OAK TREE; COLORED PENCIL

the forest is opaque; I can see only a short distance. Although I know just where the cabin is, I can't see the rectangle of pale roof through the trees, even in winter.

The oak reaches upward forever, greedy to catch the sky in its muscular branches. This is no stereotypical tree-symbol; it's as individual as I am, its personality caught in emphatic gestures.

Colored pencil is bold enough to capture not only the limbs and the variety of negative shapes between them but also the strong shadows that fall across the old trunk. I had sketched a light line for myself, a basic plan for composition, but the oak burst out of these puny boundaries like a bull from a clothesline corral.

The hardy mourning cloak and ladybug beetle winter over, hiding from the cold beneath the leaves or behind loose bark. It always seems too early when I see the velvety butterfly in the bare woods. But today I am ready for this sign of spring.

Closely hatched lines suggest the deep color of the mourning cloak.

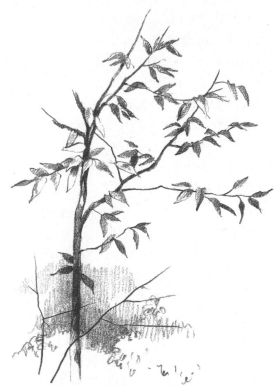

YOUNG WILD PLUM; HB PENCIL

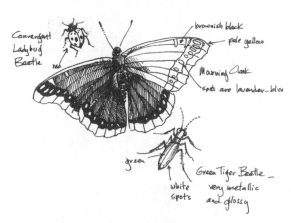

MOURNING CLOAK BUTTERFLY AND BEETLES; PEN AND INK

No wonder the Oriental masters were so taken with plum trees. From its place at the edge of the woods,

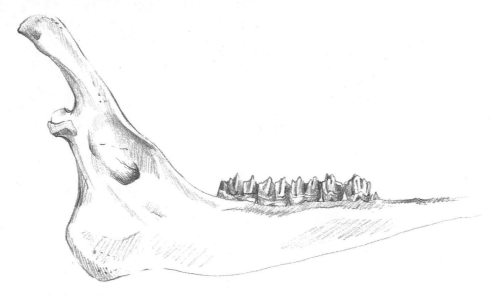

DEER'S JAWBONE; HB PENCIL

this one is the essence of simplicity and elegance. There is a faint sheen to the leaves, as though they had been lightly buffed to bring out their smooth texture. The leaves appear delicate, and the light shines through them like the oiled-paper windows of the early settlers. Even the bark looks polished, and I try to capture something of the variety of lights and darks and the clean lines of this young tree by the degree of pressure on my pencil point.

I often find remnants of the woods' other residents as I search through the fallen leaves, head-down and rambling. I am not repulsed by these calcium remains, but instructed

in the ways of the creatures that share these woods with me.

This fragment of a jawbone explains how the deer is capable of tearing the brushy browse that is its normal winter food; the teeth are sharp and closely fitted. A tracery of tiny toothmarks on the bone tells me that this, too, is food. Some small creature found the minerals here and began the long process of converting death to life.

An HB pencil works well to capture the delicacy of angles and shapes; anything harder would make too pale a line.

A deer's teeth are perfectly engineered to their task; the doe

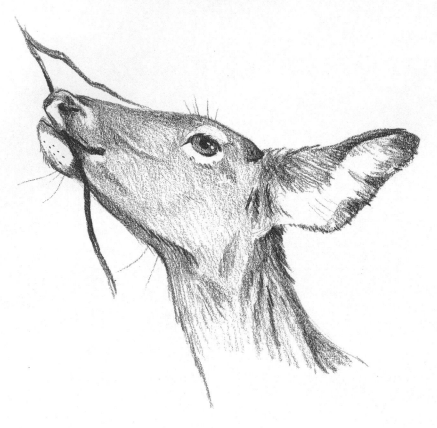

DEER; COLORED PENCIL

sketched here was working on the young dogwood in front of my cabin, and I have wildly mixed feelings. It is humbling to be so close to so large a mammal. She is delicate, beautiful, graceful as a ballerina—but she *is* eating the dogwood I nursed through the drought with water brought from town.

Colored pencil quickly captures her basic shape; I know she won't stay long once she sees me in the window. When the overall form and position are down on paper, I fill in the gaps in detail at my leisure.

There's no escaping the particular brand of spring fever that strikes here in Missouri—it's mushroom season. After years of drought—anathema to a good crop of edible morels—the snow and ice and spring rains are expected to bring the first good crop in years. We compare notes with friends in the grocery store and on the street, and stop in at Ray's Lunch, the local hangout, to check with the

MOREL; #2 PENCIL

regulars. "Found any yet?"

My mushroom book says the first of the species may pop up as early as April, though common wisdom has it the best part of the crop will appear when oak leaves are the size of squirrels' ears and sweet williams bloom in the woods. It's no good to go out too early when the soil is still cold, and once the weeds are knee-high you can't see the quarry. It's a relatively narrow window of time that comprises the prime hunting season, a week or three at best.

Conditions seem perfect. The soil is rich with leaf litter, and it's damp down as far as I can dig. The white threads of mycelium tie it all up like ribbons on a gift I am all too eager to receive. I can *smell* mushrooms.

When I find this one I whoop like a kid at the circus—it's been a long, long time. But I am not so eager for my meal that I can't take time to sketch; I can enjoy the tangible memento later, long after the meal is digested and forgotten.

Dark brownish-maroon pawpaw flowers seem carved from mahogany. There is a slight gloss and a decidedly unplantlike

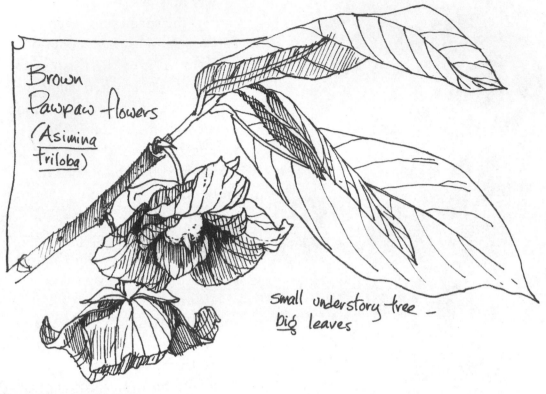

Brown
Pawpaw flowers
(Asimina
Triloba)

small understory tree —
big leaves

PAWPAW; PEN AND INK

geometry—they are more triangular than rounded, one set of waxen petals inside another like a Chinese puzzle.

The leaves are big; in the early spring woods they are moccasin prints in the air. *Asimina triloba* flowers develop into sweet, soft fruit, darkly spotted yellow things known as custard apple or wild banana; I've never found them at that stage here, but it's no wonder—they're a favorite food of opossums, raccoons, gray squirrels, and half the other denizens of the woods. They queue up for the oil- and protein-rich fruits, or perhaps for the seeds which contain a strong alkaloid that has a depressing effect on the brains of animals. Do they want to mellow out, get high, stoned here in my pawpaw thicket?

The bark strips off in long, tough strings, which Native Americans in

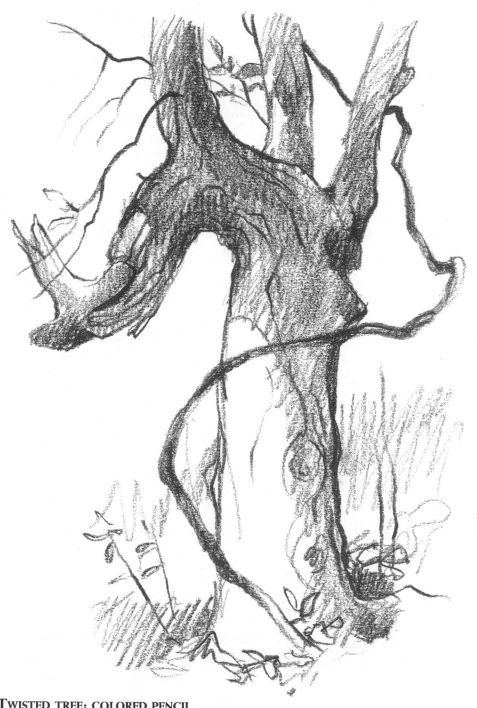

TWISTED TREE; COLORED PENCIL

Louisiana use to weave cloth. Others use these fibers to string fish on. When we knocked down a couple of the smaller trees with my neighbor's tractor, I could barely break them off and pull them out of the way. They

One odd tree (page 9) looks as though it meant to grow upright like its fellows, then suffered a split personality; one major limb takes off in a right angle, then frays into several smaller limbs still determined

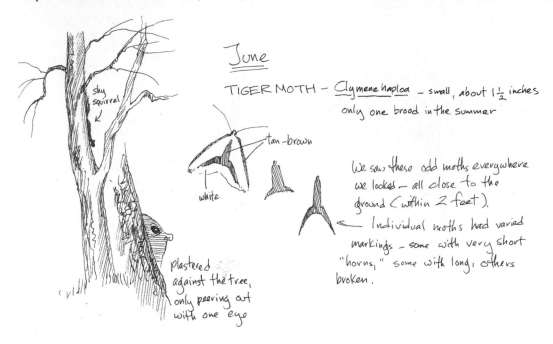

June

TIGER MOTH — *Clymene haploa* — small, about 1½ inches
only one brood in the summer

shy squirrel

tan-brown

white

plastered against the tree, only peering out with one eye

We saw these odd moths everywhere we looked — all close to the ground (within 2 feet).

← Individual moths had varied markings — some with very short "horns," some with long, others broken.

SQUIRREL BEHIND A TREE, AND MOTHS; FIBER-TIPPED PEN

held on, tenacious as a badger, and I found myself pulling an eight-foot-long strip of bark just half an inch wide, still firmly attached to the tree at one end.

A bottomland tree sends out runners from the roots; that's why you so often see them in groves or thickets.

on the original course. The L-shaped skeleton that holds the canopy upright is a puzzle; what caused that aberration? How can it remain crooked like that without breaking? Its weight must be considerable. But it's been that way for generations; the tree is a graphic demonstration of the strength inherent in the wood.

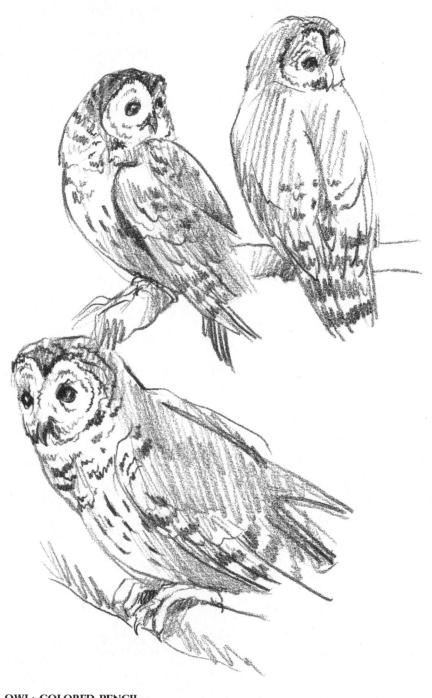

BARRED OWL; COLORED PENCIL

Every walk through the woods is a cat-and-mouse game with the resident squirrels; they scold me unmercifully or plaster themselves like a bandage to the side of the tree farthest from me, watching like guerrillas. Drawing such a sliver of squirrel is easy.

These tiger moths that perch beside the path every few feet show the diversity in pattern within a single species; they are alike, but not clones.

I hear the strangest sound in the woods, a querulous, high-pitched half-hiss. It must be a bird, but what kind?

Finally, after stepping softly down the forest path, I see a familiar shape against the sky—it's a young barred owl, talking to itself in broad daylight. I answer back in my best imitation, hoping to intrigue the bird into holding still so I can sketch, and the owl twists its head to watch, hissing again but not flying. I often hear barred owls at dusk and in the lonely hours of the night, but I've never held a conversation with one at noon.

Barred owls have dark eyes, an oddity they have in common with barn and spotted owls; most other owls have great golden orbs that pin you to the spot like a field mouse. Their dotted and striped feathers are cryptic, camouflage against mobbing crows and songbirds—they blend right into the lights and shadows of the woods. It must work; nothing seems to have found the young owl but me.

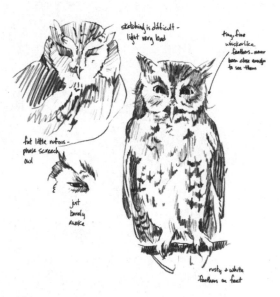

SCREECH OWL; COLORED PENCIL

Another familiar resident— familiar by voice only, usually—is the tiny screech owl, no more than eight inches long. This one is a rufous-phase, with rich, sienna coloring; most screech owls around here are gray-phase.

I don't see them at all unless something is terribly wrong. When one of these little birds loses a confrontation with a car or a cat, someone brings it in to the animal clinic. It's bad news for the screech owl, but a wonderful opportunity for me to draw at a range not ordinarily possible. Normally, the screech owl and I occupy different slices of the clock. I can't see well enough to find the owl in the dark; the nocturnal predator tries to stay hidden in the daylight hours.

The tiny owl has short, rounded wings, with fringed edges, plus the typical hooked beak and sharp talons of the owl clan. The screecher's call is not a screech at all, but a wavering, eerie cry that makes the hair stand up on my neck.

This is not the smallest owl on the square mile, though. My friend Jerri Davis, an avid birder who keeps nesting records for the Audubon Society, alerts me to the habits of the saw-whet owl, smallest of our Missouri owls. She says they are so

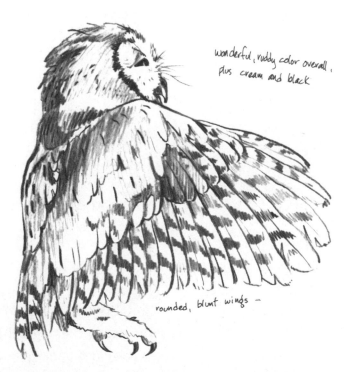

wonderful, ruddy color overall, plus cream and black

rounded, blunt wings —

SCREECH OWL FROM SIDE; COLORED PENCIL

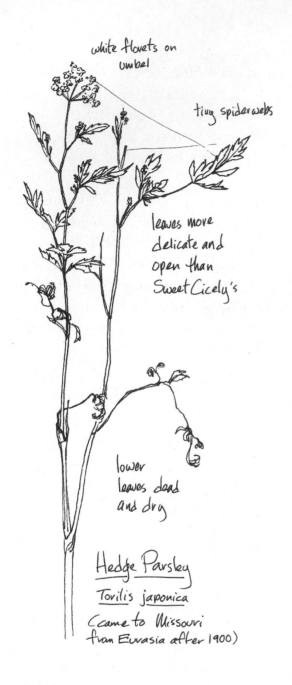

white florets on
umbel

tiny spiderwebs

leaves more
delicate and
open than
Sweet Cicely's

lower
leaves dead
and dry

Hedge Parsley

Torilis japonica

(came to Missouri
from Eurasia after 1900)

HEDGE PARSLEY; FIBER-TIPPED PEN

tame you can walk right up to one, and that they pass the day hidden in cedar trees or other thick evergreens. Three big cedars are within easy walking distance; I check one or another almost daily to try to find one of the little owls. But if it is sheltered in the prickly green tent, it is invisible as well as nocturnal.

I've seen the tiny, delicate flower shown left all my life, but I never stopped to draw or identify it until now. It wasn't easy to find in my field guides, which often show the distinguishing foliage only as a blur. The photo of hedge parsley in *Missouri Wildflowers* by Edgar Denison was best, though even here the example appeared much larger and more imposing than the wisp of a plant in my hand. The white flowers are minute, like grains of salt with five nearly invisible petals. The leaves are finely cut, fernlike, but not so ornate as water hemlock's. It most closely resembles a tiny cousin of sweet cicely, which it is—both are members of the parsley family, Apiaceae. There are between 2,500 and 3,000 species of this family, including the vegetables carrot, celery, and parsnip and the flavorings dill, anise, fennel, angelica, and

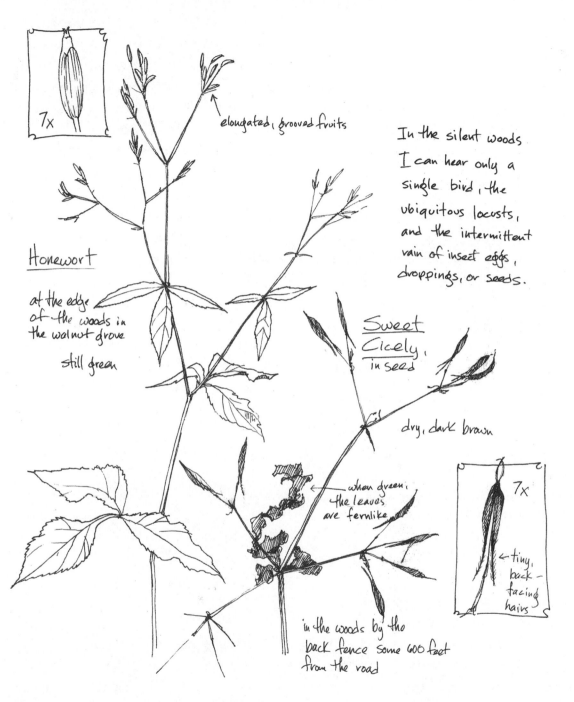

7x

elongated, grooved fruits

In the silent woods
I can hear only a
single bird, the
ubiquitous locusts,
and the intermittent
rain of insect eggs,
droppings, or seeds.

Honewort

at the edge
of the woods in
the walnut grove

still green

Sweet
Cicely,
in seed

dry, dark brown

← when green,
the leaves
are fernlike

7x

← tiny,
back-
facing
hairs

in the woods by the
back fence some 600 feet
from the road

HONEWORT AND SWEET CICELY; FIBER-TIPPED PEN

caraway—and the dark side of the family, the extremely poisonous water hemlock.

Drawing such a complicated work takes concentration; I don't try it when I'm in a hurry or feeling nervous. A fine fiber-tipped pen is perfect for details, and I try a variation on the old technique of contour drawing, looking mostly at my subject, then down at my page.

Honewort, sketched close by, has a similar growth pattern to sweet cicely, with open umbels and branching stems. In mid-July, the honewort has gone to seed, making identification more difficult (most books show the flowers, not fruit), and the sweet cicely is already dead and brown, curled crisp as bacon. I draw these two with a fine-point fiber-tipped pen—details are easier to capture clearly, helping me to identify the plants later.

When working in the field this way, I usually make as many notes to myself as I feel are needed for identifying the plant, even asking myself questions and using arrows to point to details that will help me find my prey. Later, at home, I can go through my stack of books. This is easier than toting a library to the field. To identify these plants, one would have to consult two separate books; I found the honewort with seed in my Peterson's field guide, and if I hadn't already known what sweet cicely looks like at this stage I would have resorted to one of my three books on winter weeds or flower pods. Or the gargantuan 1,728-page *Flora of Missouri* by Julian Steyermark—quite a load in anyone's daypack.

I had taken my magnifying glass with me for detail work, but the image through the inexpensive tool is distorted at the edges. My father's old glass is of much finer quality, but I use it only at the cabin; I'd hate to lose it in the woods.

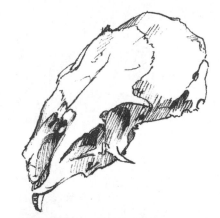

SQUIRREL SKULL; PEN AND INK

After I pass, I look back to see the squirrels dancing from tree to tree,

graceful and sure as monkeys, and wonder at their agility, their apparent indestructibility. But I know that's illusion; their lives are as fragile as our own.

I wander in the bare woods in search of early spring wildflowers. Instead I find the bleached remains of a squirrel's skull, tiny, vulnerable—touching. The teeth are curved inward, marked with a line of golden brown on the outer surface; its twin in Elizabeth and Charles Schwartz's *Wild Mammals of Missouri* confirms my identification, and after sketching this delicate ivory skull I put it on the shelf with the others that offer silent evidence of occupancy.

Sketching a creature over and over can give you a sense of confidence and authority. These squirrels were reworked from gesture sketches from a 1982 field journal; the roughest indication of position was there, and accurate, but the squirrels were almost unrecognizable as Sciuridae family members. After ten years of sketching these ubiquitous animals, I am comfortable enough to translate the rapid blobs and squiggles to believable shapes that recall the acrobatic squirrels in my own woods.

This sequence is typical of squirrels as they leap from one tree to the next—I've seen it a thousand times.

The woods are anything but silent in summer. Starting in the late

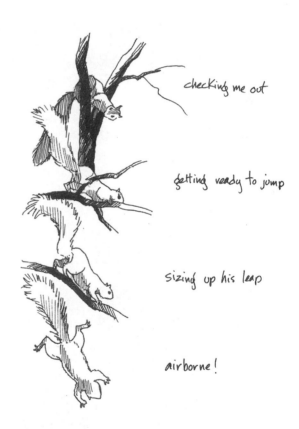

checking me out

getting ready to jump

sizing up his leap

airborne!

SQUIRREL SEQUENCE; PEN AND INK

morning, cicadas shriek and wail and drone, their voices rising and falling and rising again in a frantic

SUMMER CICADAS — their

songs are loud and insistent

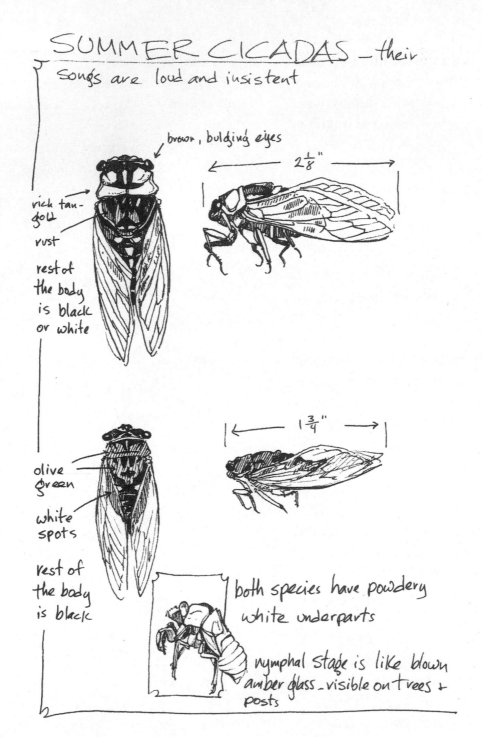

brown, bulging eyes

$2\frac{1}{8}$"

rich tan-gold

rust

rest of the body is black or white

olive green

white spots

$1\frac{3}{4}$"

rest of the body is black

both species have powdery white underparts

nymphal stage is like blown amber glass—visible on trees & posts

SUMMER CICADAS; FIBER-TIPPED PEN

crescendo. The sound can be deafening; the decibel level rivals that of a small airport—a mating call that must prove attention-getting, to say the least. It can't be ignored.

I've found two different species here, the far more plentiful olive green and black ones about one and three-quarter inches long, and a relative monster of a bug, the huge gold and black cicada that measures over two inches from mandibles to wing tip. The larger creature's nymphal exoskeleton has eluded me so far, but every twig and post and tree trunk bears the blown amber husk of the smaller insect's nymph. Both species have white underparts that look as though they fell into the flour bin; I wonder what purpose that serves.

Like all cold-blooded creatures, these are sluggish in the morning while the air is still cool. I hold one in my hand for several long minutes, drawing, and imagine it must be dead. But instead my warmth transfers itself to the insect's body, rousing it from its torpor. It rises with a startling buzz of wings and flies off between the trees, reeling its loud rattle in behind it.

Experimenting with two different pen weights in this sketch, the Micron .08 and .005. I like the bold outline and the delicate details; these are still fiber-tipped pens and relatively inexpensive, but with their smearproof, waterproof ink they're as versatile as a technical pen without the hassle of difficult start-up.

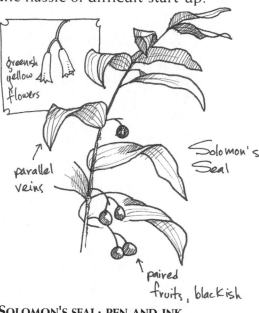

greenish yellow flowers

parallel veins

Solomon's Seal

paired fruits, blackish

SOLOMON'S SEAL; PEN AND INK

The edge of the woods is studded with these eighteen-inch plants with their paired black fruits.

This shelf fungus is dry and hard and as simple as a piece of Shaker furniture; it hugs its rotten twig like an apron.

A polyporous fungus with pores instead of gills on the underside, the

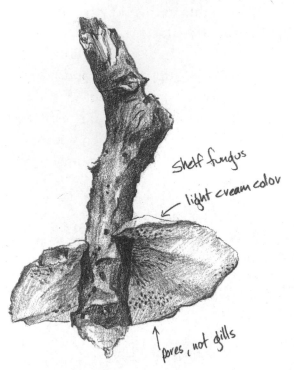

Shelf fungus

light cream color

pores, not gills

SHELF FUNGUS; HB PENCIL

top is subtly striated in shades of beige and tan and cream, with the lighter colors predominating. When I find these fungi in the woods, that pale tint catches my eye as though there were a light falling on them.

It's difficult to catch the subtlety of a subject like this with the crisp, harsh tones of pen and ink. Pencil is more suitable for patiently exploring shades and folds and shadows.

I drew this delicate, frothlike white snakeroot for ten minutes before I realized I held a minuscule predator in my hand. A crab spider huddles beneath its lacy umbrella, waiting for something small enough to eat to happen by. I'm not it.

Because of its position under the edge of the petals, I'm having trouble seeing the spider's anatomy; it looks as though it has only four legs. But as I draw, the spider leaps off the flower onto my paper—serendipitous for me, because against that featureless white I now see that the back two pairs of legs appear almost vestigial, threadlike, not a bit like the Popeye-strong forelegs that snatch prey so quickly you can hardly see the movement.

This deceptively pretty plant, innocent as a virgin bride in lacy white, is also a killer. When it is consumed by cows, its toxic juice produces "milk sickness," an illness that killed Abraham Lincoln's mother, along with many others. Nature is death in the midst of life—in the most innocent-seeming of flowers, and in the crab spider, waiting patiently for prey.

I'm no expert birder, but I'm astounded by the varieties of avian life among the varied habitat here. Between the migrants and the nesters and the just-passing-through-on-

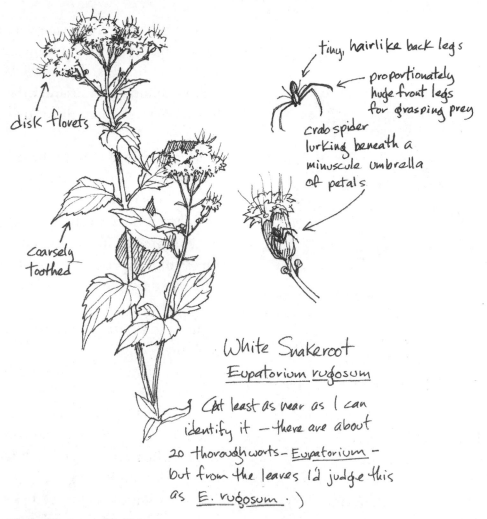

tiny, hairlike back legs

proportionately huge front legs for grasping prey

crab spider lurking beneath a minuscule umbrella of petals

disk florets

coarsely toothed

White Snakeroot

Eupatorium rugosum

(At least as near as I can identify it — there are about 20 thoroughworts — Eupatorium — but from the leaves I'd judge this as E. rugosum.)

WHITE SNAKEROOT; FIBER-TIPPED PEN

rare-occasion birds, I see almost everything but oceangoing birds. (On second thought, I *have* spotted a gull or two far overhead; they come up the Mississippi to the Missouri River and find their needs met there. Why return to the ocean?)

My friend H. A. Dickey says he's even seen a scissor-tailed flycatcher nearby. It's usually a more southerly bird.

In a drawing of a variety of birds, the stance says as much about identity—and personality—as anything. The Carolina wren stands tail up and alert, pugnacious,

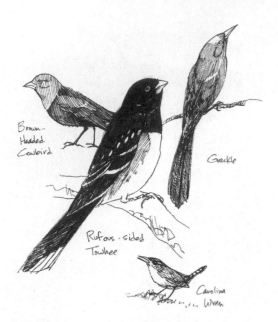

**BROWN-HEADED COWBIRD, GRACKLE,
RUFOUS-SIDED TOWHEE, CAROLINA WREN;
PEN AND INK**

scolding me with a loud burring sound. The seldom-seen towhee seems ready to take flight at a moment's notice—which indeed it is. I sketch the basic shape and the suggestion of feather pattern, then consult my bird books for more information about wing bands and spots.

Tiny, inconspicuous flowers are sometimes the most charming. They're not brash and pushy, like composite-family members; you have to look for them. Their colors, though often lovely, are in such small doses they can't shout like wild rose's large pink petals or the bright gold rays of sunflowers. Their scents are hidden among a thousand other forest aromas—they never over-power.

Lopseed is one of my favorites among these little flowers. Only a few of the quarter-inch flowers bloom at a time on the main spike or its diverging branches; when finished, they "lop" down as though exhausted by the effort, tiny green calyxes hugging the stem like a squirrel in hiding—inconspicuous as possible.

Still, on close inspection I find a marvel of orchid-like beauty. The flower itself is bi-colored, lavender and a pale near-white. The corolla has two lips, the lower much larger and paler than the upper.

I could not find lopseed in my book of Missouri flowers, even looking under its Latin moniker, but the *Audubon Society Field Guide to North American Wildflowers* showed it, in a family tree all to itself—Phrymaceae. In *Flora of Missouri*, Julian Steyermark elaborates to point out it is ubiquitous in Missouri, appearing, most probably, in every county. It ranges from Quebec to Florida and

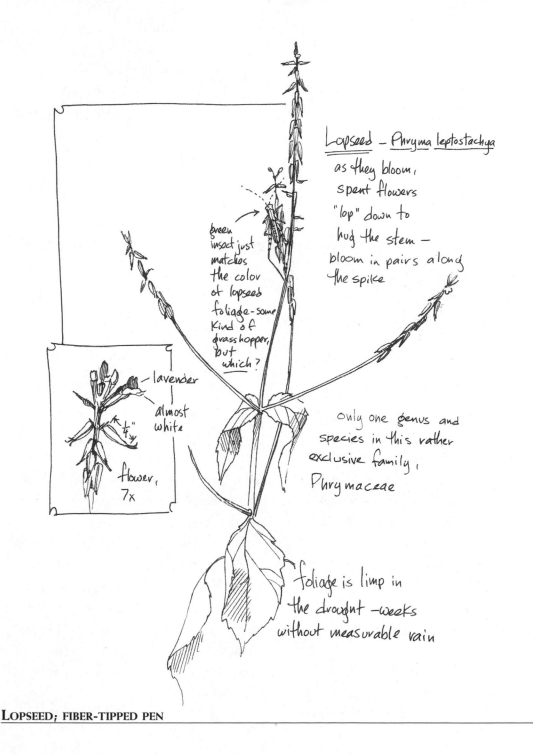

Lopseed – Phryma leptostachya

as they bloom,
spent flowers
"lop" down to
hug the stem –
bloom in pairs along
the spike

green
insect just
matches
the color
of lopseed
foliage–some
kind of
grasshopper,
but
which?

lavender

almost
white

$\frac{1}{4}$"

flower,
7x

only one genus and
species in this rather
exclusive family,
Phrymaceae

foliage is limp in
the drought –weeks
without measurable rain

LOPSEED; FIBER-TIPPED PEN

west to Texas, and yet most of us overlook it entirely.

Again, sketching a plant in the field and identifying it later saves me the bother of carrying a lot of books on these explorations.

OPOSSUM SKULL; HB PENCIL

There are Virginia opossums in the woods, though I never see them here. They're not like the bold raccoons, or even much like the opossums that took up residence in my basement at home in town. The city-cousin opossums had adapted to our presence and seemed almost unafraid. These are wild, and know it.

I found an opossum skull near the creek one winter, the only visible evidence I've found of their habitation short of road kill.

These baby opossums were brought to my veterinarian after their mother was killed; their eyes are just beginning to open. They're skinny and appear weak, but they're still squirmy enough to be difficult to draw. I can only get bits and pieces as they wriggle in Pete Rucker's hand.

The first sketches I tried were with a dried-out felt tip, all I could find in a hurry, but these are done with a warm dark gray Prismacolor pencil. The effect is more subtle and captures the soft gradations in their silvery fur. But peering over someone's shoulder while a dog is being operated on on the table behind me, with a husband waiting in the lobby, is not my favorite way to sketch!

To Pete's surprise, the baby opossums lived—the first he's been able to hand-raise. I meant to sketch them again at several growth stages, but each time something happened—he had just taken them to his home after weeks in the clinic's cage, or I got busy, or it snowed. This weekend I simply decided to go, come what may. Pete said it was "great timing; we've had three beautiful weekends, and you wait till it's supposed to snow!"

And it is indeed almost too cold

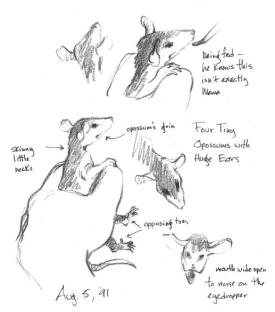

being fed –
he knows this
isn't exactly
Mama

opossum's grin

Skinny
little
necks

Four Tiny
Opossums with
Huge Ears

opposing toes

mouth wide open
to nurse on the
eyedropper

Aug. 5, '91

BABY OPOSSUMS; COLORED PENCIL

SUNSET AT RUCKERS

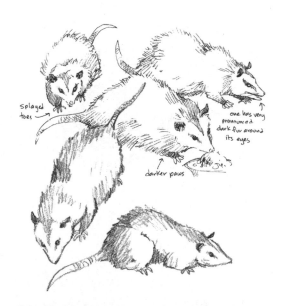

splayed
toes

one has very
pronounced
dark fur around
its eyes

darker paws

**OLDER OPOSSUMS; PEN AND INK AND
COLORED PENCIL**

to sketch out here on the hill. The sky is clotted with clouds except near the horizon. The sun disappears all too quickly after a brief appearance at the edge of the world, and my hands grow stiff. I wish for fingerless gloves!

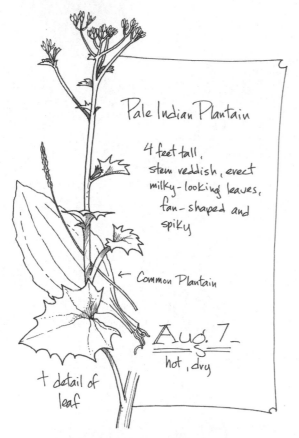

Pale Indian Plantain

4 feet tall,
stem reddish, erect
milky-looking leaves,
fan-shaped and
spiky

← Common Plantain

Aug. 7
hot, dry

+ detail of
leaf

PALE INDIAN PLANTAIN; PEN AND INK

This plant looks nothing like the common plantains I'm used to seeing in yards and waste places. There are sixteen plantain species and their variations in Missouri; pale Indian plantain shares only the common name. One of the more familiar Plantagos, English plantain, was called "white man's footprints" by the Native Americans; it was considered medicinal (laxative), and brought to dooryard gardens by our forebears. I see the basal rosette of parallel-veined leaves everywhere. Pale Indian plantain (*Cacalia atriplicifolia*), on the other hand, prefers the woods' edge—on my square mile, anyway; it's up to five feet tall with spiky leaves. The stems have a silvery coating which comes off on my fingers. *Cacalia's* meaning is lost in history, but *atriplicifolia* means its leaves are like those of saltbush, or *Atriplex*. It resembles Plantagos not at all, and I can't imagine who gave it the same common name.

For years I've noticed this odd little fall-flowering plant in the open woods and on the path up to the pond. The saclike bases of the flowers are elongated, hairy; the flowers themselves are royal purple.

On later inspection with the aid of my father's fine old 7X Coddington lens, I am able to see that what I expected to be anthers—

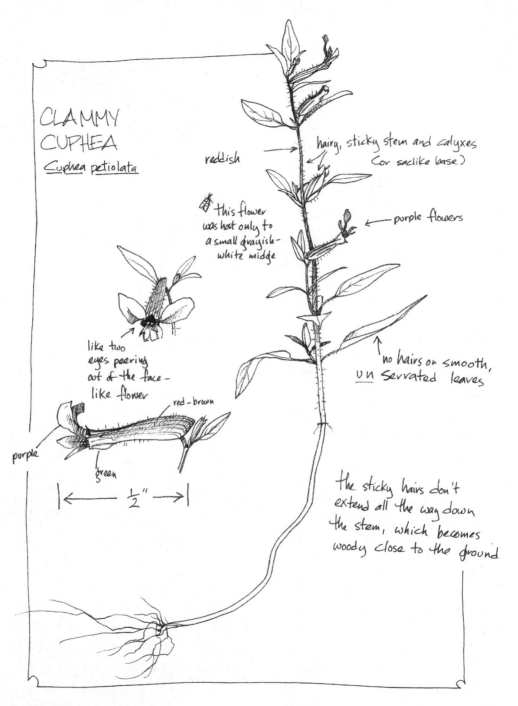

CLAMMY
CUPHEA
Cuphea petiolata

reddish

hairy, sticky stem and calyxes
(or saclike base)

this flower
was host only to
a small grayish-
white midge

purple flowers

like two
eyes peering
out of the face-
like flower

red-brown

purple

green

|← ½" →|

no hairs on smooth,
u n Servated leaves

the sticky hairs don't
extend all the way down
the stem, which becomes
woody close to the ground

CLAMMY CUPHEA; PEN AND INK

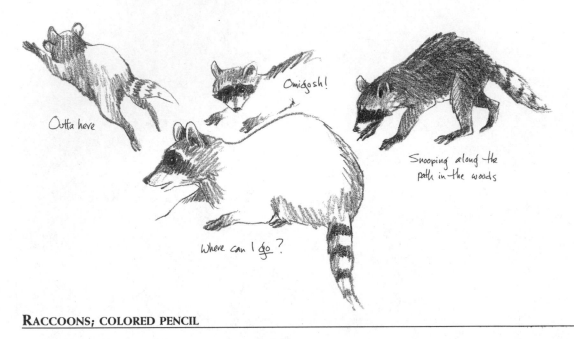

Outta here

Omigosh!

Where can I go?

Snooping along the path in the woods

RACCOONS; COLORED PENCIL

the pale eyelike apparitions within the flower I noted in the field—are instead light shining through two pale spots on the hoodlike sac. What their purpose is I can't imagine. They look as though they'd be more apt to frighten away a pollinating insect than attract one.

After a diligent search through most of my field guides and a call to Linda Ellis, of the Missouri Native Plant Society, I finally find the plant listed in Peterson, under the red-pink category rather than the blue-lavender where I had been searching.

At the feeder at night the raccoons are fearless; they own the place. That food is there for their enjoyment—though perhaps incidentally—and they seem to expect it. Meet one on the path in the woods, and it's a different story. They're shy as deer.

I hear rustling in the brush and approach cautiously, hoping to see what's making the soft noise. As I round a bend in the path, I come face-to-face with a startled bandit. There's no question of who owns this patch of woods. At this moment, in the 'coon's eyes, I do, and the animal is *out* of here.

Normally nocturnal, the 'coon must have felt out of its element as

well as outgunned by my size and unexpected presence. I never saw one move so fast—I sketched it from memory, not life!

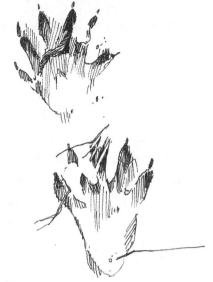

RACCOON PRINTS; PEN AND INK

Later, though, I find deep prints in the mud near the creek; the hind feet measured over three inches. No wonder I was nearly as startled as he; that was one big raccoon, and the sight of wildness in the woods never fails to undo me.

I am excited by the opportunity to draw a hornet's nest. My friend Pete found this one while hunting and loaned it to me; after the deep cold of November's early winter, there's no need to fear recriminations from the architects.

Last year I found a beautiful specimen in a tree by the road and climbed up to saw it down. It was too high and my perch too tenuous, so I decided to come back later with a ladder. The nest was gone when I returned. Someone must have seen me up in the tree or spotted the nest overhead. It was Halloween, and I'll bet a prankster cut the nest down and tossed it into someone's yard. I was furious; I'd wanted one to draw since I first saw Andrew Wyeth's wonderfully evocative sketch.

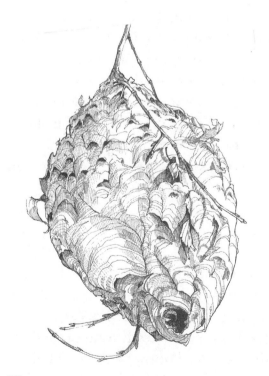

HORNET NEST; PEN AND INK

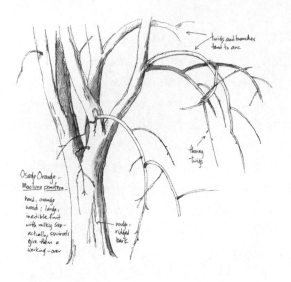

twigs and branches tend to arc.

thorny twigs

Osage Orange -
Maclura pomifera -
hard, orange
wood; large,
inedible fruit
with milky sap—
actually squirrels
give them a
working—over

rough,
ridged
bark

HEDGE TREE (OSAGE ORANGE); FIBER-TIPPED PEN AND WASH

Still, to finally have the chance—and the time—to draw this one is a delight. I had no idea how light the big football-shaped nest would be; the layers of insect-made paper and the air chambers within must make fine insulation against the heat of a Missouri summer, though not enough to carry the hornets through the winter. My insect book says only the queen lives, overwintering under the soil.

After a few days I have to hide the nest in the shed, rather than hanging it on the porch for easy access. The second day, the birds found it and ate the two dead hornets; the third day they had started on the entrance to the nest itself, enlarging it to gorge on more insects; I move it to the shed for safekeeping and laugh when I remember my father's irrational fear of the stinging insects. He once stopped the car and hit the ground running when a hornet came in the side window, leaving me and my wheelchair-bound mother behind. Nothing could have persuaded him that a nest is safe after the freeze; he'd find my sitting and calmly drawing this one quite a sight.

Here and there, someone has cut one of the hedge trees that stud the woods—perhaps for fence posts. This hard wood is like iron; a post cut from Osage orange may last a generation and more.

I find a stump as big as a coffee table; the squirrels use it to dine on. It is littered with the shredded remains of the fruits of the hedge. Nearby is a tangled stack of small branches and twigs, "slash" left over from the logging operation. In my fire the sticks that remain spark and sputter as though still filled with sap after all these years.

The trees are easy to spot in the woods; their limbs make arcs that are pleasing to sketch, intersecting one another as though drawn with a

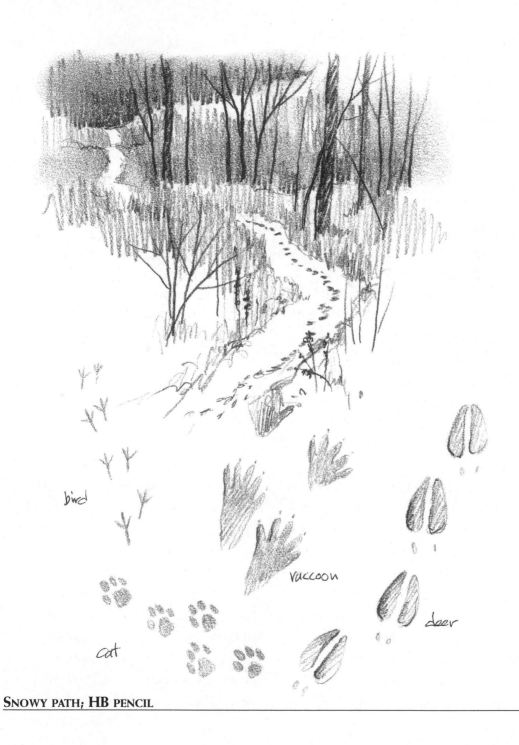

bird

raccoon

deer

cat

SNOWY PATH; HB PENCIL

compass. Their bark is finely ribbed, tight, lichen-covered. Against the orangish brown and gray of the tree bark, the lichen sings with color, telling me that so far the air here is good; lichen doesn't thrive where air pollution is severe. My ink pen cannot capture the richness of color, only the fine arcs of the limbs. I can't tell how long the slash piles have been here, but the twigs are weathered and barkless, and lichen paints them also.

According to *Lewis and Clark: Pioneering Naturalists* (Paul Russel Cutright), which lists discoveries at each leg of their journey, the explorers found and duly noted Osage orange (or bois d'arc, bodark, bowwood, hedge—a tree with many aliases) in 1804 not far from this square mile.

This new dusting of snow is like the "reveal codes" command on my computer; the strange combination of dark wet earth, still warm enough to melt the snow that fell there, and the white-coated grass beside it shows me the paths made by resident wildlife where I'd never been aware of them before. There has always been a clear track to the creek; but now I can see that it forks near the

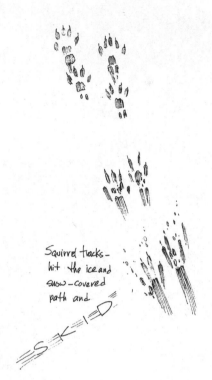

Squirrel tracks— hit the ice and snow-covered path and

SQUIRREL SKID; PEN AND INK

gravel bar, one half going directly across the creek and under the big limestone slump block where the raccoon takes up sometime residence, the other heading off downstream. A cat has left its clawless track here. Something has used the broad path Harris cut around the grove with his old mower; a deeper, narrower track now shows clearly in a long scythelike

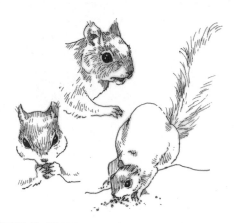

FEEDING SQUIRRELS; PEN AND INK

curve by the edge of deeper woods. The dark depression showed up as though cut with a miniature bulldozer. Deer tracks furrow the soft earth under the whiteness, deep double-parentheses that enclose a silent quote. I read the story in the woods.

Even the surefooted squirrels have trouble when the snow has a glaze of ice.

They recover quickly when food is the object; these gray squirrels find fallen birdseed and the nuts in the woods to be fine winter fare. When mast is scarce, they will eat the tender cambium layer beneath the tree bark; I see pale "blazes" in the woods, almost white against the charcoal bark. If times are extremely difficult, the squirrels can actually kill

a tree by girdling it, interrupting the flow of nutrients and moisture between the roots and leaves.

The squirrel bones in this rather large owl pellet prove they also act as prey animals, an important link in the food chain that keeps the big owls abundant in the woods.

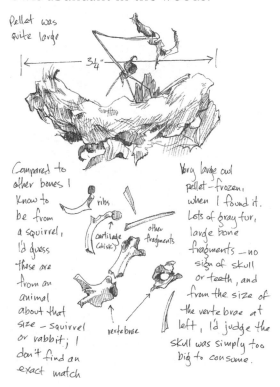

Pellet was quite large

3¼"

Compared to other bones I know to be from a squirrel, I'd guess these are from an animal about that size — squirrel or rabbit; I don't find an exact match

ribs

cartilage (disk)

other fragments

vertebrae

Very large owl pellet — frozen, when I found it. Lots of gray fur, large bone fragments — no sign of skull or teeth, and from the size of the vertebrae at left, I'd judge the skull was simply too big to consume.

OWL PELLET; FIBER-TIPPED PEN

Part II

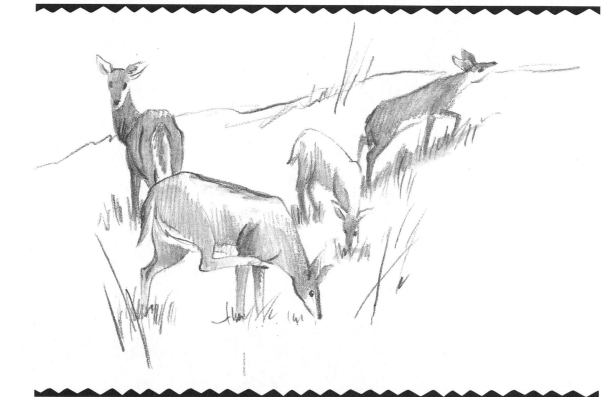

The Meadows

The meadows are a markedly different ecosystem from the forests on this square mile near the muddy Missouri River. But the meadows themselves are varied, unlike each other by virtue of soil and location and microclime. Deep-bedded soils, rocky hillsides, scalped glacial summits, glacier-deposited loess—even in the space of one square mile, the range of soil types varies dramatically. Because of that, so do the life forms that flourish here.

Some are old meadows, bristling with brambles and young saplings, well on their way to becoming new forest. Some are mowed and dotted with hundreds of hay bales; some provide browse only for the shy bands of white-tailed deer. Still others are prairie, remnants of the long fingers of tallgrass that reached deep into the nearly impenetrable forests of presettlement Missouri.

Butterflies and moths, birds and mammals interact in age-old ways in this ancient ecosystem. According to the plants that grow in each meadow community, there you will find the

insects, birds, and mammals that feed specifically on them, and the many other creatures that find these links in the food chain to their liking.

On my own land there are three distinctive meadow types, also predicated by what's going on underfoot. One of these three, the pond meadow, is cut down the middle by an invisible line. The upper meadow is lush. The plants grow thick as a dhurrie rug here, and no wonder—the soil is coffee-black. On the lower half of the meadow, Winterset limestone is exposed at the surface in a broken golden rubble. Plants are sparse and of a different community. Mammal burrows are all but nonexistent—what can bore through stone? And in Rachel's Meadow, on the high hill some 950 feet above sea level, the plant community is in an obvious state of flux. This meadow, inaccessible and cut off from the rest of the land by a thick ruff of new wood, has gone unmowed for years, and I monitor its changes with an interest both dispassionate and loving.

I stand at the top of the hill and

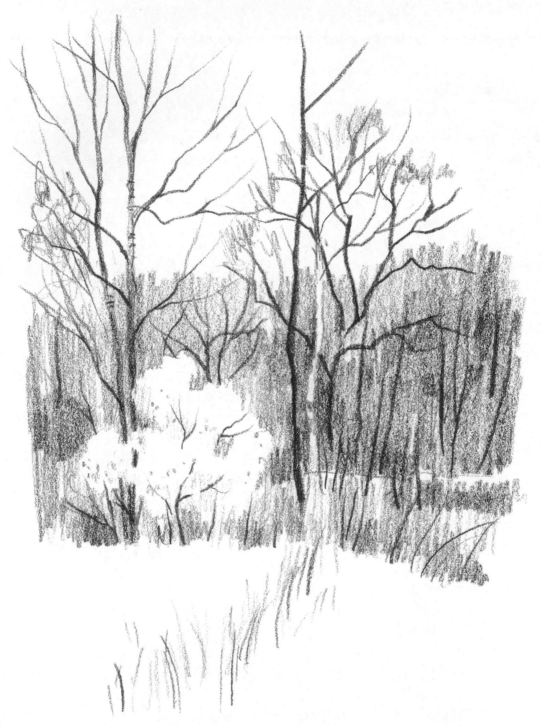

SPRING MEADOW; COLORED PENCIL

see the future without benefit of a crystal ball. Nature is devoted to change. Nothing is static. All moves slowly, glacierlike, toward that

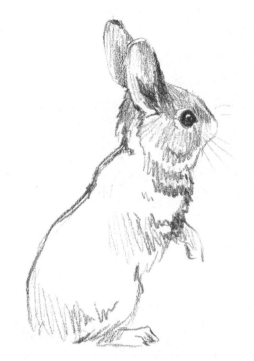

Cottontail; colored pencil

inevitability of transmutation, meadow-becoming-forest on the hill. The brambles that beard the edges of the old hay-mow are interspersed with young trees: hawthorn and osier, cottonwood and the big-leaved sprouts of half-a-dozen types of oak. Unless I take a hand, call in the

brush-hogs and reclaim the meadow, this will be woods in my lifetime.

The colors of early spring are tender. Berry canes blush with new red in the full sun where they encroach on the old meadow; wild plum foams like surf breaking against the shadowed woods. Close to the ground, basal rosettes begin to consider something more than holding their own, and send up the beginnings of spring growth.

There is no way to draw that sweet, tentative spring to adequately capture the mood. I try to suggest the explosion of white flowers on the little wild plum more by what I don't draw than by what I do; negative space shows where the blossoms are. Too much detail in such a subject would be to render it too heavily, to kill the delicacy.

I begin to see evidence of other, more sentient growth as well; baby cottontails find new sprouts to their liking. This little fellow sits up, whiskers twitching and trembling expectantly; I've never seen anything more alive.

He's only recently emerged from the fine, fur-lined nest his mother made for him and his siblings; I watch as a hawk circles the meadow

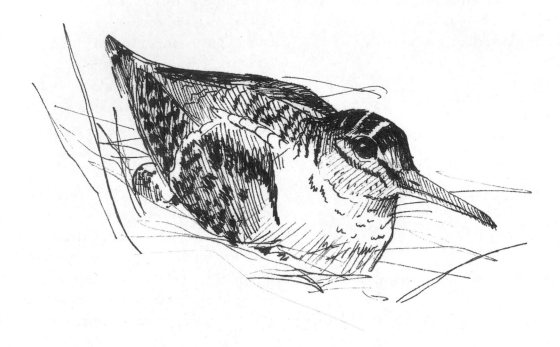

WOODCOCK; PEN AND INK

and pray he knows his way back to cover.

A female woodcock protects her new-laid egg, as cryptically marked as a stone among the meadow grasses. It is almost invisible, as is she. Only a few days ago, it seems, we watched the dizzying courtship flights of the males on Rachel's Meadow.

I draw her quickly, trying to be as unobtrusive as possible; she watches with those great black eyes, and I stand accused of insen-

sitivity to her concern. I finish a suggestion of detail later, at the cabin.

The white blossoms of wild strawberry promise sweet breakfasts in a few short weeks. My field guide says the wild plants commonly have five petals; these have six. Could they have escaped from some long-passed domestic garden?

I wait and add the nodding fruit to my drawing, weeks later; the wait is rewarded with a cupful of the fine, tart, seedy fruits that taste nothing

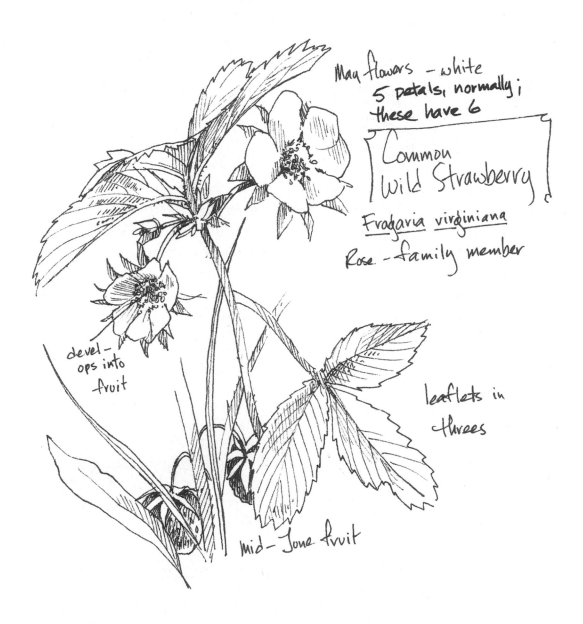

May flowers – white
5 petals, normally;
these have 6

Common
Wild Strawberry

Fragaria virginiana

Rose – family member

devel-
ops into
fruit

leaflets in
threes

mid-June fruit

WILD STRAWBERRY; FIBER-TIPPED PEN

like the huge but flavorless berries at my local market.

The goldfinches with their pennywhistle voices seem to appreciate the rough, seedy flowers we leave in the old meadow; this rich source of food attracts whole flocks of the sunny little birds. In winter they visit my feeder in camouflage color; now they've put on their breeding gold.

Quick squiggles with my pencil serve to suggest the bold markings as well as the shadows on the underbelly that suggest form and roundness.

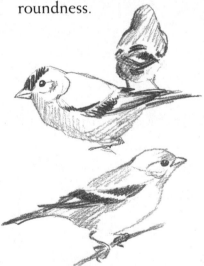

GOLDFINCHES; HB MECHANICAL PENCIL

I walk backward into the past to find evidence of the nearly extinct tallgrass prairie, and follow the tracks of the glacier that formed much of the landscape north of the Missouri River. The wall of ice left its own journal; I read it in the angular calligraphy etched into the limestone rocks, and in the rocks strewn in the gullies, rocks that were born hundreds of miles northward. A geologic Dead Sea Scroll remains in the watermarks of the receding inland ocean. The fossils of the tiny sea creatures that once swam here are bedded in the crumbling leaves of Winterset limestone.

Remnant prairie flowers dot nearby hillsides. Indian blanket, also known as showy gaillardia, is almost

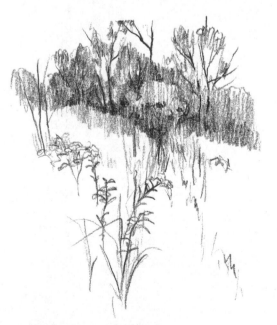

MEADOW; COLORED PENCIL

brown, the color is so rich; the ends of the toothed petals are gold. Gayfeather—blazing star or liatris— is tall and bright magenta; it must have been quite a sight when these tall flowers waved on the prairie. The Greek root for "liatris" means crowded, which could describe the leaves as well as the tightly packed flowers.

Gray-headed coneflower resembles a lavender black-eyed susan with an elongated central disk—like a somewhat rounded dunce cap. I wish I found these two on my square mile; so far, only Indian blanket on the Starfield hill.

My friend Wendy McDougal, who owns land that also adjoins the woods and meadow, named the big hill with a nod to Edwin Way Teale—and from its midnight summit the sky is indeed an endless field of sparkling stars.

A rustle in the weeds catches my eye; a mouse goes about its work, tunneling between the towering stems, finding seeds to its liking and pulling them down to its level. Jaws almost too small to imagine work vigorously, chewing the seeds. As I watch in amazement, the tiny creature puts away what looks to be

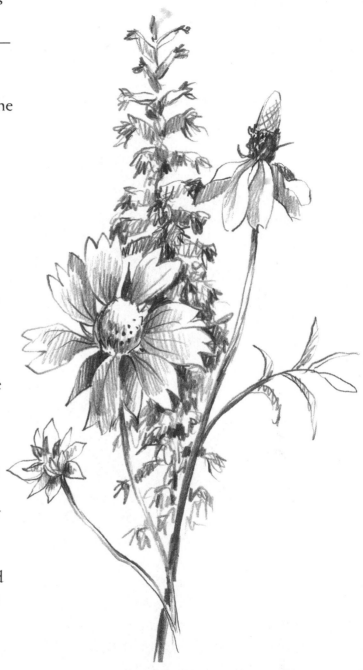

PRAIRIE FLOWERS; HB MECHANICAL PENCIL

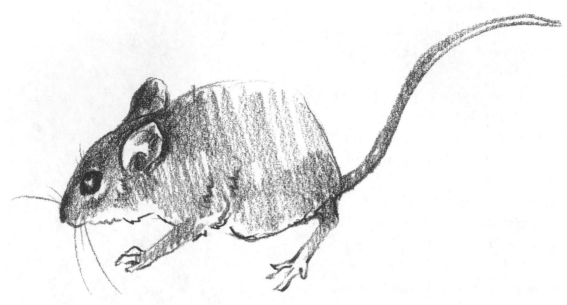

DEER MOUSE; COLORED PENCIL

its weight in grass seed.

This is not its only food, though. The mouse is insectivorous, dining on beetles and the larvae of butterflies and moths. It also eats nuts, domestic grain, fruits, and some green plant matter plus an occasional slug, spider, centipede—or even a dead mouse. Mice are survivors, and whatever it takes, they will do.

The deer mouse has a circular range, a center of activity from which the little creature ventures in search of food—or, who knows, excitement. It may find an overabundance of the latter if the

vigilant red-tails and kestrels that patrol the meadow's airspace see the same thing I do.

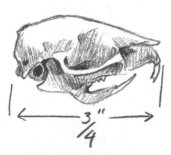

MOUSE SKULL; HB PENCIL

The tiny mouse's skull I found in my attic measures only three quarters

flowers several in a head; disk flowers, bristly white

spoon-shaped leaves

leaves woolly whitish

the little white furry flowers of this smaller pussytoes make it easy to see the reason for the namesake

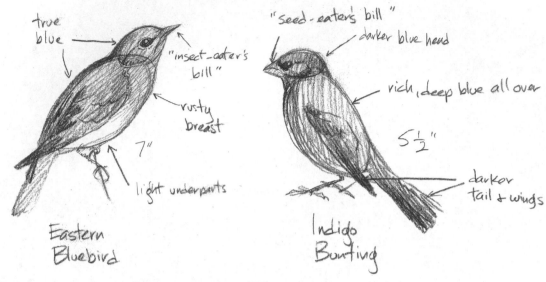

true blue

"insect-eater's bill"

rusty breast

7"

light underparts

Eastern Bluebird

"seed-eater's bill"

darker blue head

rich, deep blue all over

5½"

darker tail & wings

Indigo Bunting

EASTERN BLUEBIRD AND INDIGO BUNTING; HB PENCIL

of an inch long, so delicate it is almost transparent. The house mouse, which this undoubtedly was, is smaller than most of the "wild" mice of the meadow, but not by much. *Wild Mammals of Missouri* lists the majority of our common mice at just under an inch. The smallest is the plains harvest mouse, also three-quarters of an inch; the largest is the white-footed mouse, which may have a skull that is one and one-eighth-inch long. The deer mouse is about average, at one inch long.

Years ago, one of the rangers at

Watkins Mill State Park showed me these tiny flowers (page 45); my love of things feline extended instantly to their furry little "feet." Now I look for them everywhere in spring, and find them hugging the ground in Rachel's Meadow.

Though they are both blue, the differences between the two birds (above) are immediately apparent. The bunting feeds mainly on the seeds produced in the meadow; the bluebird feeds on the insects attracted there, and both have the typical bill designed for food preference.

In order to draw their distinctive shapes (bluebirds have short necks and rounded shoulders, buntings are more streamlined), I used quickly drawn ovals to hang my sketches on. For a more formal drawing, of course, these underpinnings would not show.

These two blue birds often make me look twice; they're both a heart-stopping blue. But the indigo bunting's shade is deeper and more iridescent, whereas the eastern bluebird is more festive, with a ruddy breast and light underparts. Bluebirds suffer from competition for nest sites and in many parts of the country are quite rare, but there is now a pair in the meadow and a pair near the cabin, territory neatly divided by a band of woods.

I remember reading about hoary vervain in one of my mother's natural history books from the 1920s; now I find the tiny flowers blooming in my meadow and feel suddenly closer to her.

The stalk is tightly knotted with buds, like a stout green rope, but here and there the rope frays into tiny, orchidlike blossoms, lipped and centered with a dot of yellow. Denison's *Missouri Wildflowers* calls this color purple, but it looks like a clear lavender to me.

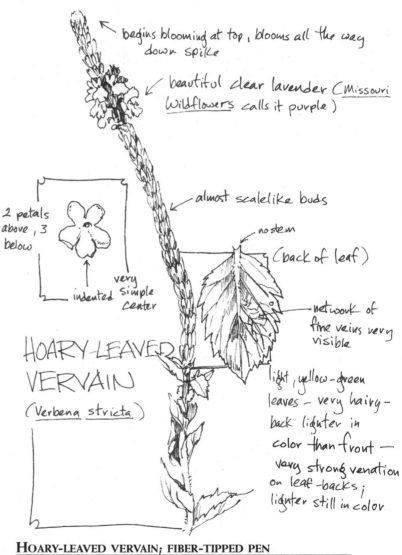

begins blooming at top, blooms all the way down spike

beautiful clear lavender (*Missouri Wildflowers* calls it purple)

almost scalelike buds

no stem

(back of leaf)

2 petals above, 3 below

very simple center

very indented

network of fine veins very visible

HOARY-LEAVED VERVAIN

(Verbena stricta)

light, yellow-green leaves — very hairy — back lighter in color than front — very strong venation on leaf-backs; lighter still in color

HOARY-LEAVED VERVAIN; FIBER-TIPPED PEN

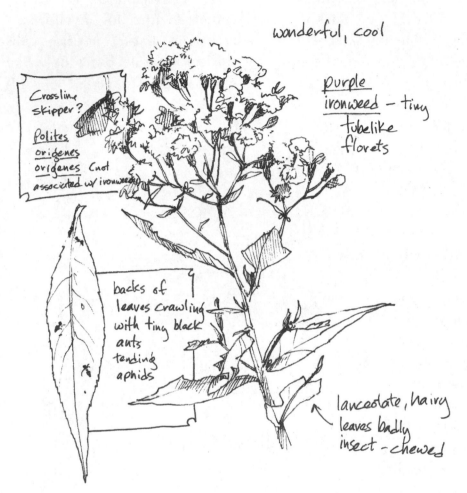

wonderful, cool

Crossline
skipper?

Polites
origenes
origenes (not
associated w/ ironweed)

purple
ironweed — tiny
tubelike
florets

backs of
leaves crawling
with tiny black
ants
tending
aphids

lanceolate, hairy
leaves badly
insect-chewed

Not sure which of the Vernonias this is — I didn't
pick a flower head, and the various species are
identified by the shape of the scales on their
bracts. Very esoteric. (Later investigation makes
it Vernonia missurica, with tight, pointed bracts, purple midribs.)

PURPLE IRONWEED; FIBER-TIPPED PEN

The rough, hairy leaves clasp the stalk; the leaves are lighter on the back, illuminating the shadows there.

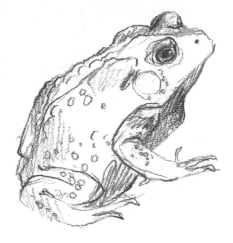

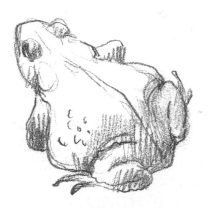

EASTERN AMERICAN TOAD; HB PENCIL

Nearby, ironweed shows what purple *really* is. These fringelike tassels of royal hue are taller than I am, waving at the tops of ragged umbels. These leaves, too, are rough and hairy, but some creature apparently finds them to its liking. They are nibbled and chewed, some almost stripped to the mid-rib.

On close inspection I find dozens of tiny brown ants, tending an aphid farm on this inhospitable-appearing plant. It may be a rough neighborhood, but it must provide a good living.

All is not loveliness, of course. But it's all interesting. This toad is stout and stolid, blinking first one large eye and then the other—until I try to pick it up. The muscular legs are as strong as they appear. The toad pushes against my palm, not frantically but determined, nonetheless, to be free of my grasp. It wriggles free and arcs away into the tall grass, bowlegging off into a dark, safe place; these toads prefer rocky wooded areas, and I note that this one is only a few yards from the forest edge. The kidney-shaped parotid glands behind the eyes are quite prominent, a wart gone mad.

The largest Missouri specimen was four and three-eighths inch; this toad is no record. Measured against my palm, it's closer to three inches long.

I do not fear the warts I'm supposed to get from touching toads;

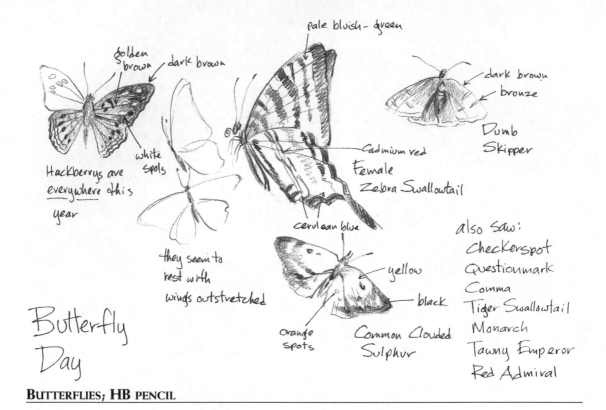

golden brown

dark brown

pale bluish-green

dark brown

bronze

Dumb Skipper

white spots

Cadmium red

Female Zebra Swallowtail

Hackberrys are everywhere this year

they seem to rest with wings outstretched

cerulean blue

yellow

black

also saw:
Checkerspot
Questionmark
Comma
Tiger Swallowtail
Monarch
Tawny Emperor
Red Admiral

orange spots

Common Clouded Sulphur

Butterfly Day

BUTTERFLIES; HB PENCIL

that much is indeed legend. But I take care not to touch hands to mouth until I've washed them. Some toads emit a bitter-tasting "predator repellent" which, in some cases, can cause death—or euphoria. I'm in the mood for neither.

A high-summer butterfly walk among the abundant flowers on the hill turns up movable "flowers" as well—butterflies are everywhere. It is as though the blossoms had become tired of the stationary life and decided to visit one another. Bright colors and movement; silken

wings; resting insects feeding deeply on nectar, proboscises unfurling like a flag—everywhere I look, there is motion and loveliness.

I hear a strange, sharp peeping noise and wonder what bird scolds so emphatically. Finally I isolate the sound that comes from halfway down the slope. It's no bird, but a cheeky ground squirrel, bantering loudly. It propels its forelegs and head upward with each sharp cheep, as though propelled into this rapid bounce by sound alone.

I seldom see these creatures unless

one darts pell-mell across the road as I drive to my square mile; now I look through my small binoculars to sketch the little rodent, which appears to be unaware of my presence. I can't see what it is he is scolding, but something certainly has aroused his ire—or his interest. Perhaps another ground squirrel threatens his territory, or a new female has wandered into view.

Large, creamy disklike umbels of Queen Anne's lace are as big as teacups. I brush against them as I walk, releasing an aroma of carrots—not surprising, since they are in fact ancestors of our domestic vegetable. The first-year taproot may be eaten, but don't expect it to be as sweet as the garden variety hybrid. The flavor is lusty and strong.

It's difficult to draw something so delicate, to capture that delicacy with the emphatic, unforgiving medium of pen and ink. Each floret is no more than a one-sixteenth-inch speck in the branching bouquet of the flower head. If I were to draw each individual floret, my lines would be so dense the flower would look black, not white. "Less is more" in this case; suggesting the open

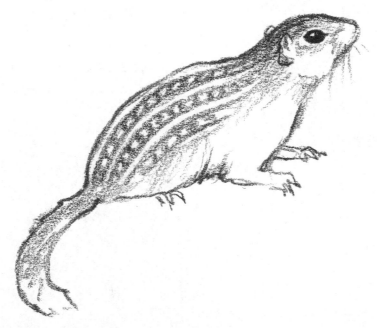

THIRTEEN-LINED GROUND SQUIRREL; COLORED PENCIL

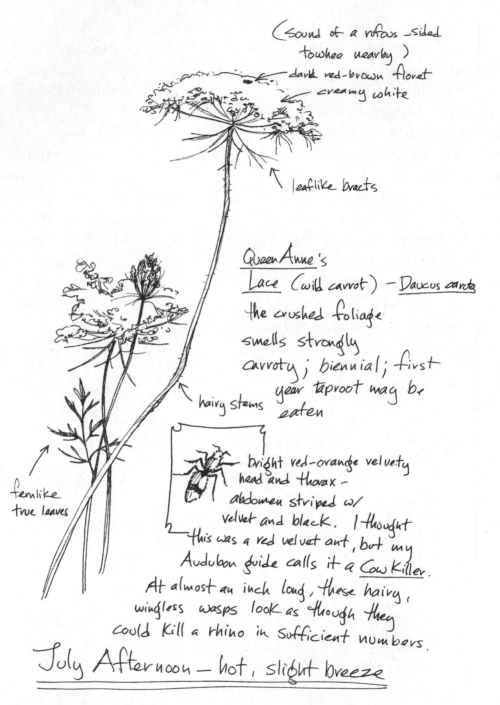

(sound of a rufous-sided
towhee nearby)

dark red-brown floret

creamy white

leaflike bracts

Queen Anne's
Lace (wild carrot) — Daucus carota
the crushed foliage
smells strongly
carroty ; biennial ; first
year taproot may be
eaten

hairy stems

bright red-orange velvety
head and thorax —
abdomen striped w/
velvet and black. I thought
this was a red velvet ant, but my
Audubon guide calls it a Cow Killer.
At almost an inch long, these hairy,
wingless wasps look as though they
could kill a rhino in sufficient numbers.

fernlike
true leaves

July Afternoon — hot, slight breeze

QUEEN ANNE'S LACE; FIBER-TIPPED PEN

laciness of the flower head is more true than a realistic rendering of each detail.

In this world of whiteness—Queen Anne's lace everywhere—the bright orange-red cow killer stops my eye like a traffic light. I thought these were red velvet ants, but my field guide says otherwise; they are hairier and much more orange than the velvet ants. The creature is amazingly fast. In order to sketch it I have to run after it, bent over and drawing frantically. These are the times I'm especially glad my part of this square mile is isolated by enough distance that I have the privacy to work without providing my neighbors too much entertainment.

Nearby, a fragment of velvety monarch wing shows that something perhaps overcame its disgust at this beautiful butterfly's reportedly bitter taste. The monarch larvae feed on the abundant milkweed plants, which impart a bitterness to match the plant's own. Most birds recognize the warning spelled out in the monarch's coloration and patterning and keep their distance.

In the autumn the meadow is painted with monarch orange and black as these lovely butterflies pass

FRAGMENT OF MONARCH WING; HB PENCIL

southward in review on their winter migration.

At this time of year the abundant goldenrod looks tired, tattered and gnawed by every chewing, sucking insect on the place. Galls form along the stem as insects lay their eggs within. I can't find a leaf along its four-foot length to sketch as a diagnostic—not one is whole, and

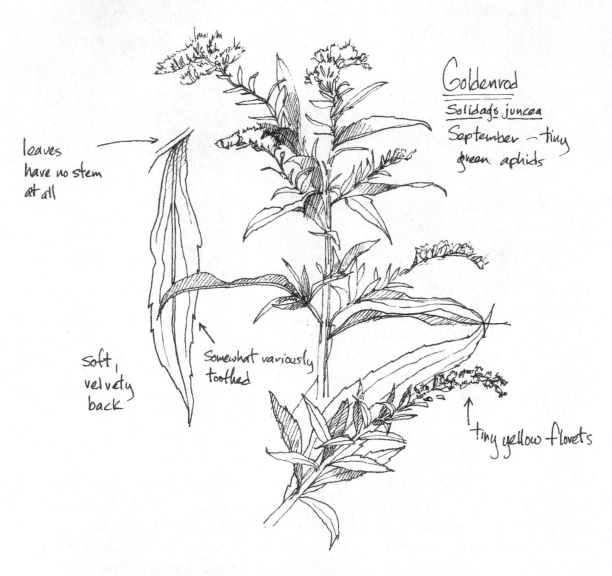

leaves
have no stem
at all

Goldenrod
Solidags juncea
September — tiny
green aphids

soft,
velvety
back

Somewhat variously
toothed

tiny yellow florets

GOLDENROD; FIBER-TIPPED PEN

most are chewed to the midrib. The one I choose, at last, grows along the raceme of fringelike yellow flowers.

Though this plant is called "early goldenrod," in fact it blooms late into October. When I was younger I blamed it for my hay-fever sneezes which seemed to go on forever, but its pollen is much too big to be airborne for any appreciable distance. The culprit instead is ragweed, with its barely discernible

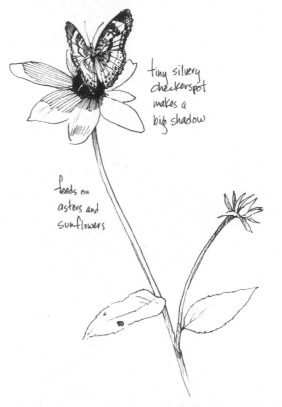

tiny silvery checkerspot makes a big shadow

feeds on asters and sunflowers

GOLDENROD WITH ASTER YELLOWS; HB PENCIL

CHECKERSPOT ON SUNFLOWER; FIBER-TIPPED PEN

flowers and even smaller grains of pollen.

This stunted goldenrod, foiled in its ancient plan to flower and seed, is the victim of an innocent-seeming insect. The Native Plant Society's Linda Ellis tells me that a tiny leafhopper has given it a disease called "aster yellows," which makes the head gnarled and strange. Now it does look more like an aster than a goldenrod, but the "petals" are

TRIPLE-DECKER GALL

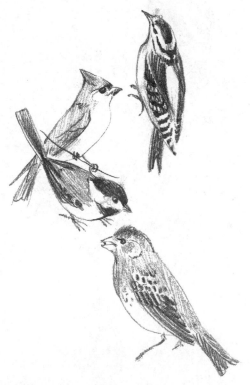

Chickadee, tufted titmouse, downy woodpecker, and purple finch; colored pencil

Goldenrod ball gall; fiber-tipped pen

deformed green leaves at the tip of the stem.

Nearby, another culprit rests on a sunflower; the larvae of this little butterfly can completely defoliate wingstem-family members. To give the drawing a sense of reality, I paid close attention to the shadow cast by the checkerspot, and to the angle of the wings themselves.

The small flocking birds find a hospitable welcome in the meadow; the tiny downy woodpecker is especially fond of the goldenrod ball galls and the insects that winter over in the rough stems of mullein and other large weeds. I hear an odd hollow banging and follow the sound to a downy beating a paradiddle on the square stem of cup plant.

I come upon a patch of goldenrod that's been co-opted by colonizing flies; each stem has swollen like a goiter, round as a marble. The dark brown weeds are bold lines and angles against the pale dry grass of winter, and easier to notice then than now.

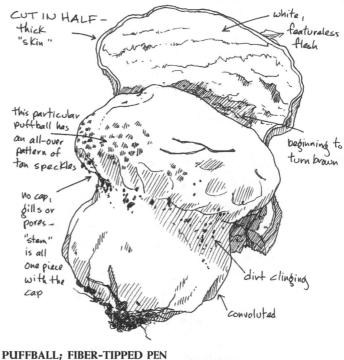

CUT IN HALF — thick "skin"

white, featureless flesh

this particular puffball has an all-over pattern of tan speckles

beginning to turn brown

no cap, gills or pores — "stem" is all one piece with the cap

dirt clinging

convoluted

PUFFBALL; FIBER-TIPPED PEN

It is a tiny fly, *Eurosta solidaginis*, that makes a home here for its larvae; when the eggs hatch, they are provided with home and sustenance, all at once. Unless, of course, a marauding bird, a gnawing mammal, or a hungry beetle finds the helpless larvae and makes a meal of *them*.

September puffball from Wendy's yard down the creek; the thing looks as big as a softball. At a distance she thought it was someone's trash blown onto her grass, but when she realized

what it was she called me. She knows I love these big mushrooms almost as much as morels.

It's too far gone to eat, although it emerged only yesterday. But it isn't too late to draw it. This particular fungus has an indented neck and a thick skin mottled with tan like a miniature giraffe's coat.

Inside, a puffball is as featureless as white bread—or it should be if you plan to eat it. When I slice this one lengthwise, I discover that it has begun to turn brown, the stain spreading upward from the base toward the crown. It is that brown stain that eventually releases a cloud of spores, giving this mushroom its common name and perpetuating the species. And now that I've seen one again this year, I begin to scan the meadow for signs of the delicacies on my own land.

The mockingbirds seem to be enjoying the last of the fall fruits before migration. I'll miss their melodious and raucous medley of greatest hits cadged from the other birds. The piercing stare of this bird pins me to the spot, and I enjoy the final concert of the season while I draw.

It's easy to go wrong with a fine but telling detail. My pencil—or my hand—seems to have a mind of its own, independent of what I see before me. I had the bill

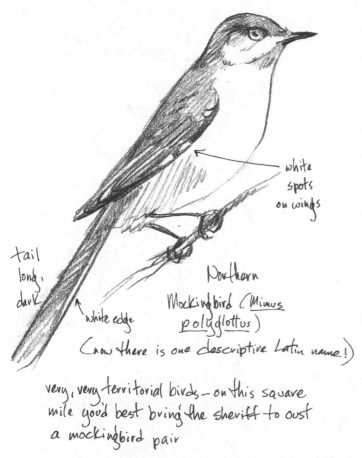

white
spots
on wings

tail
long,
dark

white edge

Northern
Mockingbird (*Mimus polyglottus*)
(now there is one descriptive Latin name!)

very, very territorial birds — on this square. mile you'd best bring the sheriff to oust a mockingbird pair

MOCKINGBIRD; #2 PENCIL

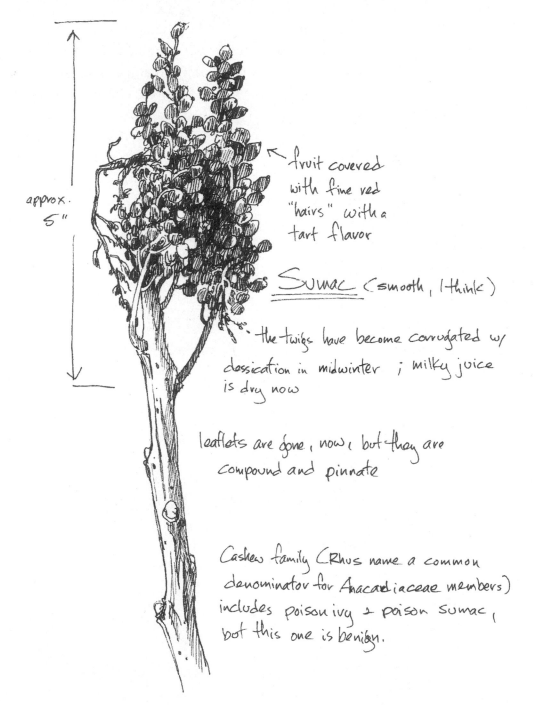

approx. 5"

fruit covered with fine red "hairs" with a tart flavor

<u>Sumac</u> (smooth, I think)

the twigs have become corrugated w/ dessication in midwinter; milky juice is dry now

leaflets are gone, now, but they are compound and pinnate

Cashew family (Rhus name a common denominator for Anacardiaceae members) includes poison ivy ± poison sumac, but this one is benign.

Sumac; fiber-tipped pen

just a hair's breadth too heavy for the mockingbird, and since I knew this was being drawn for reproduction, I used a spot of retouch white, available at the art supply store, to remedy my error.

At the meadow's edge, the thick stand of sumac proves popular with the birds—and with me. The hairy red berries have a tart flavor that makes a wonderful drink, hot or cold, when agitated in water to cover. It's only necessary to strain out the remaining hairs and add a bit of sweetener—and to be certain it is not the white-berried poison sumac you've picked.

The large, heavy heads of this brushy plant tint the meadow's edge a rich maroon, and I enjoy the view as I sit in a sunny, sheltered place to draw.

I hear coyotes more often than see them; song dogs sing arias in the night, a wild sound that plays up and down my spine as though it were a musical instrument. This coyote is thinner than most, young and quick and bony, which makes its ears look bigger than ever; it is the color of ripe wheat, and I wish I could touch the thick fur.

Here the old farmers still talk of going wolf hunting, but there are no

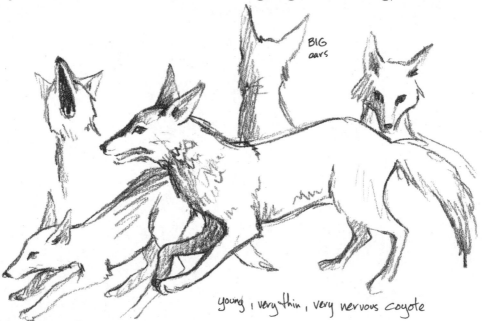

BIG
ears

young, very thin, very nervous coyote

COYOTE; COLORED PENCIL

wolves left in Missouri. They were extirpated years ago, red wolves with wild eyes, furtively living out their lives. Coyotes are more ubiquitous, and in fact are interbreeding with dogs until a pure bloodline is smudged and DNA is as tangled as a skein of yarn discovered by a pup.

Coy dogs are common as dandelions and may be dangerous in some cases. Coyotes themselves are seldom a danger to humans; they fear us, and quite rightly. We are implacable enemies; prejudice toward these wild dogs makes us irrational, cruel. I remember coming up over a hill road near my square mile to find that someone had shot a coyote and hung the carcass on the barbed-wire fence beside the road as a "warning" to other predators. It was a grisly sight. If it acted as a deterrent, it was only to me; I chose another route to town.

I am no sparrow expert; they seem to fall among that amateur ornithologist's bane, Little Brown

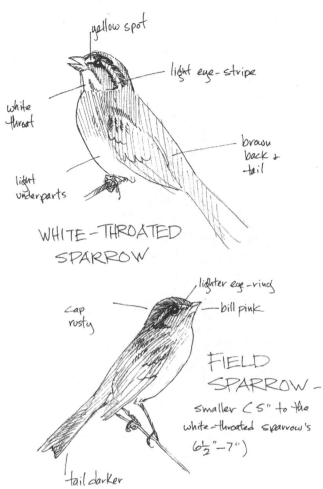

yellow spot
light eye-stripe
white throat
brown back & tail
light underparts

WHITE-THROATED SPARROW

lighter eye-ring
bill pink
cap rusty

FIELD SPARROW –
smaller (5" to the white-throated sparrow's 6½"–7")

tail darker

Sparrows; fiber-tipped pen

Birds. But these two frequent the meadow often enough that I begin to know them. In spring, the lovely song of the white-throated sparrow threw me back in memory to a salt marsh in Maine; I'd never noticed them here before, but now the sound seems everywhere.

Ladies' tresses orchid; HB pencil

Two bits of white against the ochre grasses stop me cold; I've never seen these flowers before, but I know instantly what they are: ladies' tresses orchids. They are more rare here north of the river, growing in limestone glades or upland prairie, late summer to November.

I've looked for them all my life, and now I can't seem to get my fill of their graceful loveliness, like a flight of snow geese furled against the sky. I lie on my stomach beside them and shoot my photos; sketch carefully, trying to get just that perfect spiraling of tiny flowers on the tall stem.

"Sketch" is perhaps an incorrect word for this; it is really much more of a formal drawing, with attention paid to shading and negative shapes, and more background information than I usually include.

There is an almost Oriental simplicity, an angular grace to the wild grasses and sedges. A winter's walk through the meadow to collect specimens is almost too successful— my hands are full, and there is no room on the page for all of them. I find the beautiful and tawny broomsedge, *Andropogon virginicus*, growing in a patch of hillside. The basal leaves are springy as a mattress, and I am tempted to lie there staring at the sky until I make sense of the universe; I stay ten minutes, instead, admiring the delicate tufts of seeds along the jointed stems, a pale

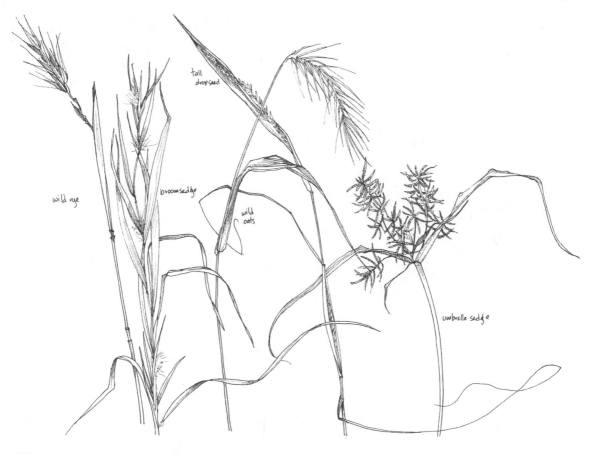

Labels within illustration: tall dropseed, wild rye, broomsedge, wild oats, umbrella sedge

MEADOW GRASSES; PEN AND INK

orange blanket that catches the sunset light and tosses it back in reflected color. There's no mistaking that hue.

Protective shafts of tall dropseed clasp their seeds tightly to the stem; I had passed them a hundred times without noticing their miserly construction. Dropseed appears on overgrazed prairies; it isn't as palatable as some grasses, and after the others are all eaten, it takes over. As my friend with the Missouri Native Plant Society says, it's a prairie grass but a junky one.

Wild rye and umbrella sedge grow at the edge of the meadow closest to the pond.

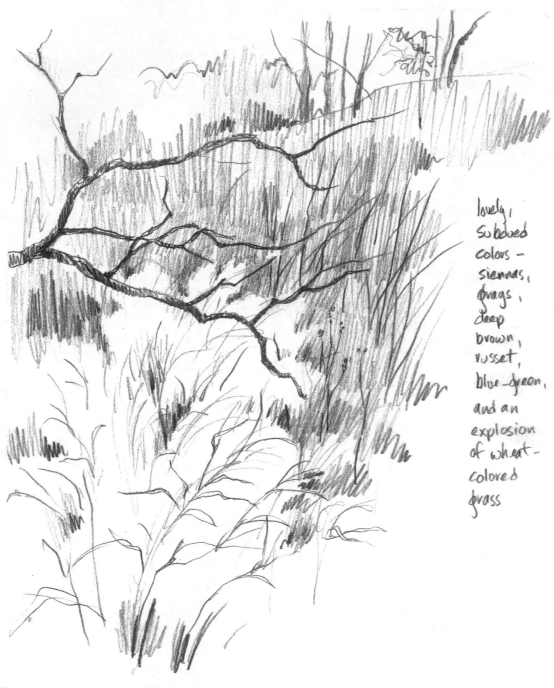

lovely,
subdued
colours –
siennas,
grays,
deep
brown,
russet,
blue-green,
and an
explosion
of wheat-
colored
grass

GRASS AND DARK LIMB; HB PENCIL

Colors are wonderful on a cloudy winter's day; they seem intensified, distilled. Today, the woods are a tapestry of grays and maroons and siennas, painted with blue shadows. The hillside is tawny with fallen leaves and the rich, pale palomino of broomsedge. But close by, my eye falls on the explosion of pale wheat at my feet—an antic patch of grass whose inflorescences and narrow, strappy leaves seem to go in every direction at once.

There's no way to draw what I see. If I were to sketch in these arcing shapes in all their complexity, my drawing would be covered with dark lines and the overall sense of light-against-dark would be lost. I console myself with a light patch with almost no detail, as I did with the young plum tree and the Queen Anne's lace earlier, then add the suggestion of a few plants within the whole. The dark tree limb that reaches from the edge of the woods into the meadow accentuates the lighter tone and suggests depth and perspective.

Down among the thicket of leaves and stems in the winter meadow is a patch of soldier lichen, further softening the fractured plates of

SOLDIER LICHEN; #2 PENCIL

ochre-colored Winterset limestone. Eventually, with the determined roots of broomsedge, the lichen will break down the rock into a fine, calcareous soil. But for now, green the color of the pale inner leaves of cabbage encrusts the rocks; ruffled and modest in its tiny scale and low estate, the lichen begs exploration with a hand lens. Stalks rise from the ruffles, each bearing a velvety brown head—the little "soldiers" that give this lichen its name. These must be Missouri Valley irregulars; lichen with red heads instead of brown is called British soldier lichen.

Deer are infrequent visitors to the pond meadow, but I see them in Rachel's Meadow with some regularity; it is private, inaccessible. They feed on the brushy browse that threatens to reclaim this unmowed

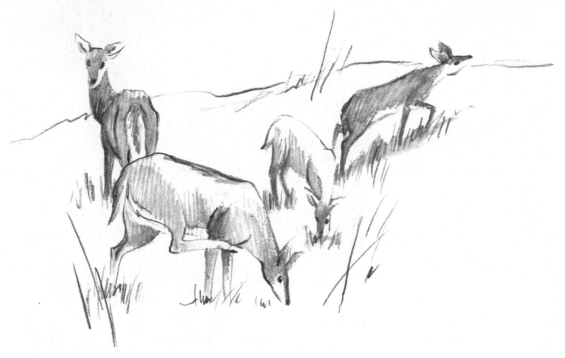

DEER; WATER-SOLUBLE PENCIL

field, and I am delighted to provide for them with my negligence.

I am not particularly happy with the water-soluble pencils; they seem too hard and weak to make a good, dark wash, though this is the softest lead made.

The rock-cobbled path—naturally cobbled by the flat, eroding stones of this narrow-bedded Winterset limestone—leads through the meadow to the woods. Winter and summer, it is used by other feet than my own; I find the prints of deer and coyote, raccoon and dog here.

To catch the sense of the path leading off into the distance, I pay careful attention to the shapes of things that are *not* path. I find the

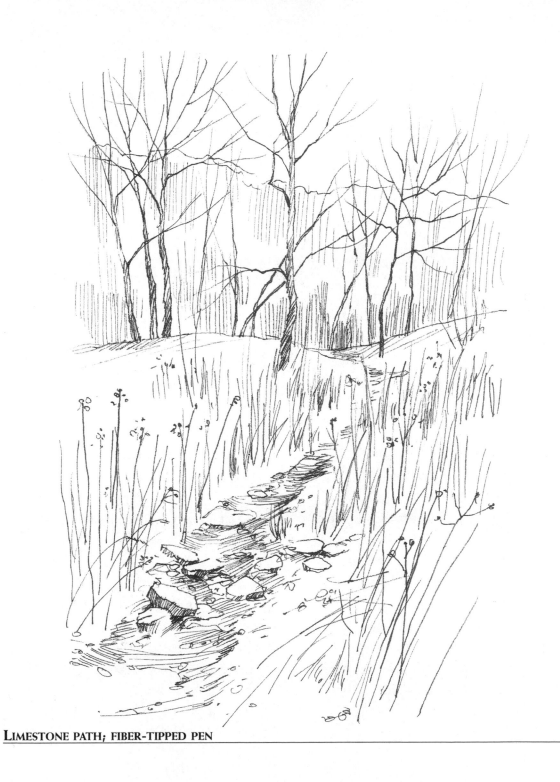

LIMESTONE PATH; FIBER-TIPPED PEN

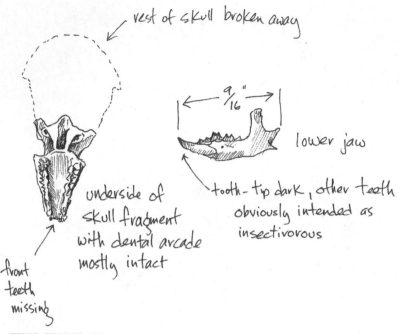

PROBABLY A SHORT-TAILED SHREW

rest of skull broken away

9/16"

lower jaw

underside of skull fragment with dental arcade mostly intact

tooth-tip dark, other teeth obviously intended as insectivorous

front teeth missing

SHREW SKULL; FIBER-TIPPED PEN

negative shapes that surround the path and draw them; the path appears.

A barred-owl pellet reveals a bit more about the meadow's sometime inhabitants. The indigestible parts—tiny bones and hair—of the small prey animal are distinctive in the pellet. The delicate brainpan may have been crushed in the owl's digestive tract, but the dental arcade tells the tale, easily differentiating this small insectivorous mammal from the mouse whose skull and

jawbones I compare it with. Rows of sharp little teeth make it obvious that this is no mouse. My treasured copy of *Wild Mammals of Missouri* helps me to identify it as a short-tailed shrew (most likely), though the palate seems a bit wide.

Even in winter, there is plenty of food—unless it is locked away in ice. The birds have made inroads on the grasses and seed-bearing wildflowers of late December, finding the tiny seeds of grease grass and the hairy, carrot-flavored fruits of the Queen

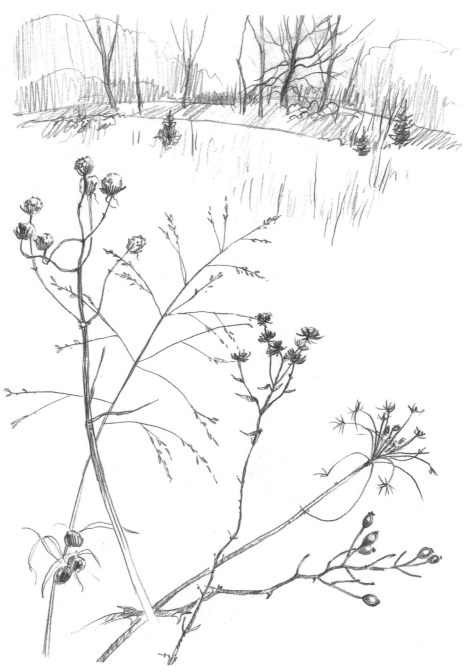

SEED HEADS; HB MECHANICAL PENCIL

Anne's lace a fine supplement for a winter diet. The bright red beads of wild rose hips are popular, too, and not only with birds. Mice and voles and even the larger browsers like deer make use of this vitamin-rich foodstuff.

Nearby, a rabbit's droppings provide circumstantial evidence that the Eastern cottontail finds the meadow hospitable as well. I imagine them everywhere but am still startled when one bolts practically at my feet, leading my eye with amazing bounds of that spot of bright white. How does anything *ever* catch a cottontail? But the circling hawks overhead know the answer; to them, it is not a rhetorical but a tactical question.

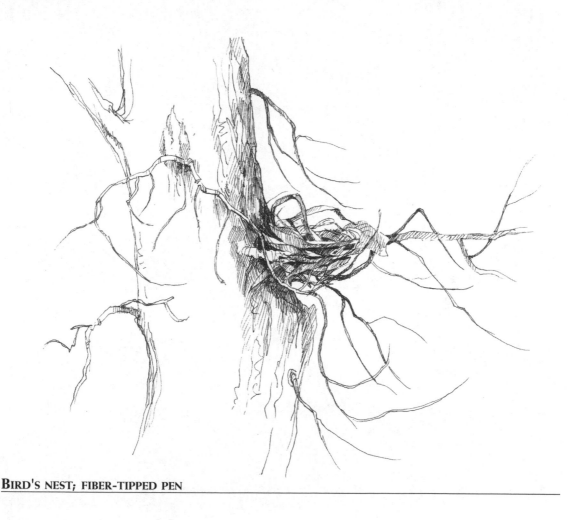

BIRD'S NEST; FIBER-TIPPED PEN

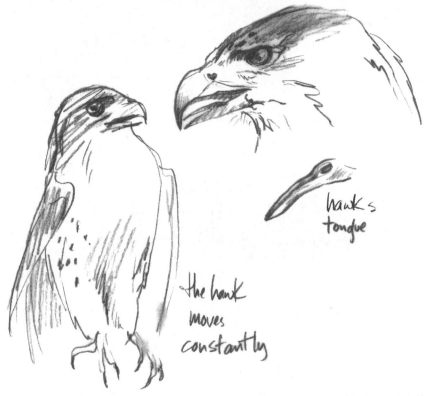

hawks tongue

the hawk moves constantly

RED-TAILED HAWK; COLORED PENCIL

The meadow's avian inhabitants are quite capable of finding their own shelter or building it. This tree, bristling with twigs and small branches, provides the perfect place for a protected nest. Opportunistic birds have used strips of grapevine and soft dry grasses for their safehouse.

The red-tails stay year-round, unlike some of the other hawks I see reeling themselves southward on an invisible helix-shaped trajectory. Once rare in Missouri, the red tails have made a remarkable recovery; now I can mark territory with a surveyor's accuracy from the distance between hunting hawks. It is not far.

Other hawks that make occasional forays into this territory include red-shouldered, Cooper's, broad-wings, kestrels, Northern harriers, and a falcon-winged visitor too high above me to identify.

From the Starfield meadow, I can see deep into four counties. In the distance, Nebo Hill, an important archaeological site, shows on a 1932

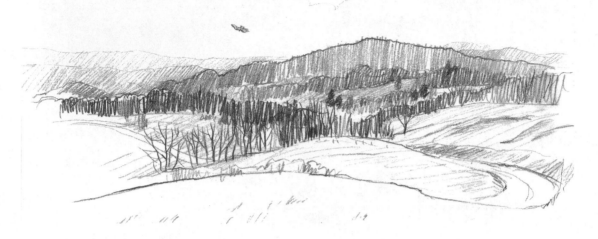

map as the highest point between St. Louis and Kansas City. From here, it looks tiny.

On this winter day, the wind is mild but brisk. A hawk plies the air currents, effortlessly kiting on powerful wings. The hills are done in diminishing shades of blue; the sky is dotted with white clouds, and I am at peace in this world of open space and blowing grass.

Part III

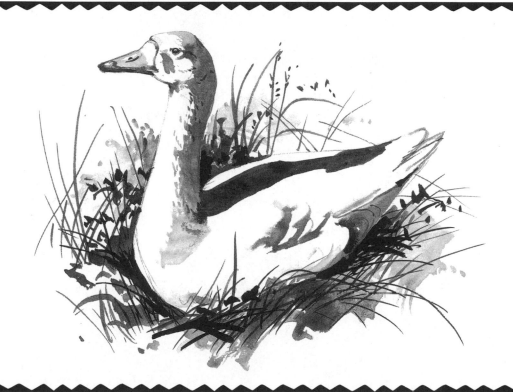

The Pond

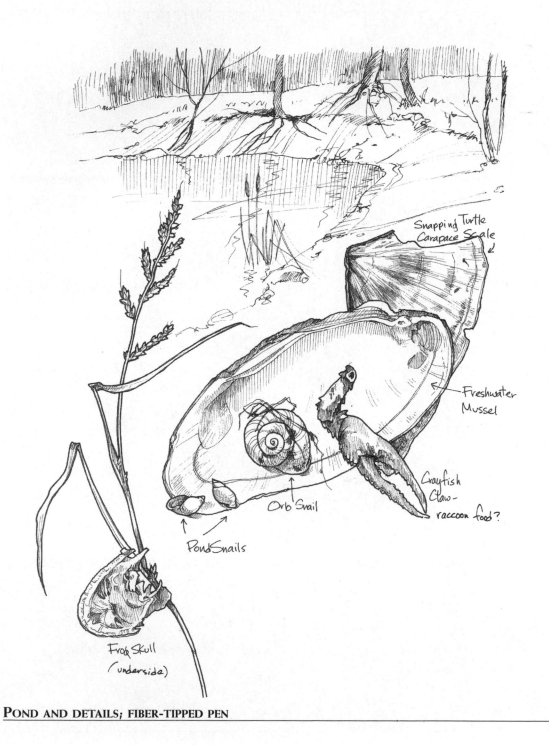

Snapping Turtle
Carapace Scale

Freshwater
Mussel

Crayfish
Claw —
raccoon food?

Orb Snail

Pond Snails

Frog Skull
(underside)

POND AND DETAILS; FIBER-TIPPED PEN

The signs of life are unmistakable. Turtles bob lazily like miniature rafts, then pull in their necks and disappear with decidedly unturtlelike speed. Unseen fish arrow through the water, marking their passage with rippled Vs. At the pond's surface, a water snake spells out sensuous grace with fine Spencerian curves. And the tangled ribbons of tracks that pock the deep black mud are the shore's journal of use and visitation.

One year an algal bloom threatened to overtake the water's surface, and pea green hairlike fronds nearly met midpond. Then it died off, turned a sickening avocado, and sank to the bottom. I feared that the pond's aquatic life would die off, too, starved of oxygen, but it thrived instead. Mosquitoes, water striders, whirligig beetles, dragonflies, damselflies—all made fine fodder for the underwater denizens, the carp, bass, bluegills, crappie, and the bottom-feeding catfish. Frogs and turtles are as numerous as ever, and the signs of life make clear signposts at the pond.

Even in drought there is action here. In fact, of course, it is stepped up as all manner of creatures visit the only remaining source of water on my bit of the square mile. The big lakes over by the road are as busy.

When it rains plentifully, the lakes and ponds fill, and their spillways sing like waterfalls. I can hear the sound of water in the woods from a hundred yards away, and discover that part of the pond's life, at least, has made its getaway. The new stream of the spillway flashes with minnows and young sunfish, and the raccoons feast on easy pickings.

Even in late winter the pond shows signs of life. Recently thawed, the crystalline water is limned by a fish-drawn arrow: action, even now. The fish seem hungry after their ice-down; at evening the water's surface is dimpled with their concentric feeding rings.

Dry grasses and sedges rim the water like a ratty fur ruff. A bullfrog skull, with dried skin still clinging to it, tells the tale of a raccoon's meal not too long past; low water reveals a black mussel, also a casualty of the

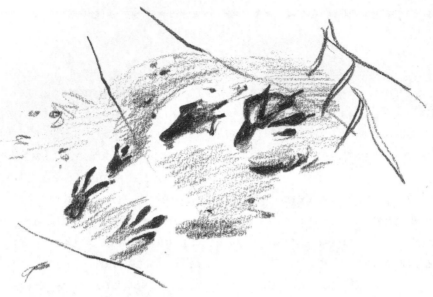

RACCOON TRACKS; COLORED PENCIL

raccoon's endless quest for food.

I try to find this specimen in *Missouri Naiades; A Guide to the Mussels of Missouri* by Ronald D. Oesch, but am frustrated by the variety and arcane details that go to make up identification. Just as I think I've found my mussel, I discover it occurs only in the southeastern part of the state. Still, I am lost in the fascinating details of this book; maps for each species are marked with those specimens found since 1965; before 1920; and in archaeological digs, telling me which species were abundant enough—and succulent enough—to have provided food for the earliest inhabitants of my state.

Crayfish, orb snails, and little pond snails comprise the rest of the menu at today's raccoon restaurant. I'd never have known what was here were it not for the hungry mammal's predation—and the low water of a long drought.

A piece of scale from a snapping turtle's carapace is like a flake of amber on the ground. I wash it tenderly in the chill water as though it were a piece of fine crystal, and it becomes translucent, rich brown and gold. Someone killed a snapping turtle here this summer, a mindless act that made no sense to me; this scale is all that's left, except a fragment of skull.

Proof of what has been hunting here is impressed in the soft mud at pond's edge—raccoon tracks.

The water is low; varicolored bands of vegetative zones tell a graphic tale of months without measurable precipitation; the autumn rains did little to replenish the ponds and lakes on this square mile. A ring of watergrass along the shore is several degrees lighter in tint than the grass above the dam, even in winter; the color difference is an obvious demonstration of this plant's ability to fill in new areas despite the ravages of drought. The pond should be four feet deeper at least. Marsh-loving cattails and arrowhead plants that normally stand knee-deep in water look as pale and dry as bleached whale bones, abandoned by the receding pond.

When I first saw this odd-looking mass of roots, I thought something had been dumped in the pond and had washed ashore to tangle around

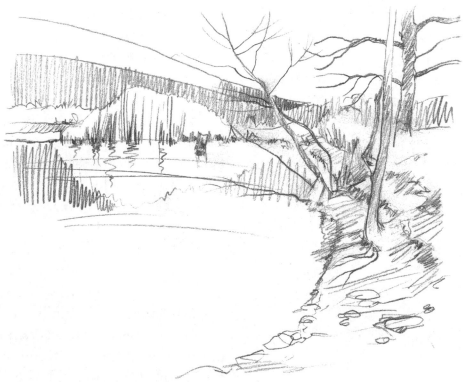

LOW WATER BY THE DAM; HB MECHANICAL PENCIL

WILLOW AT WATER'S EDGE; FIBER-TIPPED PEN

the willow's trunk. But it is the exposed, thready roots that grow like stairsteps a foot and a half above the present water line.

The pond is too small to tempt wild geese very often, though I've scared up a Canada or two over the years as I come up over the dam. But this domestic goose shared our lives for three months the first year we owned the place, and his presence was a magnet. I had to feed him every day, and in so doing, became attached to my new place and its changes. He disappeared on New Year's Day, and I looked for days for signs of violence. I never found so much as a pile of down.

Early in the year, we put up a nest box to ensure the continuing flash of blue of Eastern bluebird wing. We chose the location carefully: at the edge of the meadow for its rich mine of insects, near the pond, and five feet up off the ground. The bluebirds noticed immediately and accepted

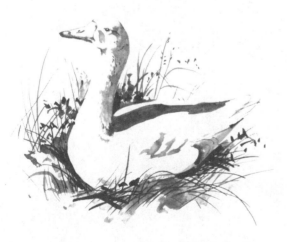

GOOSE; WATERCOLOR (LAMP BLACK)

our offering. Today, when the birds are gone for the winter, I can inspect the nest they built and smile.

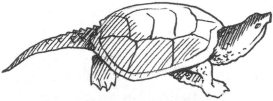

SNAPPING TURTLE; .08 INK PEN

The common snapping turtle (*Chelydra serpentina serpentina*) is formidable; its looks seem designed to warn us off, and woe be to any turtle-loving kid who picks up one of these—they bite, and bite hard. The old story is that they won't let go till it thunders, and perhaps it's true, though I usually find they simply don't care to be crossed.

When we were building the cabin, we were stopped on our way down the hill by a monster snapper midtrack in our narrow drive. With trees as close as the sides of a tunnel, there was nothing to do but get out of the truck and try to convince the nesting turtle to move. She was not amenable. She hissed and snapped, turning whenever we did, amazingly agile for something so prehistoric;

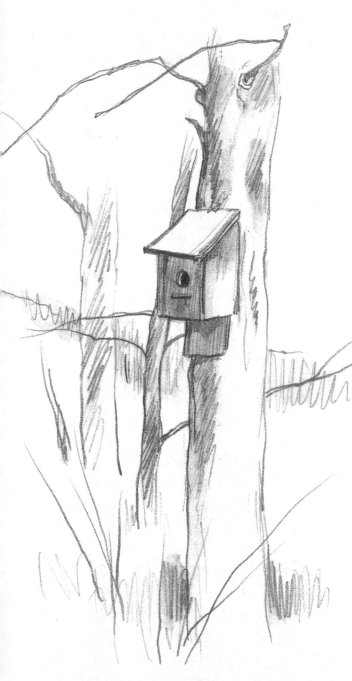

BLUEBIRD HOUSE; WATER-SOLUBLE PENCIL

fossilized turtle shells 200 million years old, from the Triassic Period, have been found.

This was a common snapping turtle, with an algae-slimed shell about a foot long; the even more forbidding alligator snappers live along the Mississippi and in Missouri's southern fringe of counties. At about thirty pounds, this one was a dainty thing compared with the alligator, which weighs between thirty-five and 150 pounds, but she looked as big as a Jeep parked in the drive. Finally we lured her off the track by giving her

something to attack, one of us offering the stick and the other gingerly nudging from behind. Sketching never entered my mind, at the time.

I had better luck this summer when Wendy called to ask if I wanted a dead snapping turtle she had seen at Lawson Lake. My answer was immediate and affirmative; it's wonderful when your friends know you well enough to know what pleases!

We carried it back to my place through the deepening dusk, held in a feed sack out the car window; it had become aromatic in a decidedly musky way. I put it in a safe place to weather—Pete's flight cage was still at the edge of the woods, and the raccoons couldn't make off with the turtle if it was in jail.

Now in the winter I can sketch these reminders without holding my nose. The beautiful, rugged bones amaze me. The skull is rough and ridged as though to hold the skin in place from the under-side; the bony carapace is knitted together only loosely now, and I carry the thing as

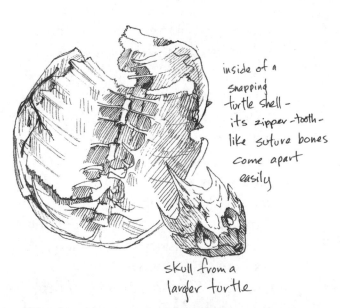

inside of a snapping turtle shell - its zipper-tooth-like suture bones come apart easily

skull from a larger turtle

SNAPPING TURTLE SKULL AND SHELL; .01 INK PEN

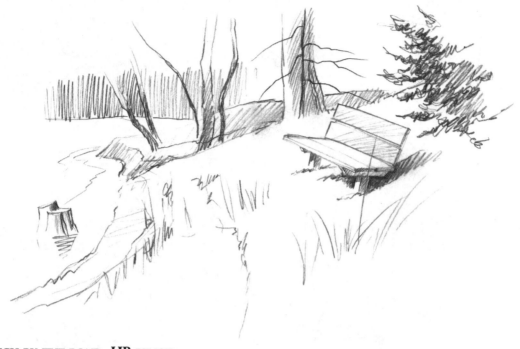

BENCH BY THE POND; HB PENCIL

carefully as a Waterford crystal bowl.

I can see where the turtle's backbone was fused to the shell. Contrary to childhood's imaginings, the turtle's snug carapace and plastron aren't his home in the same sense as a hermit crab's assumed shell; they're part of his body. They grow with him, and I can see the rings in the flaking scales, resembling the growth rings in a downed tree.

Our simple bench is a great observation spot; its wide seat and slanted back provide comfort, and the huge Eastern red cedar that grows by the

pond offers a natural privacy screen. Passersby on the road can't see me here, even in winter. The birds and mammals seem to forget I am here if I maintain a respectful distance and just draw, though I am still in plain

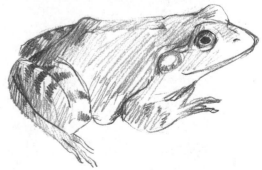

BULLFROG; B PENCIL

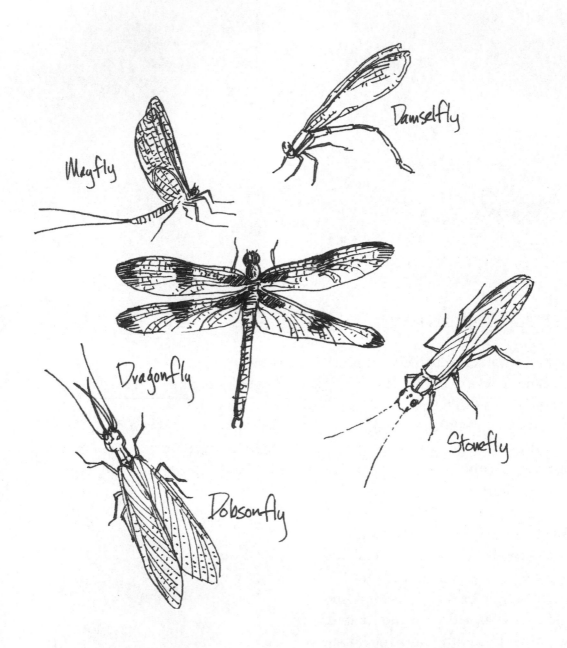

Mayfly

Damselfly

Dragonfly

Stonefly

Dobsonfly

FLYING INSECTS; FIBER-TIPPED PEN

sight. It is as though I am just another part of the scenery.

The bullfrogs claim territory with their voices, much as birds do—or so it would seem. I can map out the boundaries of each of the four big frogs in our pond by the distance between their deep "jug-o'-rums."

This one sat by the dam for twenty minutes or more, unaware of my presence or uninterested in it. It moved slightly from time to time, but not so rapidly that it was difficult to draw.

The day is punctuated with the glistening, leaded-glass wings of insects. These delicate-appearing flight members must have been the inspiration for the cut-glass windows that bracket the doors of elegant homes; they glitter like crystal in the sun. I couldn't begin to capture the intricacy of their designs, but only hint at them with short, interrupted strokes.

Dragonflies and damselflies, golden mayflies, stoneflies, and

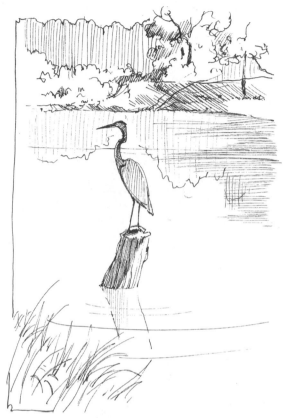

GREAT BLUE HERON AT THE POND; FIBER-TIPPED PEN

dobsonflies in fifty different guises— how could I have imagined the pond to be deserted simply because of the absence of birds this day?

I am sitting quietly on the bench, drawing. It is too hot to do anything else. Thick, wet air funnels up from the gulf, rendering the atmosphere almost liquid, and my energy is

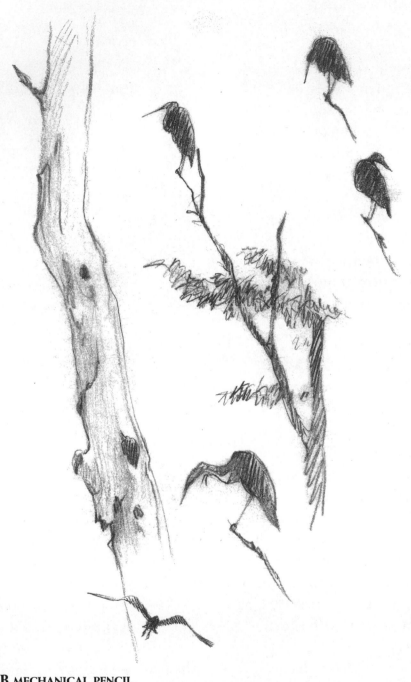

HERON; **HB** MECHANICAL PENCIL

sapped just walking up the hill.

My reward, my restorative, is a great blue heron—seldom seen on the small pond. It circles in from the west in a wide, slow, silent arc and lands, light as thistledown, on the stump. I am startled, delighted at my good fortune to be here at just this moment. The big bird flexes its serpentine neck and surveys my pond as though assessing its possibilities. These are many, I know. I have been watching turtles and fish and bullfrogs for thirty minutes.

I flip the page of my sketchbook to a fresh sheet to capture my visitor, and that quick movement is enough to spook the heron. The sleek, hunched bird hesitates only a moment—long enough for me to sketch the beginnings of the heavy beak and that S-curved neck before it spreads wings with a reach as wide as sailplane wings and takes off. Again the heron is silent, circling once more and taking its leave the way it came, leaving me to finish my drawing from memory.

It isn't hard. That image is impressed on my gray cells as though imprinted on the back side of my eyes. Practice in memory drawing pays off with dividends like this.

Another day, just at sunset, I am

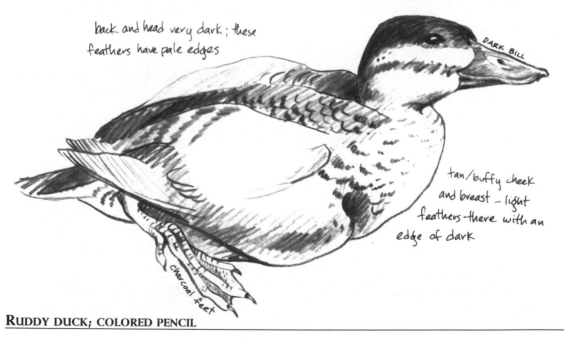

back and head very dark; these feathers have pale edges

DARK BILL

tan/buffy cheek and breast – light feathers there with an edge of dark

charcoal feet

RUDDY DUCK; COLORED PENCIL

more fortunate—or more ready. The heron appears not to notice me as I stalk it through the tall grasses, pad open and pencil in hand. Each time it looks toward me, I freeze, and finally find a place to sketch behind the impromptu blind of an old tree. I manage four quick sketches before the heron tires of being observed and flies off.

Waterfowl find even these small ponds for stopovers—or for private strongholds away from the competition at the lakes west and south of here. These lakes are large enough to encourage nesting by a number of species, but shy wood ducks visit the cattails at the edge of my pond and may nest; mallards and pintails make a pit stop here.

Today I have the chance to draw a ruddy duck, a small, compact creature that resembles a female mallard or black duck but without the bright teal blue on the wing. Someone has brought her in to my vet; she was discovered under one of the city trucks suffering from a broken wing. I am amazed at the size of her feet, but when I think how fast those webbed propellers can move her through the water, I know it's good planning. Even without taking flight, she could escape many predators.

The wax-based black colored pencil works well for sketching. It's quick; it has a lot of range; and it doesn't smear, as a lead pencil might.

I've walked up to the pond to sit in the shade of the oak trees, trying to cool off. There is the usual array of litter, and I muse on my ineffectual "fishing by permission only" sign. It might as well say "fish, here, please—and while you're at it, trash the place. I insist."

I've discovered limbs hacked from the oaks on the dam for no better reason than to allow someone a better cast, without thought of ownership, or the tree's health or beauty—cut and tossed in a tangled pile behind the dam. I've found beer and pop cans thrown into the brambles, and yards and yards of transparent fishing leader discarded where the birds can become tangled in it. There have been cigarette butts in the tinder-dry grass; dead fish discarded on the shore; turtles killed for no reason other than having something to kill.

I find a plastic fishing worm beside my favorite perch, one of many; someone has tossed aside a

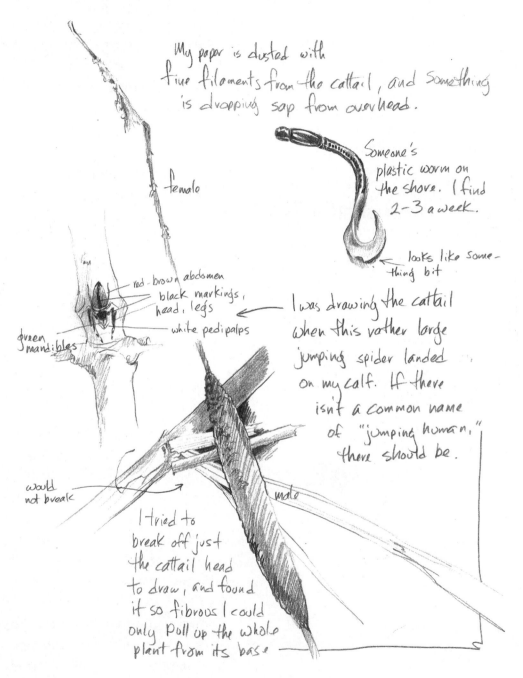

My paper is dusted with
fine filaments from the cattail, and something
is dropping sap from overhead.

Someone's
plastic worm on
the shore. I find
2-3 a week.

looks like some-
thing bit

female

red-brown abdomen
black markings,
head, legs

white pedipalps

green
mandibles

I was drawing the cattail
when this rather large
jumping spider landed
on my calf. If there
isn't a common name
of "jumping human,"
there should be.

would
not break

male

I tried to
break off just
the cattail head
to draw, and found
it so fibrous I could
only pull up the whole
plant from its base

JULY 15; HB PENCIL

container of bait. But soon I slip into thought, ignoring the evidence of other humans, and enjoy the day, the cool, calligraphic reflections, the conversation of frogs. The silvery shading of an HB pencil is wonderful for sketching the cattail reeds that are so strong and fibrous I could not even break one off to draw.

A spider leaps to my leg; it is bright orange and black and hairy— too large and neon to ignore. I brush it off, then find a stick for it to sit on so I can draw without quite so much intimacy. The spider waves pale pedipalps at me, perhaps trying to smell me or deduce what my intentions are. Jade green mandibles, smaller than the pedipalps, wave less energetically behind the mittenlike extensions. Each time I look away to my paper, the spider retreats to the underside of the stick. Each time I turn it up again so I can continue my drawing. I forget my anger at the litterers. Drawing can do that; it allows me to get outside my own concerns, to center on my subject, to lose myself in what I see.

From a distance, the pond looks serene and deserted, as though there were no life here at all. When I sit quietly by the water's edge, I begin to notice there is an astounding amount of activity. In the water itself, giant waterboatmen oar themselves about looking for dinner; whirligig beetles seem intent only on spinning and spinning endlessly on the surface film in an uninterrupted tarantella—when do they eat or mate? Water striders, on the other hand, are constantly on

WATER INSECTS; EBONY PENCIL

the hunt. They scull from here to there on their long legs, feet dimpling the surface film, and pounce on anything that looks edible—or irritating. They grapple with one another at the least provocation, tangling like rival gang members intent on maintaining their "turf."

There is a mat of sound woven thick and warm as a braided rug—insects, birdsong, a syncopated, extended splash as a pile of startled turtles notice me and slip off the basking stump. I am aware of many ways to experience the life of this place beyond the visual, but those ways cannot be captured on paper.

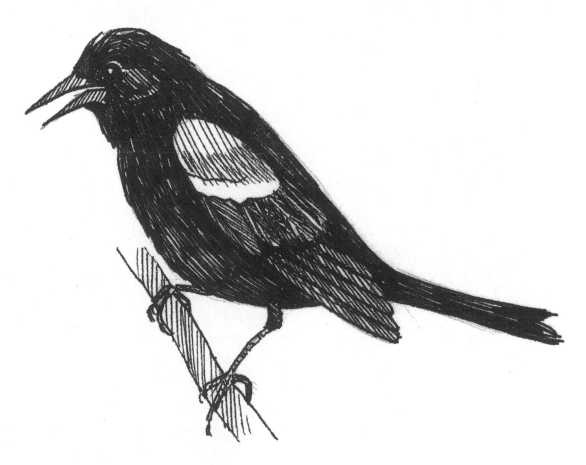

RED-WINGED BLACKBIRD; PEN AND INK

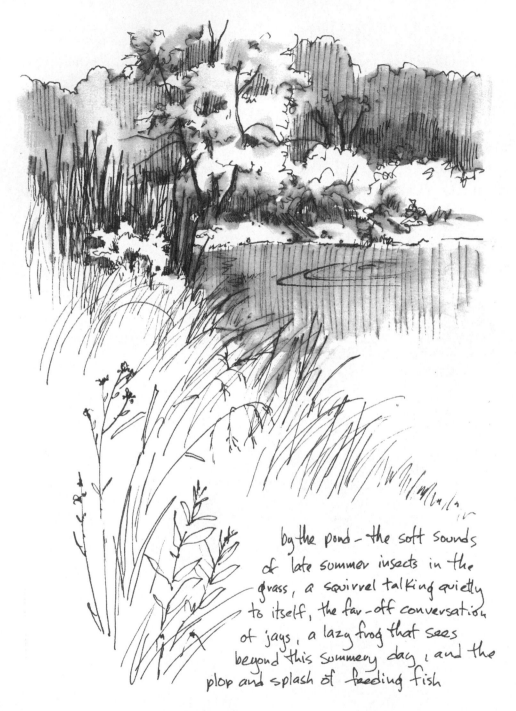

by the pond – the soft sounds
of late summer insects in the
grass, a squirrel talking quietly
to itself, the far-off conversation
of jays, a lazy frog that sees
beyond this summery day, and the
plop and splash of feeding fish

POND SOUNDS; FIBER-TIPPED PEN AND WASH

There is no way to sketch sound, or the feel of a gentle, questing wind against my face. I can't draw contentment.

I want a different effect for this drawing and experiment with wash on the water-soluble ink, applied only here and there with an old brush. The far trees seem to recede into the background when they are so treated, and the water is suddenly limpid.

It looks peaceful, a strain of music by Vivaldi, but suddenly it is not. The resident red-wings notice me and object strenuously. These birds are extremely territorial (though often colonial) and guard their nests with their lives in breeding season.

Their voices, male and female, are harsh expletives—this is not the melodious "o-ka-lee" of the courting male. The protective father shows me his epaulets as though to intimidate me with his superior authority. It works. I retreat and allow the little family to reclaim its calm; I discover that it must be a total rout. I have to back off half a block or more before the birds shut up.

On a larger body of water, there could be entire colonies of these birds, sharing a single larger territory; here, only one family stakes claim, homesteading my small pond.

The green heron that fishes here is a miniature relative of the great

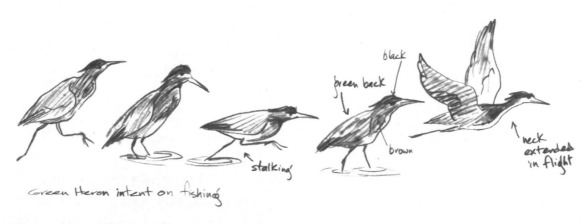

Green Heron intent on fishing

stalking

green back

black

brown

neck extended in flight

GREEN HERON; HB MECHANICAL PENCIL

blue, only fourteen inches in length compared to the larger bird's thirty-eight inches. But this richly colored Ardeidae stalks with an unmistakable heron gait; the legs, at least, bear the family resemblance. Her neck is much shorter than the blue heron's, even taking relative proportions into account.

I watch as a gangly chick harasses the mother bird for food, following her, beak open and begging. The scenario is impossible to misread, most often seen in the candy aisle at the local supermarket. The female apparently concurs; she brings her prize to the youngster, and he

ARROWHEAD; **HB** MECHANICAL PENCIL

swallows it all in one gulp. And immediately begs for more.

The leaves of this aquatic plant, the Arrowhead, are distinctive and eye-catching. But not all members of the family have arrow-shaped leaves; some have oval leaves, others, lanceolate. The flowers are waxy, white, and three-petaled, pretty things that remind me of the faces of children.

The underwater tubers of the plant are edible; hence its sometime name, "duck potatoes."

There are twenty-two species of turtles in my home state of Missouri, though not all are found on this square mile. From the irascible snapping turtles to the map turtles and cooters and sliders and mud turtles and soft-shells, these ancient reptiles occupy a wide variety of habitats: marshes, creeks, and sloughs; open woods and glades; pastures, prairies—and the pond that caught my eye during the long drought.

My sketch is simple, only the barest suggestion of sunning turtle on the old stump. The willow limbs give it a feeling of depth, and to suggest a simple background I simply smeared the soft lead with my finger. I picked out the turtle's light-struck

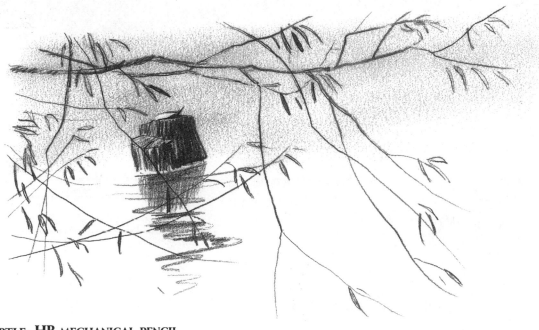

TURTLE; HB MECHANICAL PENCIL

shell with a bit of kneaded eraser
twisted to a point.

This red slider shell is a marvel of
engineering and design. It is strong
as armor, beautiful as inlaid ivory.
The patterns are distinctive, a turtle's
equivalent of a fingerprint, and they
allow biologists to identify
individuals. (They put the turtle on a
copy machine, plastron, or under-
side, down, and photocopy the
reptile as a mug shot.)

The turtles here want no part of
my curiosity; perhaps they fear being

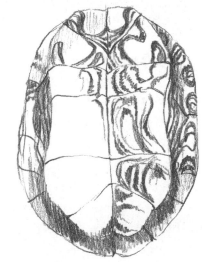

TURTLE SHELL; HB MECHANICAL PENCIL

*back in the cove, the shadows are deep
and the water still*

COVE; COLORED PENCIL

booked and printed. They certainly don't care to be my entertainment. They slip beneath the water at the first sign of my presence. Perhaps they remember their forebear, the tiny red slider that met his demise in my childhood fishbowl, and avoid me like a half-remembered ancestral curse.

It is so dark back in the cove in contrast to the bright sun that strikes my face here on the dam that I can scarcely see into the depths. It looks cool as a cave, and inviting—cool colors: green and blues, and every shade in between in the serene, still water. I've come here to escape the late-summer heat, and it was a good

WATER SNAKE; COLORED PENCIL

scene. Black and white seemed inadequate to suggest the transparent shadows, the range of blues and greens that reflected the light like an underwater scene from Jacques Cousteau. But when I looked at it later, it seemed to capture something of the inviting nature of what I saw.

In this sector of Missouri the water snakes are harmless; in southern Missouri, the water moccasin is anything but.

The presence of year-round water seems to encourage life. Wildflowers flourish, terrestrial as well as aquatic; perhaps the birds that frequent the pond like a giant birdbath leave seeds in their droppings. In summer, the banks are a riot of black- and brown-eyed Susans, Queen Anne's lace, bergamot, and clover. In the spring, a thick stand of wild garlic scents the air with surprising sweetness; the flowers, at least, are fragrant in a more expected sense. The scent of the garlic bulbs and bulblets is richer and more robust; thoughts of hearty platters of Italian pasta come unbidden to my mind.

choice. Even the frogs seem cooler here. Silver rings painted on the featureless surface of the water tell of fish in those depths, feeding unconcerned by the oppressive heat.

I was unhappy with my drawing, at first. It didn't begin to express the

WILDFLOWERS BY THE POND; FIBER-TIPPED PEN

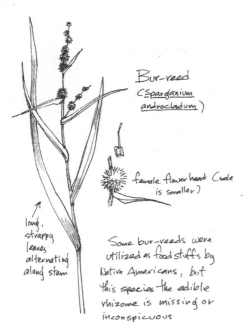

Bur-reed (*Sparganium androcladum*)

female flower head (male is smaller)

long, strappy leaves alternating along stem

Some bur-reeds were utilized as food stuffs by Native Americans, but this species the edible rhizome is missing or inconspicuous

BUR-REED; PEN AND INK

Another common water-loving plant is the bur-reed. This is one of several species in Missouri.

Also nearby is the tall, daisylike goat's beard, *Tragopon dubius*. A bit later in the season this light yellow blossom will become a huge, silky balloon that looks like a dandelion's seed head, but much larger. Imagine the difference between a ping-pong ball and a softball, and you have the picture.

I used a pair of ovals to help contain and shape the flower head and the disk of the center. It is tempting to put the center of the

GOAT'S BEARD; HB MECHANICAL PENCIL

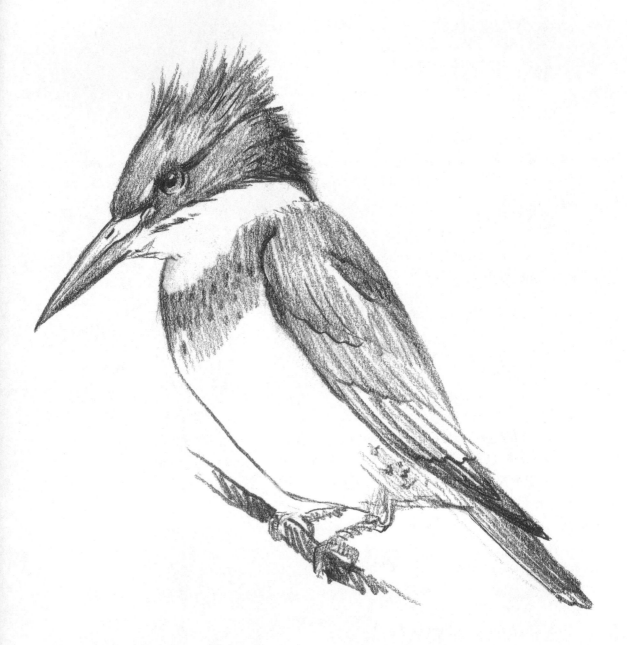

KINGFISHER; HB MECHANICAL PENCIL

flower in the middle of a circle, as a child would—and so it would be if I were looking down on it from an aerial perspective. But here, a different perspective makes it necessary to foreshorten the petals that come toward me, and to suggest the cuplike shape of the flower head.

I love to watch the belted kingfishers at work. Efficient little hunting machines, they are far more successful at catching anything than the humans who work the place with their rods and reels.

CRAPPIE; INK AND PENCIL

I don't fish much anymore; lack of time and lack of stomach for it, I suppose. But beneath the water's

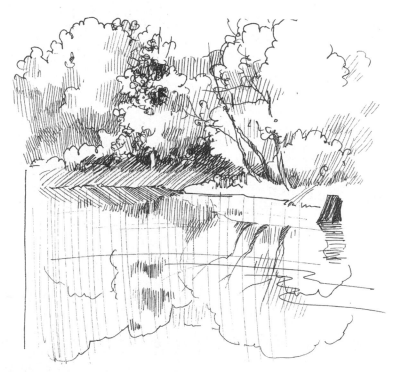

POND; FIBER-TIPPED PEN

leaves turn a lovely
purple in fall

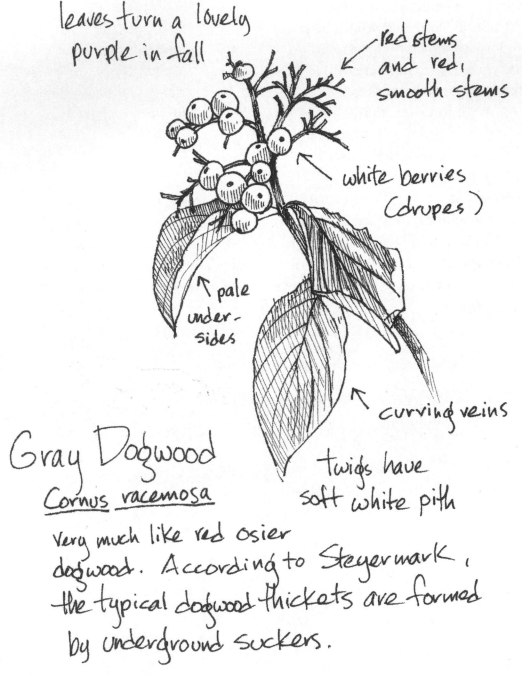

red stems
and red,
smooth stems

white berries
(drupes)

pale
under-
sides

curving veins

Gray Dogwood
Cornus racemosa

twigs have
soft white pith

Very much like red osier
dogwood. According to Steyermark,
the typical dogwood thickets are formed
by underground suckers.

GRAY DOGWOOD; PEN AND INK

surface are crappie, bluegills, bass, catfish, and carp—not to mention the tiny minnows and shiners that school and flash near the shore.

There are so many details in nature that to capture them all is impossible. Even here at the pond where the water, at least, is relatively simple, there are still a million different leaf shapes on the trees, a million configurations of branch and limb and twig. If I were one of the

HERON; B PENCIL

early artist-naturalists who explored this land, perhaps I'd have the time and patience to sketch them. Instead, I make do with quick squiggles and repeated lines to stand in for reality.

So similar to red osier dogwood that most people call it that, this gray dogwood grows in nearly impenetrable thickets near the dam.

Here's the Heron again. These big birds fascinate me; their patience is astounding. They can stand motionless for what seems like hours, waiting for the mud to settle around their feet, waiting for the ripples to dissipate, waiting for the small fish and frogs that are their prey to forget what made the disturbance in the first place and return to their normal activities in the heron's general direction. This one stands motionless for so long I could swear the big bird waited for algae to form on the scaly feet for the little fish to feed from—bait.

At the other end of the size scale is a bright scarlet freshwater mite. (See next page.) If it were bigger, the effect would be startling. As it is, you'd hardly notice the tiny spiderlike creature. I look through a hand microscope to draw it.

Red Freshwater Mite

SCARLET MITE; PEN AND INK

The Native Plant Society's Linda Ellis was so impressed by the size of this tree that she got me to wondering if it could be a Grand Champion. It is not, but it *is* big. The limbs reach out like an oak's, which indeed I thought it was when I saw it in winter. The leaves are so far above the canopy of understory that I couldn't see them until I climbed the tree this fall.

The original of this drawing is in my journal, which I couldn't tear out without interrupting the flow; I used a translucent sheet of Denril™ to trace over the original. My fiber-tipped pens seemed too pale on the thin plastic sheet, and the water-

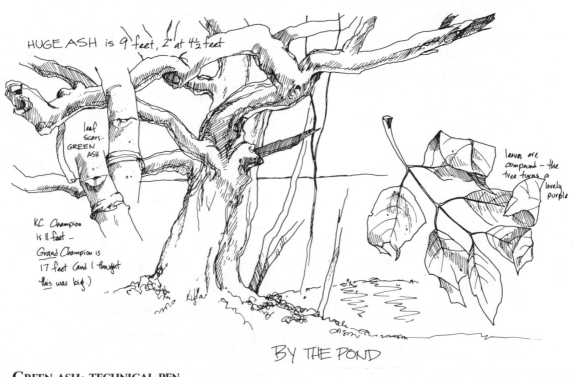

HUGE ASH is 9 feet, 2' at 4½ feet

leaf scars-GREEN ASH

KC Champion is 11 feet –
Grand Champion is 17 feet (and I thought this was big.)

leaves are compound – the tree turns a lovely purple

BY THE POND

GREEN ASH; TECHNICAL PEN

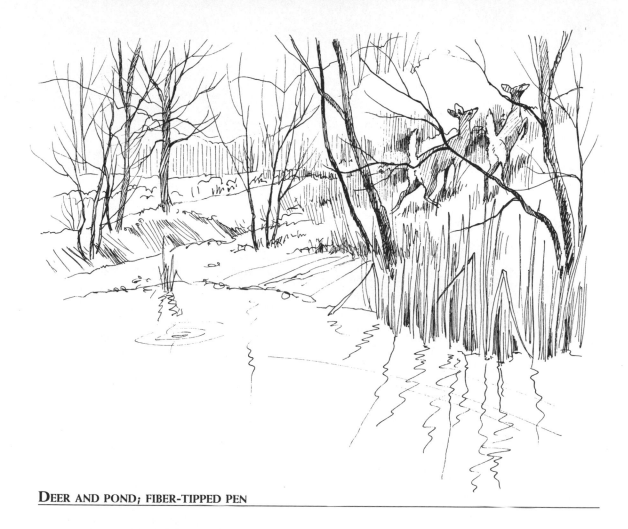

DEER AND POND; FIBER-TIPPED PEN

soluble ones smeared easily, so I switched to a technical pen—frustrating but precise.

Harris and I leave the cabin early in the day and broach the dam as we walk to the car; it's too muddy to drive in, and I like the necessity of walking. I see more.

This morning the payoff is big. Two deer sprint away from the water's edge, disappearing into the frosty morning. If it weren't for their white flags, I would never have noticed them. Theory has it that the flags are an alarm signal to other deer, and perhaps a moving target for a predator—he aims for the wrong end of his quarry, and the prey escapes.

The deer are difficult to see; their coloring is cryptic. I try to capture that sense of now-you-see-them,

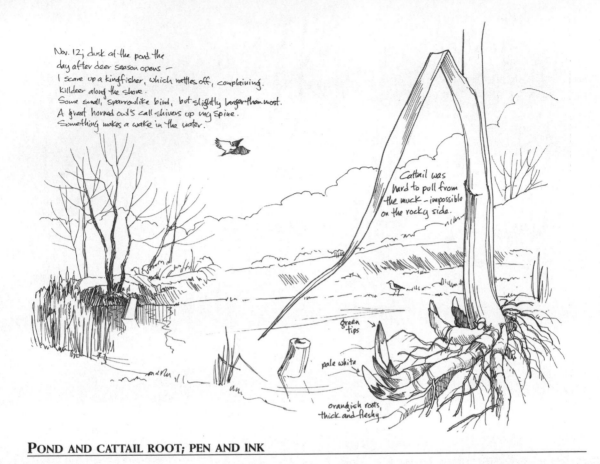

Nov. 12; dusk at the pond the
day after deer season opens —
I scare up a kingfisher, which rattles off, complaining.
Killdeer along the shore.
Some small, sparrowlike bird, but slightly larger than most.
A great horned owl's call shivers up my spine.
Something makes a wake in the water.

Cattail was
hard to pull from
the muck — impossible
on the rocky side.

green
tips

pale white

orangish roots,
thick and fleshy

POND AND CATTAIL ROOT; PEN AND INK

now-you-don't in my sketch by not making them stand out too boldly.

The less familiar part of the cattail is underwater—unfamiliar unless you're a devotee of wild foods. There are those who call this common plant a wild supermarket, there are so many edible parts. Young, tender shoots are good in spring; green cattail heads can be steamed and eaten like corn on the cob; pollen can substitute for all or part of the flour in a recipe, giving your baked goods a saffron glow. Even in early winter after the pond has skimmed over with ice, the cattail offers edibles—they're just a bit more difficult to get. I couldn't pull loose a plant on the rock side of the pond; its roots had a death grip on the stone and weren't about to give it up. On the side where the soil is deep and black and loamy, a good yank brought up thick, orange roots and crisp white shoots, ready to be washed and lightly steamed.

The stumps have held or gathered just enough warmth to melt perfectly round holes around themselves by 11:30am

MELTING ICE; FIBER-TIPPED PEN AND COLORED PENCIL

Birds are active at dusk; a kingfisher and killdeer are out for their dinner, and I'd bet it isn't cattail roots.

I'm careful to let the shapes of reflections mirror those of their objects. Repeated lines and simple squiggles suggest the still, tranquil quality of the water. What's tough to capture are the jackstraw lines of the aging and weathered cattail marsh; after a few light snows many of the slender leaves are bent over, and the little marsh looks like a hay-stack, pale as wheat straw under a summer sun.

The thicket of cattail is snug as a hunting lodge for the birds that overwinter here. As I approach, a seemingly endless stream of dark-winged creatures flows from beneath the stalks with a great rush and clatter that seems never to end; they were completely invisible in the cattail leaves.

The pond changes as quickly as the calendar; each day brings something new. Today, each protruding stump has a donut of open water around it; the shore is lined with sharp black and white images of winter's reflective

landscape, while only a foot or two away, the remaining ice is opaque and nearly featureless. Invisible microclimes are made visible in these graphic illustrations, telling of the difference of temperature of only a few degrees and the effects writ large enough to see on the face of the pond.

My friend "Poppy the Clown" gave me a pair of fingerless gloves for winter sketching — one blue, one hot pink

FINGERLESS GLOVES; FIBER-TIPPED PEN

It is cold sketching by the icy water, but my wish has come true. I have fingerless gloves to buffer the stiffening, chilling effects; my fingers remain movable much longer before

I have to stuff them in my pockets to warm them.

You can buy these gloves in specialty stores, for outdoor people or hunters; you can order them from a catalog. Or you can do what a friend did: go to your local discount store, buy an inexpensive pair of knit gloves, and cut off the fingers. Works wonderfully, and if my color scheme matches Poppy the Clown's, it seems fitting.

I notice a flash of pearl-white on the frozen shore and go to investigate. It is a seven-inch sunfish, dead and slowly freezing on the beach. I can't tell what happened; there are no marks or dangling hooks. Did it become disoriented and beach itself like a whale?

I am tempted to eat the fish. It smells fresh and inviting. But there are too many unanswered questions, and my neighbor's garage and septic

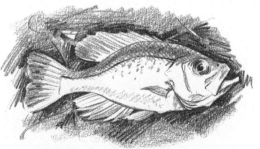

STRANDED FISH; COLORED PENCIL

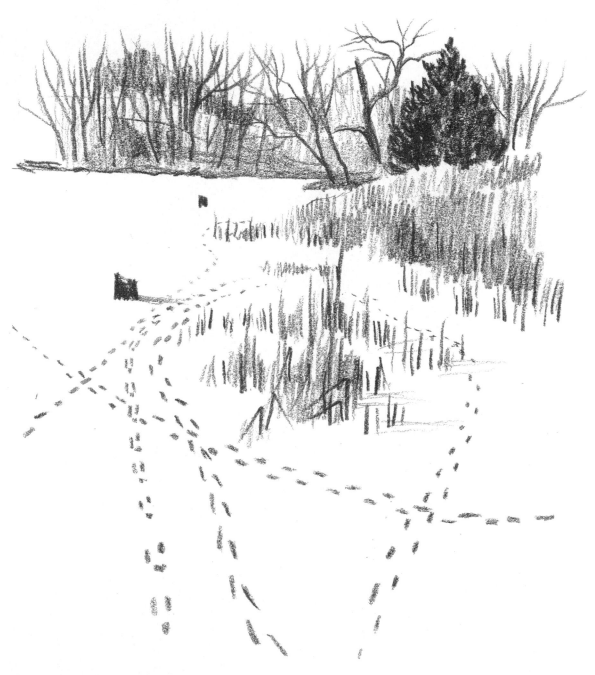

SNOW ON POND; COLORED PENCIL

tanks are too near. What may he have discarded? What might have washed into the pond? Though fried fish sounds wonderful this cold winter day, I will wait to see if tomorrow brings more dead fish washed up on the pebbled shore.

A dusting of snow turns the pond's surface into a pristine sheet of paper just waiting to be written on. Last night's snowfall is already scrolled with the prints of rabbits, squirrels, dogs, and cats, all purposefully heading from here to there, driven by instinct or need—or curiosity.

Part IV

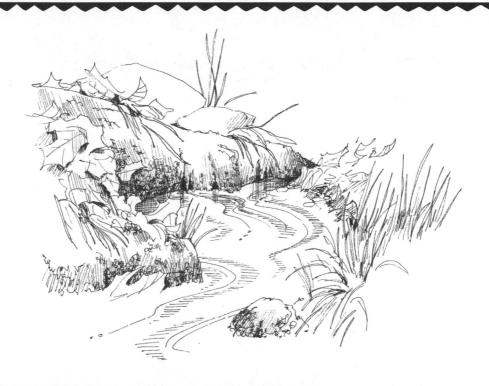

The Creek

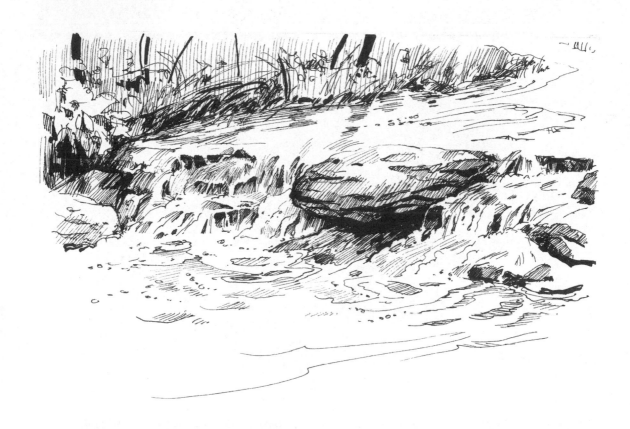

LITTLE WATERFALL; FIBER-TIPPED PEN AND BRUSH PEN

The creek is a moving, kinetic environment, year-round. It is active even in drought, when a river of life uses this open channel through the trees as a thoroughfare, paved with a jumble of rocks and pebbles that requires a special surefootedness.

Birds use this open highway—robins, grackles, red-wing blackbirds—providing them an easy shot between the trees. The fact that spiders know the creek, too, and weave their webs like fishing weirs, is no accident. It is good hunting ground, a rich mine of insects, a butterfly magnet.

When there is water in the seasonal creek, there are frogs and tadpoles, minnows, crayfish, and water insects. Birds hunt here—flycatchers, kingfishers, green herons. Miniature summer fish like cloisonné lapel pins lie as still as photographic images or cut the water as they hunt. Golden-eyed green frogs, one of Missouri's larger amphibians, find ample food here, too.

Limestone fossils 300 million years old are scattered in the creek bed like lost treasure—seashells and sharks' teeth. Chert weathers from the limestone matrix. Glacial erratics wash into the stream and shine like the anomalies they are among the gray of native stone. Arrowheads and tools find their way here after a hard rain frees them from the nearby soil.

All is not idyllic. Litter washes up here, too, tossed from cars on the nearby road or dumped into the ditch. Downstream, where houses top the ridge, the creek has been confused with a landfill. All-terrain vehicles damage the delicate ecosystem. I pick up the trash and curse the heedless damage, and time and silence heal even my anger.

The sound of falling water is soothing and atavistic. It is rare enough at this little seasonal creek; dry weather three years of the last four keeps the water's voice sporadic at best. Often the creek is dry, a rocky marker to show the water where to go when it rains. *If* it rains. Today, the tiny waterfall gurgles and rushes, a sound to soothe my dreams.

Drawing such a confusion of motion is not easy; all I can do is to

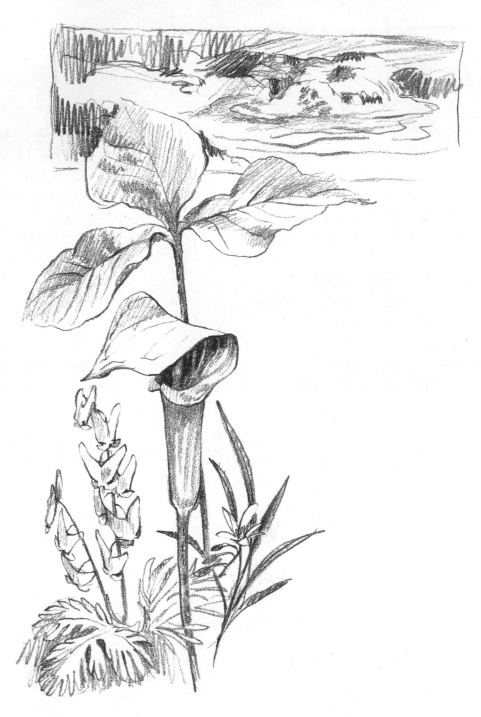

SPRING FLOWERS; #2 PENCIL

try to see repeated chaos and what causes it. The underlying bones of the rock ledge inform the moving shapes, and I try to remember the shape of the rocks in the dry seasons.

The only way to keep the sense of this oxygen-filled water is to leave the paper white and to pay attention to the negative shapes where the flow is broken by protruding rocks along the ledge.

The limestone glade near the creek proves the perfect habitat for early spring flowers. I find these just downstream from the waterfall, in a rocky glade by a limestone bluff. Jack-in-the-pulpit, Dutchmen's breeches, and spring beauty grow near tiny yellow corydalis and a bed of false rue anemone.

I like the delicacy and value range of pencil for these flowers, and use it to suggest the deep shadows beneath the jack's folded hood. Light pressure on my point lets me suggest the pale stripes on the jack's pulpit and the shape of the leaves.

After a heavy rain, I find stone tools washed free of the soil that has hoarded its secrets for two hundred years—for two thousand. There is amazing delicacy and control evident in these relics. Modern-day flint knappers have mastered the techniques, patiently chipping away at chert edges with a bit of deer's antler; their works are beautiful. But

ARROWHEADS AND KNIFE; #2 PENCIL

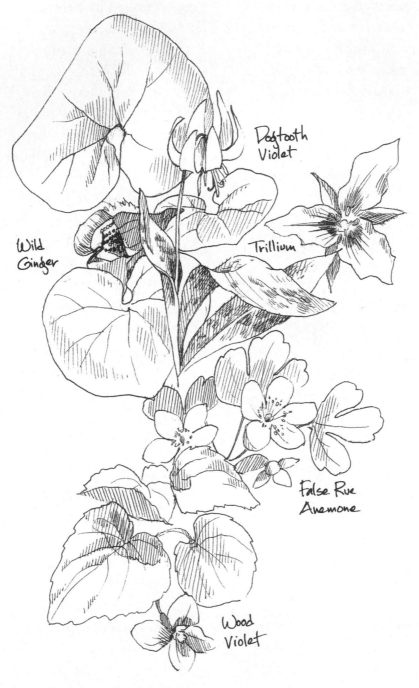

Dogtooth
Violet

Wild
Ginger

Trillium

False Rue
Anemone

Wood
Violet

SPRING FLOWERS; FIBER-TIPPED PENCIL

there is something about these ancient artifacts that is different. I can tell at a glance which is artifact, which is artifice; what I can't tell you is how or why. The past is an intangible constant in these stone tools; my quick sketches don't begin to do them justice.

There are times when I want a crisper effect with my drawings. These spring flowers are rendered in pen; subtlety of line is lost, but fine details may be easier to capture. Here, the false rue anemone is outsized, and trillium should be larger. Still the variety of forms found on this square mile is nothing short of amazing; this drawing and the previous one only scratch the surface of the more common early flowers that grow where the soil is richest.

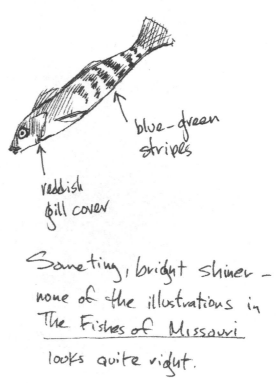

blue-green stripes

reddish gill cover

Someting, bright shiner — none of the illustrations in The Fishes of Missouri looks quite right.

SHINER; FIBER-TIPPED PEN

TADPOLE; HB MECHANICAL PENCIL

In deep pools in the creek, pools that remain long after the water has ceased to flow, there are tadpoles of many kinds; the trick is to capture the shine on that smooth skin while still suggesting the subtle details.

These tads are an important link in the food chain; they are preyed upon by raccoons, herons—and adult frogs.

This colorful one-and-a-half-inch shiner doesn't quite match any in my big book of Missouri fishes.

This green frog has a conspicuous ear that really does resemble a

GREEN FROG; BLACK BRUSH PEN

drumhead. One of our larger frogs, it is fair game for licensed hunters in frog-gigging season.

The frog is game at any time for this heron, as are the tads and little fish that find themselves trapped in shrinking pools as the year advances toward the dry season.

I hear a strange sound, a primitive, harsh note, and come to the creek to investigate. Moving slowly and silently, I see a large, dark shadow overhead and hear that pterodactyl "skronck!" Ubiquitous in many parts of the world, the green heron here gives itself away with its voice. Now I look closely to find the long toes wrapped around a branch overhead, and at last manage to keep still enough that I am rewarded with a view of the heron's rich plumage.

The common names for this bird are many, worldwide. "Heron" itself has many roots, from the Middle English *heroun*, *harn*, and *heiron* and the Old French *hairon* to the High German *heiger*. According to *The Dictionary of American Bird Names* by

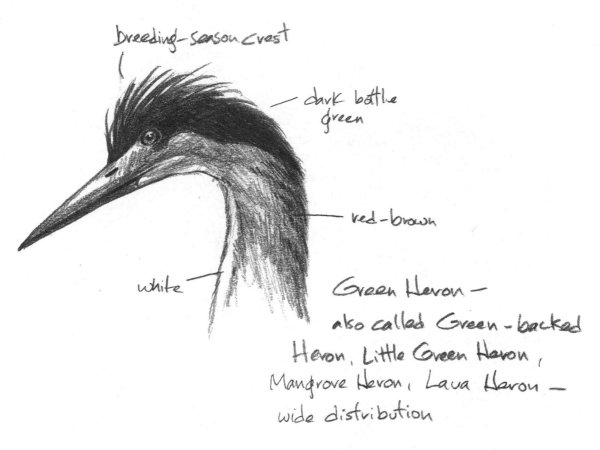

breeding-season crest

dark bottle green

red-brown

white

Green Heron — also called Green-backed Heron, Little Green Heron, Mangrove Heron, Lava Heron — wide distribution

GREEN HERON; #2 PENCIL

Ernest A. Choate (Harvard and Boston, Mass.: Harvard Common Press, 1985), "hern" is also a common contraction.

The same source says that this heron was once known as the "little green heron," not for its size but because it has so little green in its plumage!

The creek cuts through Bethany Falls limestone, a particularly fine, deep-bedded rock of pale gray. The waters of the long-departed inland sea were shallow, and warm, and

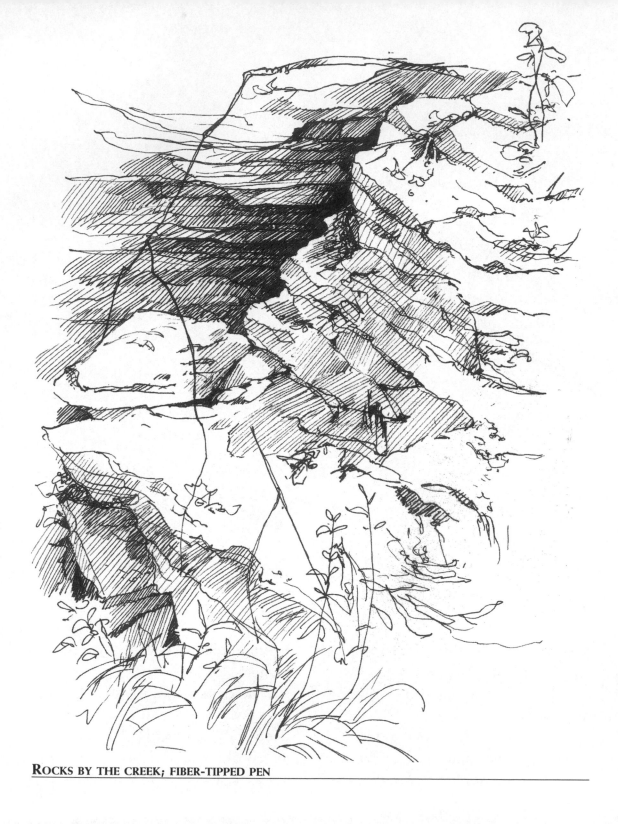

ROCKS BY THE CREEK; FIBER-TIPPED PEN

bursting with life. There were brachiopods, pelecypods, and ammonoids (creatures very similar to modern-day mussels, clams, and nautiluslike gastropods), and billions of tiny sea creatures that lived and died here, sinking to the bottom of the sea to lay down a layer of calcium that has become the stone. Some strata are more richly fossilated than others; Winterset limestone is full of bits of prehistory not usually present to any degree in Bethany Falls rock.

This particular rock *is* excellent for quarrying. Some say if it weren't for Bethany Falls, Kansas City would not have had such a firm foundation.

A characteristic of this formation is a tendency for large blocks to fall from the face of a bluff, remaining in a chunk; slump blocks, they're called. Here, the jagged edge of a slump block angles off from the upright stone like the teeth of a giant. I followed the planes of the rock with my pen point in a kind of modified contour drawing, letting my eyes range over the rock and only half looking at the paper. Repeated strokes and crosshatching lay down darker values, giving the illusion of shadow and form.

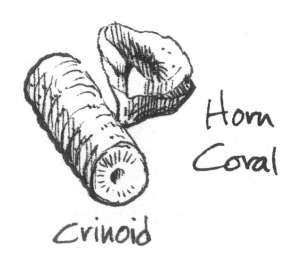

CRINOID AND HORN CORAL; FIBER-TIPPED PEN

There may not be many fossils in Bethany Falls limestone itself, but just upstream from the slump block I find many varieties that have weathered out of other layers in the limestone layer cake that underlies much of this country. Crinoids, sometimes found in this form and sometimes as single disk-shaped "beads," are common; horn coral less so.

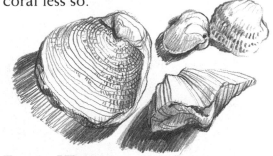

FOSSILS; HB PENCIL

Stone seashells wash loose in my creek; the limestone is older than dirt here, quite literally. It's got ironclad seniority over the organic soil only a few thousand to a few hundred years old—with a top dressing as new as yesterday's fallen leaf.

These tiny sea creatures amaze me with their varieties of form and size. Some appear plain as the gray limestone matrix; others glitter like crystals. But viewed through the everyday magic of my microscope's lens, most have their crystalline aspects as living matter was recrystallized into fossil.

The larger brachiopod here is curved like the more common mussel or clam on one side, but flat on the other. The flat side is also striated

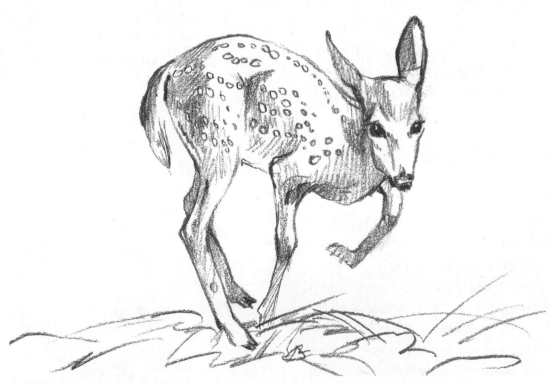

FAWN; HB MECHANICAL PENCIL

with row upon row of segmented markings; it is most likely a Juresania, with one curved shell and one straight one—it came that way from the maker, and wasn't flattened after the fact, as I had first imagined.

The tiniest shell has a minute hole where the creature attached itself to the rock; the one to its right was once decorated with spines at each dash on the convex surface. But my favorites of the common fossils are the Cupid's bow mouth-shapes of the bottom specimen, a spirifer—a most decorative shape for an articulate brachiopod.

As I sit on the gravel bar sifting through the rocks for fossil shapes, I catch a glimpse of ruddy brown through the leaves. It is a tiny fawn, wandering down the old trace through the woods that overlook the creek.

When our eyes meet, it wheels and darts off up the trace, its tiny feet making a surprising thunder against the soft earth.

Later in the season, the seedpods of Jacob's ladder remind me of a child's toy rattle. I've not come equipped to draw; today I am taking

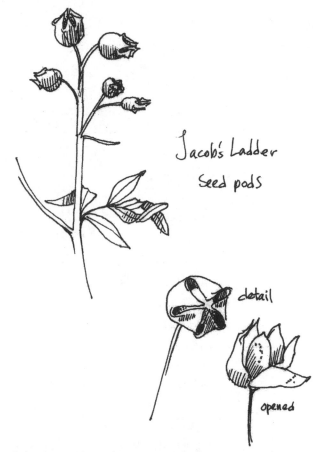

Jacob's Ladder
Seed pods

detail

opened

JACOB'S LADDER; FIBER-TIPPED PEN

notes in an old striped notebook, but the flower shape intrigues me. The faint blue lines will not show in reproduction, and it's far more important to get down what you see when you see it, no matter what equipment you have at your disposal. I once sketched a scene with the charcoal remains from someone's

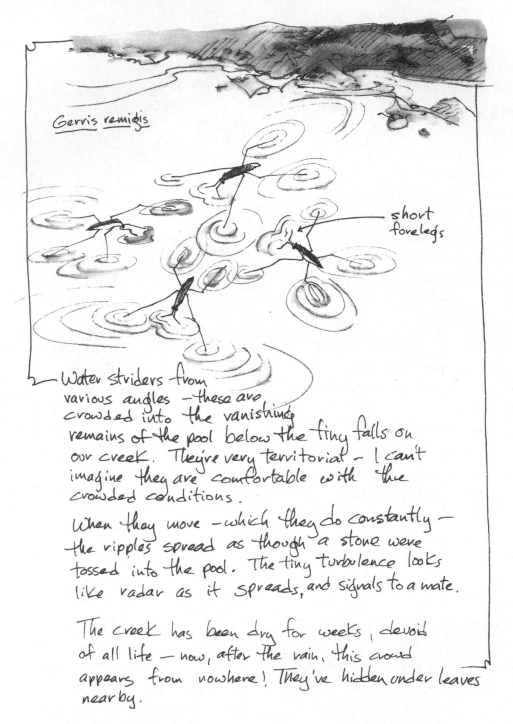

Gerris remigis

short
forelegs

Water striders from
various angles — these are
crowded into the vanishing
remains of the pool below the tiny falls on
our creek. They're very territorial — I can't
imagine they are comfortable with the
crowded conditions.

When they move — which they do constantly —
the ripples spread as though a stone were
tossed into the pool. The tiny turbulence looks
like radar as it spreads, and signals to a mate.

The creek has been dry for weeks, devoid
of all life — now, after the rain, this crowd
appears from nowhere! They've hidden under leaves
nearby.

WATER STRIDERS AT CREEK'S EDGE; FIBER-TIPPED PEN

campfire after discovering I had forgotten my pencil; the drawing still serves to remind me of that day.

I am taking a break from the heat to visit the coolness of the pool below the tiny waterfall; I dip my feet in the water, hoping to cool my blood. The creek is refreshing, as full of life as ever. Whirligig beetles spin erratically. Water striders oar their way across the pool, in search of— what? I luxuriate in coolness as the striders ply the waters, skirmish briefly, then drift apart only to reengage a few moments later.

As I watch, a black threadlike creature undulates just below the surface. Graceful as a curl of smoke in the wind, it turns slowly back upon itself, leaning against the slight current.

It is that countermotion that makes me realize, finally, that here is life. This is no errant thread pulled from my jacket, no jet-black horsehair washed downstream, though it is exactly that thickness and color. It is as if a fine ink line draws itself over and over in the water, delineating who knows what.

Out of water, it feels wiry, a tiny muscularity that squirms willfully against my hand, palpably wanting escape. It is very nearly uniform in thickness, with a swelling on what I take to be the head end. I carry it as quickly as possible the few feet to the cabin to show my friend Wendy, but it isn't quickly enough. The thing knots itself in a half hitch,

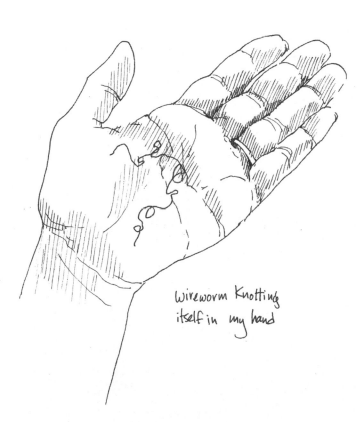

Wireworm knotting itself in my hand

WIREWORM IN MY HAND; FIBER-TIPPED PEN

then a double, making loops no Boy Scout ever thought of. By the time I get to Wendy, it's hopelessly snarled, knots upon knots like the shoelaces in a child's sneakers.

I am mortified. Such graceful, dancing life, and I have caused it to tangle itself beyond repair—or so I assume. I return it to the pool with a contrite R.I.P. and watch, expecting nothing.

To my delight, the thing twitches once, twice, as if testing the knots, trying to remember how it had tied them. And then, as easily as it had first moved through the water, it untwines the tangles and shimmies away.

Some things are not so lovely. I had told the kids who played in the water that there were no leeches here (and crossed my fingers with a "probably, anyway"). But one of the high school boys calls me to the creek with a question.

"What is *that* thing?" John asks, as he holds up a rock with a telltale, soft-bodied creature attached to its dripping underside.

It is, of course, a leech, and I am instantly thrown back to a childhood experience with the long, slimy bloodsuckers in the Great Lakes. This one seems docile enough, so we replace the rock and forget it is there.

leech on the underside of a creek-rock

LEECH; FIBER-TIPPED PEN

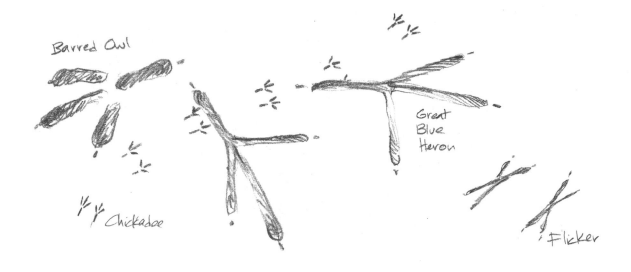

Barred Owl

Chickadee

Great Blue Heron

Flicker

BIRD TRACKS; #2 PENCIL

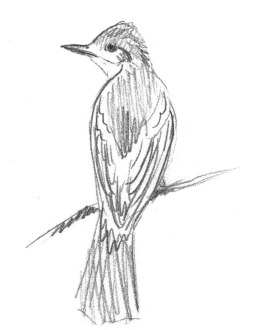

GREAT CRESTED FLYCATCHER; #2 PENCIL

The birds have left their ornate Victorian calling cards at the creek to let me know who has visited in my absence.

The hyperkinetic flycatcher stalls out for only a moment overhead, and I sketch his head and overall shape before he speeds off again to loop-the-loop after some doomed insect. I got the details of the head fairly well, but the feathers are only a suggestion, scribbled down from memory.

A single lime or linden tree has split into two trunks, a lovely demonstration of balance and tension. The more upright of the

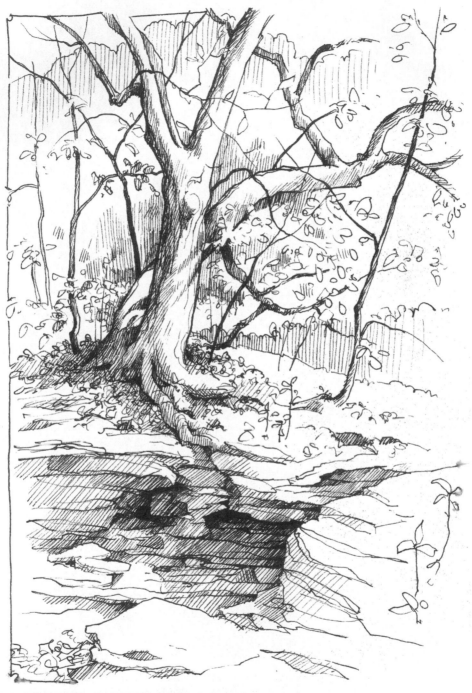

AMERICAN LIME TREES BY CREEK; FIBER-TIPPED PEN

trunks has developed a strong visible root system, the better to cling to the limestone bank of the creek. Its limblike roots are ropy, invasive, reaching between the flaking limestone layers for purchase. The other trunk flings itself backward up the hill, the lower limbs actually touching the ground.

The tree reminds me of childhood games in which one participant balances the weight of the other,

holding hands against the irresistible pull of gravity.

Drawing such a complicated subject in ink is difficult. How do I show the curve of the trunks, the overlapping forms, the depth of shadow in the rocks and their rugged stratification? How can I suggest the detail of leaf and fallen leaf, twig and branch and sapling? Short, crosshatched strokes help suggest the turning away of forms; a range of values delineates the shadowy rocks and the light-struck limbs. Modified contour drawing helps catch the sense of the limbs and rock shapes— and fatigue helps tell me when to quit without overworking my sketch!

Down below, spotted jewelweed blooms. I read that hummingbirds favor these little flowers, but though I watch for half an hour, none visits this jewelweed. Succulent relatives of garden impatiens, these plants are good for soothing the pain of contact with nettles; I crush a leaf and rub it on a sting and find the sensation abates almost immediately. According

spent seed case

bud

seed case forming

flower

Spotted Jewelweed (Touch-me-not)
Impatiens capensis

JEWELWEED; FIBER-TIPPED PEN

to *Wildflower Folklore* (Chester, CT: Globe Pequot Press, 1984), by Laura C. Martin, Native Americans also used jewelweed to treat athlete's foot as well as other rashes and skin irritations. Denison's *Missouri Wildflowers* states that these leaves have also been used to prevent or cure infection by poison ivy , and that recent scientific research seems to indicate some basis in fact to my folk medicine; the juice contains naturally occurring chemical fungicides.

These odd plants make botanizing a game; their seeds are enclosed in slender spring-loaded capsules, ready to explode at the slightest touch. Can I catch them before they scatter?

The plant isn't interested in my amusement; this explosive seed scattering is deadly serious and meant to disperse the plant's hope for the future to new and uncrowded habitat. The common name, touch-me-not, is a bit of a misnomer; what this plant most desperately wants is a touch to liberate its seeds.

Near the limestone slump block, I

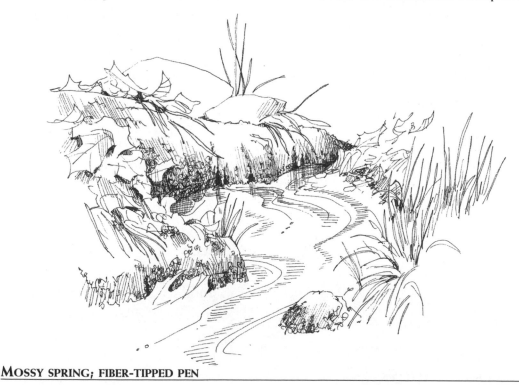

MOSSY SPRING; FIBER-TIPPED PEN

find one of the reasons the big pools stay viable so much longer than the general run of the stream itself. Here, a tiny spring flows from the rock to replenish the pool in all but the driest weather. All down the length of the creek and until it runs into the Missouri River a few miles away, the story is the same—springs and seeps keep the creek alive.

In summer, when the water in the pools is almost warm, this clear rivulet is icy where it flows from beneath the moss-covered rock. Here and for a few feet downstream, the water still moves, glistening in the filtered light, and all the rocks wear sweaters knit of rich green moss.

My first attempt at capturing the feeling went wrong; done with a dark colored pencil, it was too bold, too simple. The charm of this small place is the fineness of detail, the lacy quality of the moss, the grace of spring-fed grass, still green when everything around it begins to wither in the heat. The fine-pointed pen works better.

Quick gesture sketches serve to capture the varied positions of this robin as he catches ants and rubs them through his feathers near the creek banks. Some believe the formic

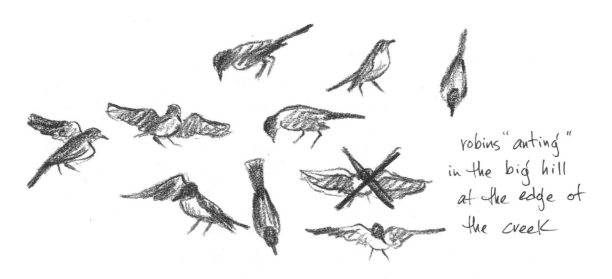

robins "anting" in the big hill at the edge of the creek

ROBIN ANTING; COLORED PENCIL

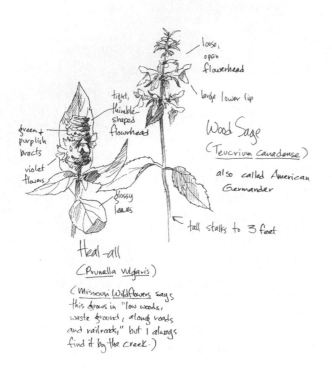

loose, open flowerhead

large lower lip

tight, thimble-shaped flowerhead

green + purplish bracts

violet flowers

glossy leaves

tall stalks to 3 feet

Wood Sage

(Teucrium canadense)

also called American Germander

Heal-all

(Prunella vulgaris)

(Missouri Wildflowers says this grows in "low woods, waste ground, along roads and railroads," but I always find it by the creek.)

MINT-FAMILY MEMBERS; FIBER-TIPPED PEN

acid in ants helps protect the birds from parasites and pests.

These mints seem to fare well here in spite of their varied growth habits. Heal-all is short and stout; wood sage is as gangly and tall as Wilt Chamberlain.

Each tiny flower of heal-all has a mouth and throat, and according to the doctrine of signatures it was thought to cure diseases that pertained to that part of the body. It does contain a powerful astringent and has been used to staunch the flow of blood from a wound—a lovelier styptic pencil couldn't be found.

Although wood sage is comfortable in this habitat, my field guide says heal-all should be found in meadows or by roadsides. Another book puts it in the vicinity of low woods and waste ground, so it must be fairly adaptable. It's acclimated well to the land that borders the creek, at any rate.

The creek bed, even when devoid of water, is a popular place. Along its open thoroughfare, animals, birds, and insects travel as though on an open highway. It's the path of least resistance through most of the year, easier to travel along than the brushy paths on the hillside, and even the moths and butterflies use this thoroughfare.

The spiders know it. Particularly in late summer when the orb weavers are busy stringing their nets across every path on my acreage, the creek

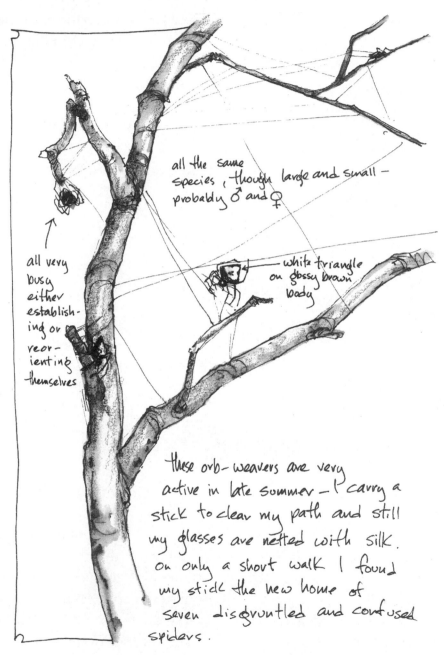

all the same
species, though large and small –
probably ♂ and ♀

white triangle
on glossy brown
body

all very
busy
either
establish-
ing or
reor-
ienting
themselves

these orb-weavers are very
active in late summer – I carry a
stick to clear my path and still
my glasses are netted with silk.
on only a short walk I found
my stick the new home of
seven disgruntled and confused
spiders.

ORB-WEAVERS; FIBER-TIPPED PEN AND WASH

has its full contingent of eight-legged predators. I usually carry a stick with me and wave it before my face like an amateur sword fighter; otherwise my glasses are sticky with silk, and I have a faceful of spider's dinner. I may look foolish waving my rough baton in the creek, but who's to see?

Most of these are tiny blue hairstreaks and checkerspots, but a few larger butterflies like the comma punctuate the crowd like a giant among children. For the most part, a quick double arc captures the suggestion of the dozens of wings, but even that doesn't begin to catch

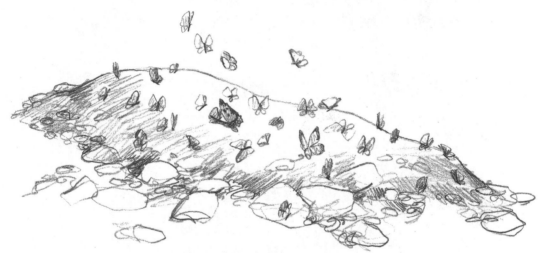

SANDBAR WITH BUTTERFLIES; HB MECHANICAL PENCIL

As the water in the creek dries up, butterflies concentrate in great numbers where moisture is still to be found. It is present in abundance between the sand grains and small rocks of this sandbar, and as I pass, the butterflies rise with an audible flutter of wings and brush against my hands and cheeks.

the feeling of action at this one small sandbar.

This red-spotted purple found the seemingly dry creek bed a welcome source of moisture. Like many other butterfly species, this one can also be found around mud puddles or animal droppings—not exactly what you expect if you imagine these delicate

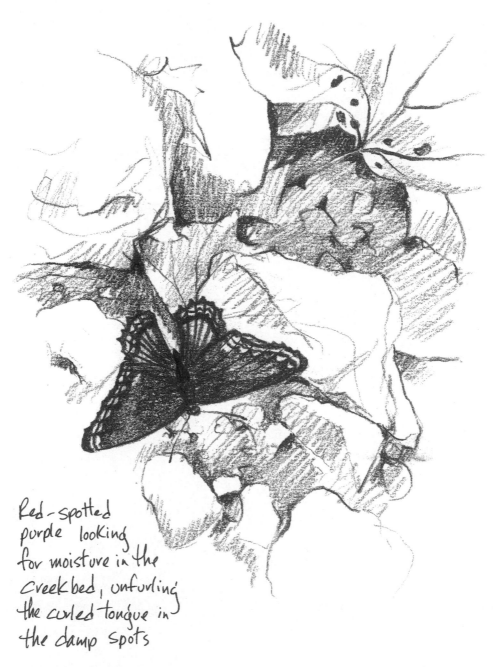

Red-spotted
purple looking
for moisture in the
creekbed, unfurling
the curled tongue in
the damp spots

RED-SPOTTED PURPLE; COLORED PENCIL

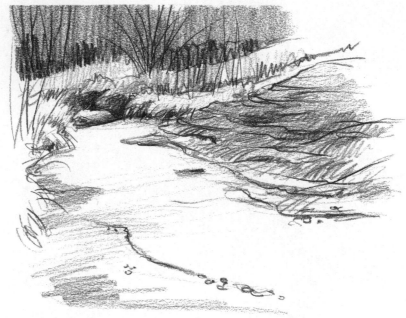

DRY CREEK BED; COLORED PENCIL

creatures flitting romantically from flower to scented flower.

Here and there the creek bed is as level as poured concrete where the water has worn away the rock. When the creek is dry, this scoured rock is as white as a skull.

A few feet away is a boulder as big as a washtub, weathered out of a thick lens of chert pocketed in the limestone somewhere upstream. Over the years, it has come to rest here, still angular and largely unweathered by long contact with water. It is as big as the stray hound

BOULDER AND DOG; #2 PENCIL

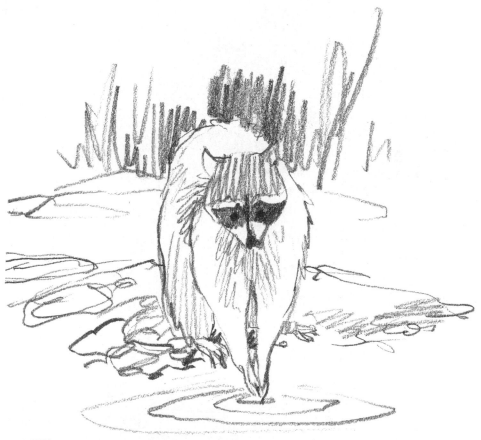

RACCOON; HB MECHANICAL PENCIL

that accompanies me on my walk today, and outweighs him by many pounds; it's hard to imagine how it came to be here.

Sketching the angles and planes of the rock is good practice in drawing values; capturing the moving target of the dog is more difficult.

Today I watched a raccoon fishing in one of the pools, its sensitive paws reaching below the surface of the water and feeling in the mud for food. It must be successful on a regular basis; this is one large raccoon.

I don't try for much detail when sketching mammals; they move too

Den; colored pencil

quickly and startle too easily. I am satisfied, instead, with catching a suggestion of position or action.

I found this den a few months ago, its cavelike opening blocked when high water re-sorted the stones. I moved the largest one, and today find my work is appreciated. Raccoon tracks mark the soft mud at the entrance beyond the jumble of stones.

The bluffs along the creek provide habitation for a number of ferns; it looks as though the rocks would be inhospitably dry, but the ferns, for the most part, seem quite content. I find smooth cliffbrake, common woodsia, maidenhair, and walking fern pocketed in stony crevices. Rattlesnake fern and adder's tongue prefer the rich brown soil of the banks and nearby woods, where I also find more verdant stands of woodsia.

The adder's tongue and the walking fern don't seem fernlike at all

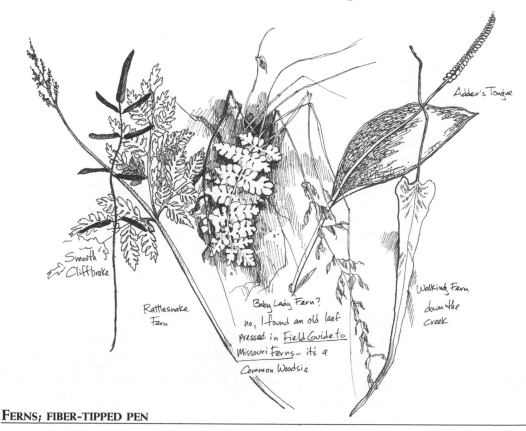

Smooth Cliffbrake

Rattlesnake Fern

Baby Lady Fern? no, I found an old leaf pressed in Field Guide to Missouri Ferns — it's a Common Woodsia

Adder's Tongue

Walking Fern down the Creek

FERNS; FIBER-TIPPED PEN

WOODCHUCK IN TREE; BRUSH PEN

bankside tree rustling and shaking violently. I imagine a squirrel making the disturbance, but to my amazement a fat, dark-brown woodchuck runs down the trunk and off down the bank.

I am stunned! I am almost fifty years old. I've seen a lot of woodchucks in my life, eating grass, lazing beside their burrows, hustling off into the shelter of the brush, but never, never have I seen one up a tree. Apparently neither has anyone else I speak to the rest of the day— they all look at me as though I am crazy, don't know a woodchuck when I see one, or am in my cups.

Finally the Missouri Department of Conservation, my authority in time of trouble, comes to my rescue in the guise of a biologist familiar with woodchuck behavior. I am *not* crazy, though the expert tells me the first time he saw one climb a tree he thought he was. They do, in fact, climb. When I ask *why*, the biologist tells me they most often do it to escape a predator, a fox or a coyote. I

to my mental image of the plant. It seems as though they should be ornate and divided, finely articulated; these simple leaflike shapes don't fit the M.O., but ferns they are, spread by spores.

Today as Harris and I walk beside the creek I notice the leaves in a

suppose we happened
along just as he was tired of perching
up there and decided to make his
return to normal groundhog
territory, terra firma—though
maybe his woodchuck *nom de plume*
was earned when someone saw him
up a tree.

Down among the rocks of the
streambed, sometime later, I find
further evidence of groundhogs, this
jawbone and a broken skull.

Members of the rodent family must
wear down their continually growing
teeth; this dry specimen is now loose
and the scimitarlike tooth pulls out
of the bone to an astounding length.

Last year a sulphur-yellow fungus
sprouted at the base of one of my
favorite trees, bright and ruffled as a
huge chrysanthemum. I couldn't
remember its season, but only that
glow, incandescent in the woods. I
watch, again and again, for the edible

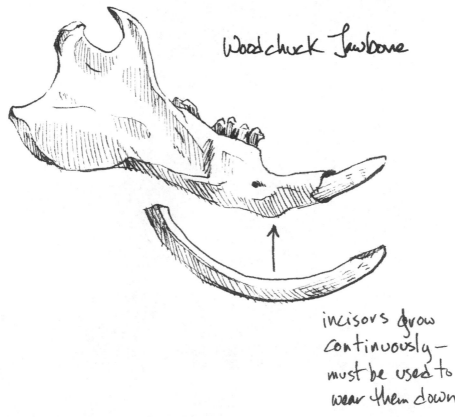

Woodchuck Jawbone

incisors grow
continuously—
must be used to
wear them down

WOODCHUCK JAWBONE; FIBER-TIPPED PEN

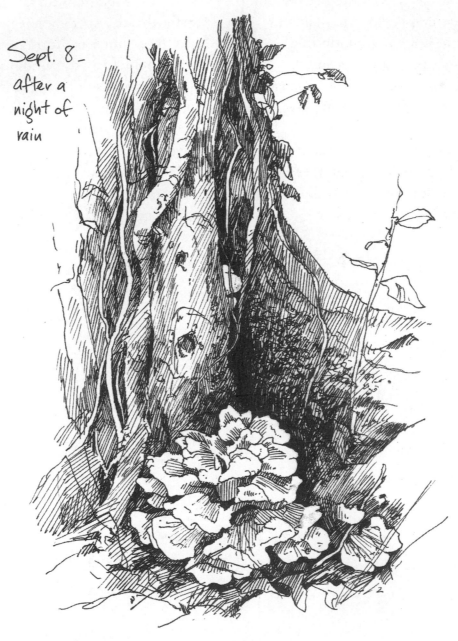

Sept. 8 –
after a
night of
rain

CHICKEN MUSHROOM; FIBER-TIPPED PEN

Laetiporus sulphureus mushroom to return, as the huge hen-of-the-woods by the oak tree on the hill does. But today as I walk beside the creek after a night of gentle rain, I find that familiar explosion of gold not at the base of last year's host tree but a few yards farther downstream. After weeks of drought, the rain brought forth the fruiting body; it could happen May to November, according to the *Audubon Society Field Guide to North American Mushrooms*.

This year's tree is in a shadowy draw, and even with the drought the mossy stockings on the roots are lush, now acid-green and moist from their soaking. Against the lichen-covered bark and the green of the moss, the fungus is doubly visible, as though there were a lantern in its center. I wonder if the spores of last year's mushroom were washed downhill to come to rest here, thirty feet below?

Equisetum, a primitive plant often found in fossil form, is a fern ally, also spread by comical little spores that wriggle when I breathe on them. They look like tiny balls with arms that hug themselves tightly, then reach out to dance with the air.

EQUISETUM; PEN AND INK

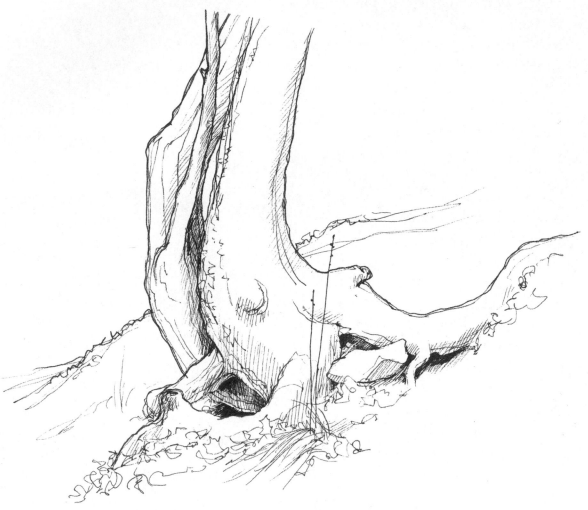

TREES ON THE BANKS; FIBER-TIPPED PEN

Tenaciously, these trees grip the banks with roots as big as limbs. They must have a good hold; when the water rises, it is as though it tries to dislodge everything in its path.

On the big limestone slickrock by the creek, there are thick cushions of moss I scarcely notice when it is dry. After a rain, they plump up and turn almost neon green. That is, part of them do; here one is a soft, almost featureless light-green pillow, the

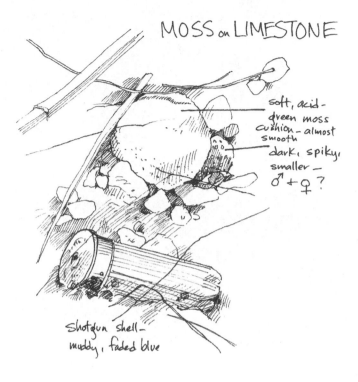

MOSS on LIMESTONE

soft, acid-
green moss
cushion – almost
smooth

dark, spiky,
smaller –

♂ + ♀ ?

Shotgun shell –
muddy, faded blue

MOSS AND SHOTGUN SHELL; FIBER-TIPPED PEN

other is dark—almost black—and studded with tiny green efflorescences. Sketching them with a fiber-tipped pen was a challenge, and without my notes you'd never know they were moss—these little cryptic plants need color to bring them to life.

Nearby is incontrovertible evidence that this square mile has been hunted. But from the faded blue of the plastic sleeve, I'd say the shotgun shell is an old one.

Hunting and guns are a fact of life in the country. Like it or not, the sound of gunfire is so common as to seem almost natural; if you heard that many guns go off in the city, you'd think there was a riot brewing. I try to adopt a live-and-let-live policy, though there's no hunting on my little piece of the mile. I just hope the hunters with the big guns respect my posted signs. They're armed; I'm not.

Downstream from my place is the elusive waterfall I call Brigadoon—because I found it once, then lost the way back to it. It is a perfect graphic demonstration of the power of moving water, even on seemingly immutable stone. As the rock weathers, it falls away, retreating backward into the hill. The layers of stone laid down by advancing and receding prehistoric seas give access to the wicking action of rainwater, also, which alternately thaws and freezes, further wedging apart the rock.

Today, the waterfall is frozen into

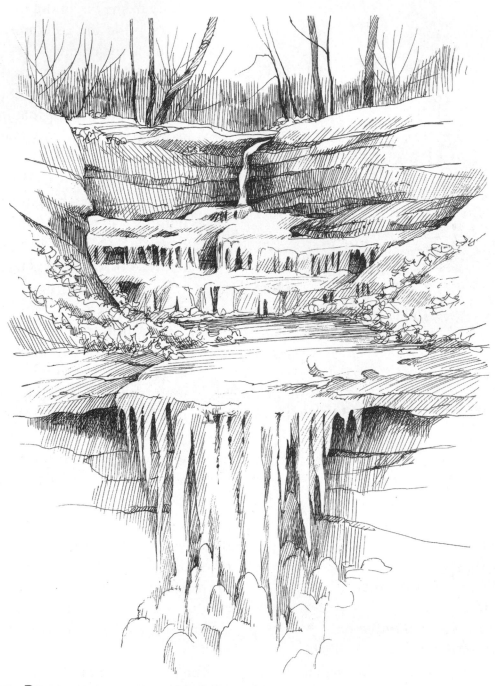

WINTER BRIGADOON IN WATER; FIBER-TIPPED PEN

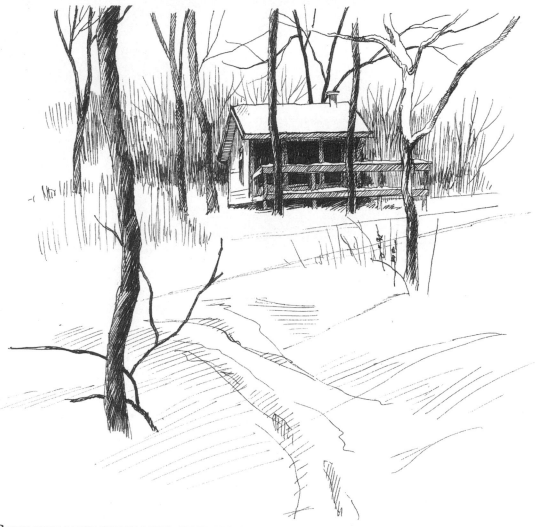

CABIN FROM THE CREEK BANK; FIBER-TIPPED PEN

fantastic forms, stalactites and stalagmites of transient ice.

A few yards from the edge of the creek, the cabin looks inviting through the fringe of trees. Snow covers the ground, and the prints of animals and birds are clearly visible going to and from the only open water left on this square mile; the ponds are frozen iron-hard, and the only other available drinking water is the snow itself. Clearly, many creatures prefer the pool, which is kept open in all but the coldest weather by the tiny spring nearby.

Part V

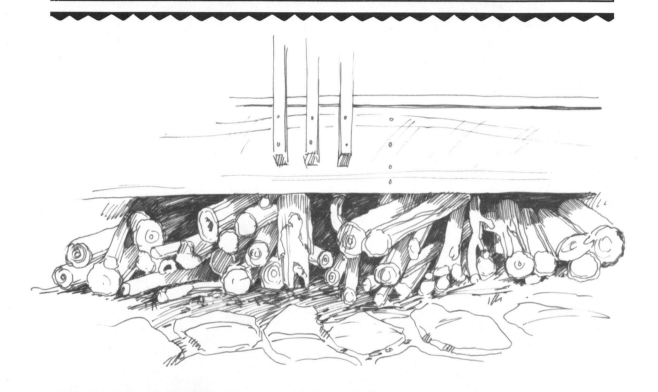

The Cabin and the Walnut Grove—and Other Signs of Life

The cabin I built in the midst of this square mile (with the help of a young carpenter) functions just as I had planned—as refuge, studio, office, and observation blind. From my desk or drawing board, I have played war correspondent to the minuscule drama of a short, violent skirmish between the two wren species that make claim to this area. They had both inspected my housing possibilities; one couple had found them to their liking and had begun the moving-in process. The other male objected, vociferously. The result was that for a year all the wrens vacated the neighborhood— much too rough for raising a family.

I have watched a tiny fawn wobble up the path not ten feet from where I sat, and enter the woods beyond the shed. A rotund groundhog noses the tender grasses at the far edge of the walnut grove; cottontail rabbits come out to play at dusk. Woodcocks fly over the grove at dusk each spring, and I lie on my back to watch them.

The bird feeders are kept full; the suet feeder attracts an enthusiastic competition between downy, hairy, and red-bellied woodpeckers, with the occasional flicker thrown in. (The flickers, incidentally, seem to want to move in with me on a permanent basis, making holes in my siding during mating season.) Bees visit the platform feeder during the January thaw, attracted there by relict pollen on the grain and seeds. Raccoons wage wars under the deck, and young *Procyon lotor* kits get their first lessons in opportunism at our offerings; the mother knows there is food to be found here. The deck offers additional viewing possibilities, from which we've watched a woodcock's spring mating ritual, the brief stopover of a rose-breasted grosbeak, and the antics of a dozen or so goldfinches just beginning to take on spring color; and the open, savannalike grove attracts visitors not seen in forest or meadow.

This interaction between the human and the wild alters both, and whereas I would not be so bold as to say it enhances both, it certainly makes *my* life richer and fuller. I try

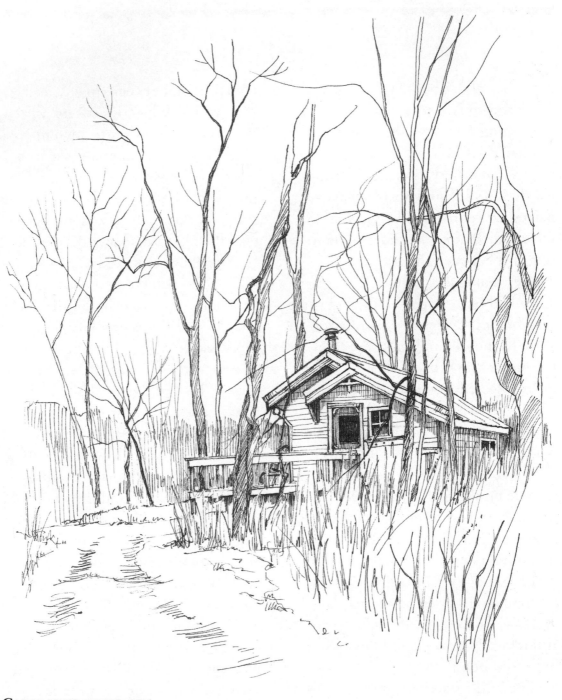

CABIN; FIBER-TIPPED PEN

to return the favor, insofar as I can provide food in times of harsh weather, and nest boxes for come-what-may—and January pollen for the bees.

The cabin fits its location like a hand in a fine kid glove. Drawing it on this winter day is pure pleasure; January thaw keeps the mercury hovering at about forty degrees, and I am comfortable in my heavy sweater and jeans. But when the sun drops behind the west hill, the marrow congeals and I go inside to hug the stovepipe like an old friend.

Like the cabin, this nest fits its setting. The buckbrush that rings the walnut grove is fine cover, and the birds are quick to take advantage of it.

There are times when I want a strong, simple effect. Wash lends itself to the idea, but it's not always convenient to take a paintbox into the woods. It's easy, though, to take the faithful (and inexpensive) fiber-tipped pen and a brush along with my lightweight canteen of water (which I try to take on all excursions). I lay down a simple drawing with the pen, making my strokes closer together where I want darker values, then wet the lines with clear water. Since the ink is water-soluble, I can get some interesting (if somewhat unpredictable) effects.

It's possible to manipulate these miniwashes with my wet

BIRD'S NEST IN BUCKBRUSH; WAX-BASED COLOR PENCIL

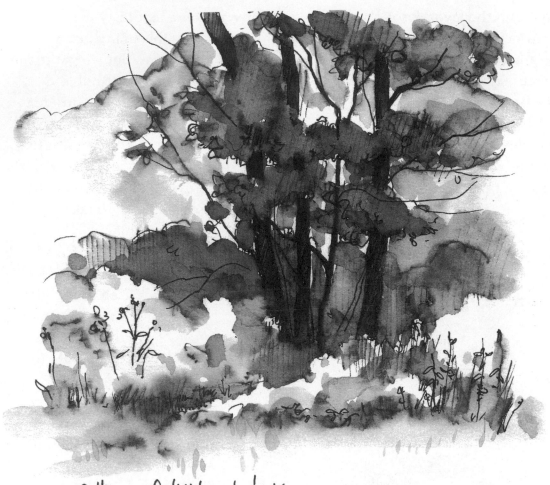

*patterns of light and dark
at the edge of the walnut-grove trail*

TRAIL IN WALNUT GROVE; FIBER-TIPPED PEN AND WASH

brush to pull dissolved ink into areas where I had no lines at all. Then when the washes are dry, I can go back in and restate detail if I need to, as in the weeds at the edge of the grassy area in the foreground. In a pinch, I've moistened areas with saliva on the tip of my finger—unsanitary, but effective.

A somewhat immobile visitor, a baby starling, Dulcinea, allows me the chance to sketch more slowly

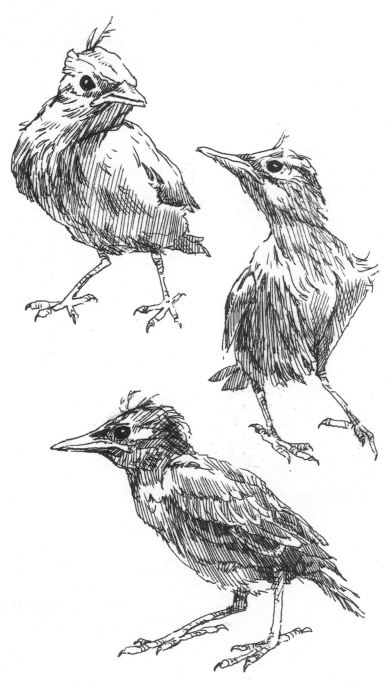

BABY STARLING; FIBER-TIPPED PEN

and carefully than I am used to when sketching birds. It is in the care of a friend who lives nearby; I am starling-sitting while she is in the city, alternately feeding the little bird and sketching it. Repeated hatch lines let me suggest feathers and enough shading for a sense of volume.

I don't see starlings here deep in the woods, but elsewhere around the square mile—in the more civilized sectors—they are common.

Luna moths are considered endangered in some parts of the country, but I find evidence that the night woods are full of them. Occasionally one plasters itself against the cabin's lit windows; more often I find the remnants that prove the moths are a popular item on some creature's diet.

The diet of the luna itself is vegetarian, and it's certainly not surprising to find them in such abundance here. The caterpillar eats

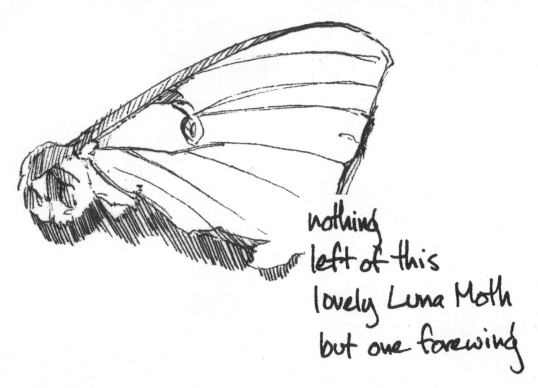

nothing left of this lovely Luna Moth but one forewing

LUNA MOTH FRAGMENT; FIBER-TIPPED PEN

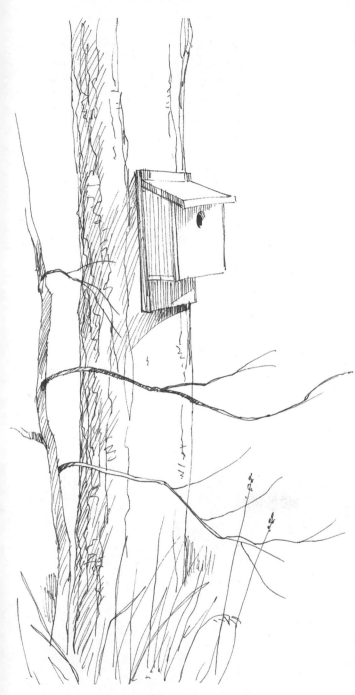

BLUEBIRD HOUSE; FIBER-TIPPED PEN

the leaves of walnut, hickory, and persimmon, of which there are plenty locally, as well as sweet gum and birch and sometimes other trees.

This ethereal creature, a member of the giant silkworm family, lives only in North America, and in abundance here in the woods of northwest Missouri—in a good year.

Titmice and chickadees seem to use this as winter shelter more often than the bluebirds it was intended to house. The bluebirds inspect and leave, it seems, though I see a number of eastern bluebirds, both male and female, nearby.

Larry, a friend, noticed an abundance of competition at his birdhouse when starlings and other interlopers harassed the bluebird family unmercifully, threatening to move in whenever they were away from the nest. He made a bluebird decoy to guard the house around the clock to discourage transients. It worked, and the bluebirds were unmolested for the remainder of the summer. Now that he has moved, I have the decoy at my place, where I hope it will perform the same good function.

In such crowded conditions trees don't grow like field-guide

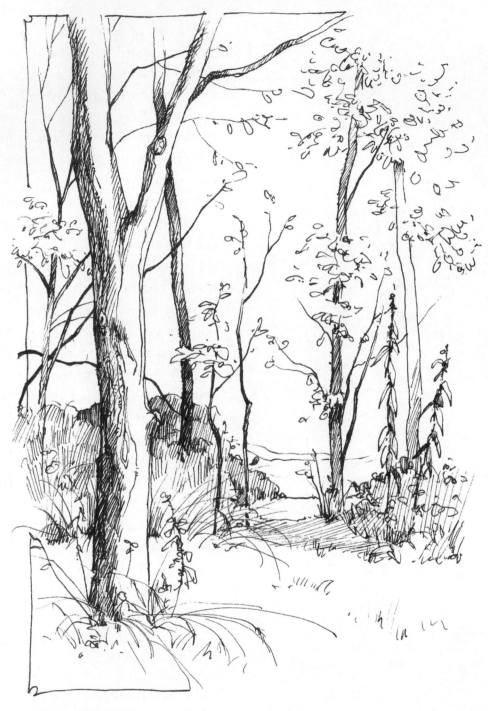

TALL TREES; FIBER-TIPPED PEN

illustrations but stretch impatiently upward in competition for light. Side branches are few, mostly with acute angles as in the walnut tree in the foreground. The trees appear to be of two stages of growth, fully grown specimens side by side with younger saplings, suggesting that at one time the area had been cleared, then abandoned, then again cleared of competing saplings before it was left alone to grow again.

I like the rhythm of the trees, their lines upturned each at its own angle. Here at the edge of the grove there is a clean angularity that rests the eye. A fiber-tipped pen works well to catch this angularity; there's no softness in it. Even the leaves are crisp and strong in ink.

I like to explore ways to suggest depth on the flat plane of my paper; here, detail (or lack of it) joins value in giving a sense of aerial perspective, of the immediate foreground and beyond.

This year the squirrels seemed particularly fond of leaves; a quick sketch of this fat little fellow perched on a limb supplements other more formal sketches.

These were done with a technical pen on Denril™, which has a frosted surface, because I originally drew them in my journal. Rather than tear out the page, I literally traced over them for they showed clearly through the translucent surface.

There are signs of earlier

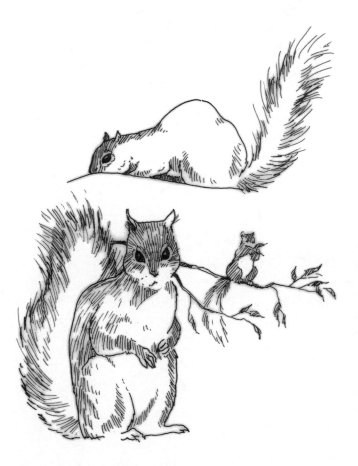

SQUIRRELS; TECHNICAL PEN

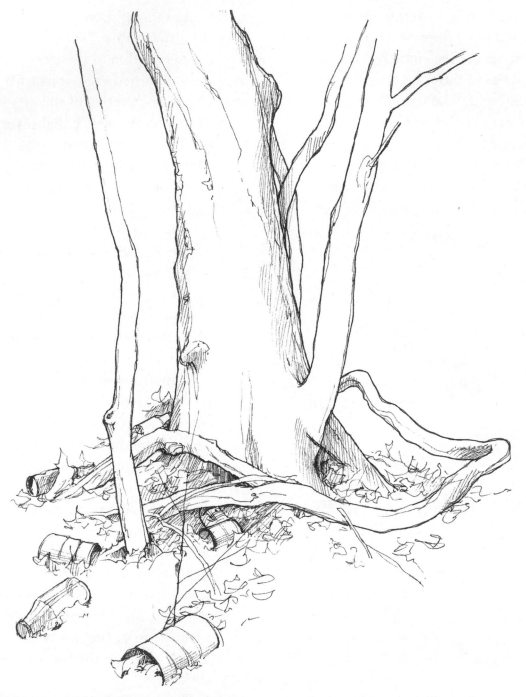

TREE AND TRASH MIDDEN; FIBER-TIPPED PEN

occupancy or human use near the grove; why that must always mean trash, I have yet to understand. When I began this book, I imagined drawing only those things that were beautiful, natural. But I decided that didn't reflect the reality of a square mile so close to human habitation— or, sadly, much of anywhere that's accessible to our kind. Unthinking people leave their detritus in the woods (or the desert, or the ocean) and think it is "gone." It is not, and I come across the trash pile left, perhaps, by the boys who used to camp here. There was no other reason to trek this stuff back into the woods.

Still, the cylindrical cans and cone-shaped tops on the juice bottles give me a bit of classical drawing practice; these artificial shapes are more demanding of the technical artist in me, though less interesting than natural ones.

This year the tall bellflower is very sparse—as sparse as the rain. After only one year of ample precipitation and a good wet spring, now we are back to over five inches behind normal; the ground is cracked and hard; dust paints the world pastel, one hundred feet and more

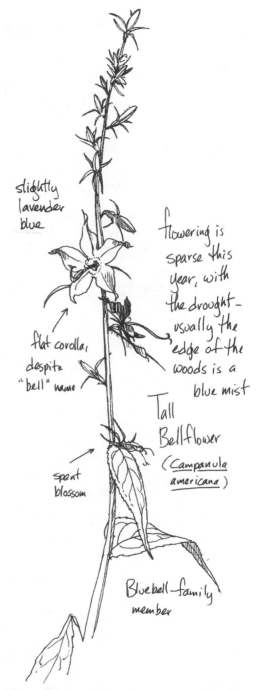

slightly lavender blue

flat corolla, despite "bell" name

spent blossom

flowering is sparse this year, with the drought— usually the edge of the woods is a blue mist

Tall Bellflower (Campanula americana)

Bluebell-family member

TALL BELLFLOWER; FIBER-TIPPED PEN

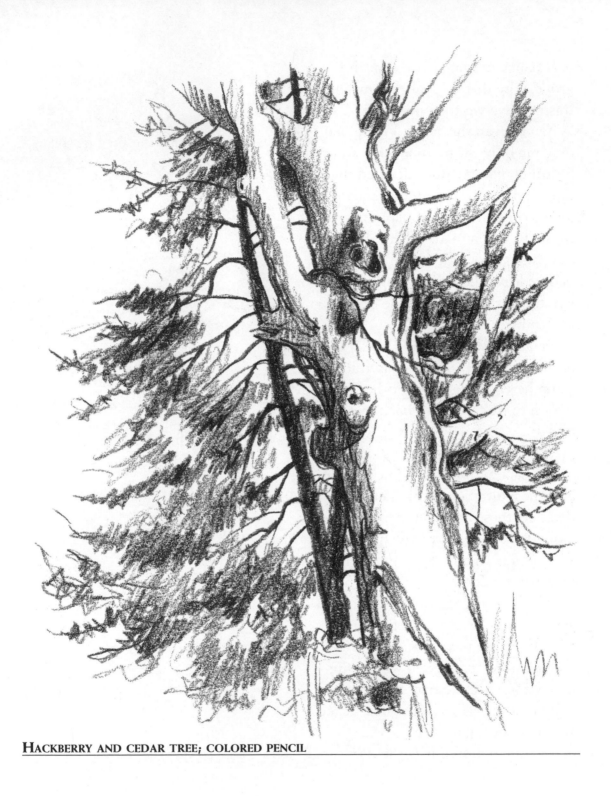

HACKBERRY AND CEDAR TREE; COLORED PENCIL

from the gravel road. The cabin is dusty at six hundred feet.

At this time of year the walnut grove should be fringed in regal bellflower blue. Instead, the spikes have only a flower or two in full bloom; the rest are tight buds or spent flowers. In a good year the plants may be six feet tall; this year they are closer to three or four.

Missouri Wildflowers describes these as light blue, but they are slightly lavender as I see it. A white ring marks the center, punctuated by a long, curved pistil. Spiky bracts distinguish the flower, giving it a pleasingly bristly appearance; even in this harsh, dry summer the flowers are beautiful, perhaps more so for their comparative rarity.

A fiber-tipped pen is wonderful for capturing detail, though not so good for catching nuances of shading or form. In order to suggest shadow areas, I must make either hatched lines or tiny dots like a newspaper photo, which is much too tedious for field sketching.

I like the clean lines and crisp detail of the pen. Only when it rains or I sneeze do I have a problem—the ink is not waterproof.

These two trees have grown up in close proximity, neither seeming to suffer. The knots and galls on the hackberry are natural for this species, and although the cedar is less full than the one by the pond, that's more a result of less available light here at the forest's edge than of crowding by the other tree. Though I've checked the cedar's branches many times, I've yet to find a saw-whet owl there, as a friend with the Audubon Society assures me I might.

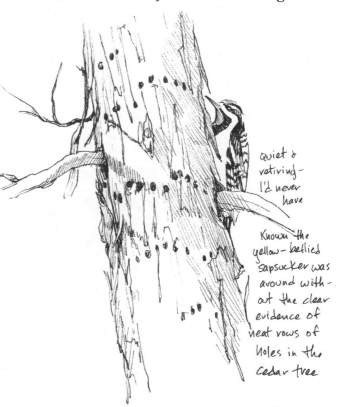

quiet & retiving—I'd never have known the yellow-bellied sapsucker was around without the clear evidence of neat rows of holes in the cedar tree

SAPSUCKER AND CEDAR TREE; FIBER-TIPPED PEN

The strong lights and darks possible with a black Prismacolor pencil worked well to capture the sense of sunlight on this warm winter day.

Close in to the cedar, I can see that at least one bird has found this tree a welcome habitat. Rows upon rows of sapsucker holes ring the trunk. The sticky sap comes to the

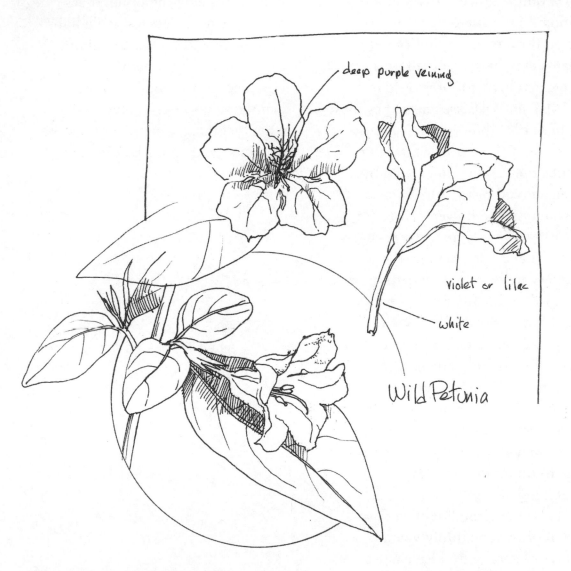

deep purple veining

violet or lilac

white

Wild Petunia

WILD PETUNIA; FIBER-TIPPED PEN

Flight cage at the edge of the woods near the creek — the owl is very much aware of my presence. Even caged the bird looks big — and it is. I'm excited with the prospect of keeping the great horned owl for two days — I'll have lots of chances to sketch.

OWL IN FLIGHT CAGE; BALL POINT PEN

fiber-tipped pen—all easy to carry. I could, however, have used a pencil sharpener; the soft, wax-and-pigment-based "leads" of the colored pencil dull quickly, and I switch to the pen for a second sketch—a wild petunia.

These purplish flowers delight the eye with their crinkled petals. They look like more modest members of the cultivated crew, not unlike Missouri's Mennonite, who live quietly on the land while the rest of us carouse the town making all kinds of noise.

The great horned owl watches me warily from behind the narrow-gauge wire and two-by-two pine boards, eyes wild and glaring; even caged, he has nothing of the domestic about him.

The big bird had tried to run interference with a car. Surprisingly, only a wing was broken—a five-

surface where it attracts insects; the sapsucker dines on both.

On my sketching expedition I've taken a five-by-seven-inch sketchbook, a colored pencil, and a

pound owl in a contest with a two-thousand-pound automobile is going to be the loser, big time or otherwise, and this one was lucky. Some animal-loving Samaritan picked him up and took him to Pete Rucker for rehabilitation.

Pete, a veterinarian by trade, has a wildlife rehabber's license. He set the bird's wing, keeping it immobile until the hollow bones knit. During the

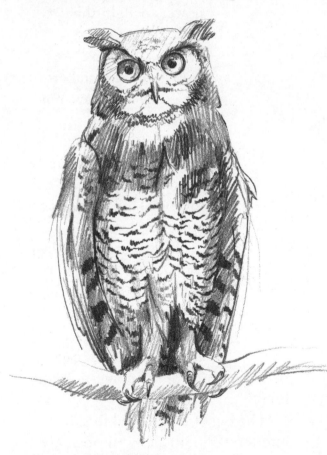

time the Assassin (as his kids named the big owl) was in his care, he also had a barred owl for a patient, smaller and slow to learn. When the time came to release them, Pete was concerned about *Strix varia* becoming prey for the great horned owl.

The answer was to free the barred owl close to Pete's and to bring *Bubo virginianus* to my place, flight cage and all. For a few days, the owl will remain in the cage to become accustomed to the area, then be released on his own recognizance. Sink or swim, kiddo—hunt or starve.

I chose a soft black graphite pencil for this drawing, an Eberhard Faber Ebony. It is bold enough for his persona as well as for his coloration, yet capable of subtlety. Quick darks for his wing bands are a simple matter of pressing down harder on my pencil; lighter grays require a more delicate touch.

It is one hundred degrees, even in the shade of the walnut trees, and every sweat bee and mosquito in Missouri finds me as I sketch. Never for an instant does the great horned owl forget my presence. I bend to pick up a dropped pencil,

and he watches every move. I look up from sketching and find startling gold eyes boring into mine, avid, white throat feathers pulsating rapidly, and I can't shake the feeling that the big owl pants in anticipation. The panting part is right, anyway. This "gular fluttering" is a cooling-off response which helps the owl to dissipate heat. Like the family dog, the bird doesn't sweat.

To the owl, I must seem both predator and prey. It remains constantly alert to my presence. Even when I sit fifty feet away on the deck and watch him through binoculars, I find those golden eyes always on me. As I move around the grove the big head swivels to keep me in sight. It never allows me to approach beyond what it apparently considers a comfortable distance without lowering the tufts of feather that give the owl its name—whenever I come closer than fifteen feet, the "horns" go down. The owl hisses and clacks its beak, an angry castanet that tells me no matter how much time I spend in close proximity it will never be enough. This is not Bernd Heinrich's semitame "Bubo," described in *One Man's Owl* (Princeton, N.J.: Princeton University Press, 1987); this owl was already fully grown when injured and will never willingly accept humans.

The Assassin lowers his head threateningly whenever I come near; the feathers stand out around the body—a corolla that serves to make the bird as large and fearsome as possible. An owl uses its feathers to effectively express its state of mind; once you learn to read them, you have some idea what the big bird is thinking, and whether it is angry or alert or unconcerned. After a few minutes of my quiet sketching, the Assassin relaxes, lowering the body feathers and coming out of defensive posture, but the feathers on the head stay down like an angry cat's ears whenever I'm within range.

These tufts are not ears, though they look as though they might be. This creature does not have external ears like a mammal's. An owl's large, funnel-shaped ears are hidden beneath the soft feathers that form the edge of the facial disk, set asymmetrically for "binaural" hearing: the owl can triangulate sound, pinpointing prey with deadly accuracy. The fine feathers of the broad face also serve to collect sound waves and direct them to the ear canal, and one reason an owl ducks

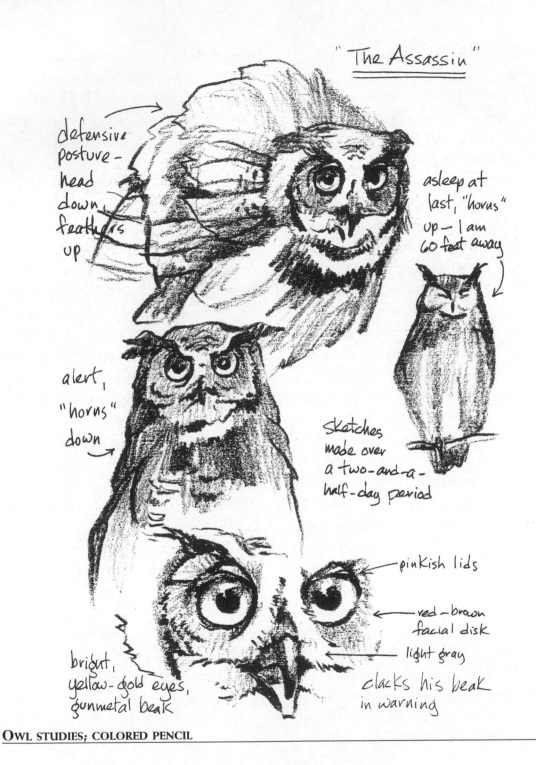

"The Assassin"

defensive
posture—
head
down,
feathers
up

asleep at
last, "horns"
up— I am
60 feet away

alert,
"horns"
down

Sketches
made over
a two-and-a-
half-day period

pinkish lids

red-brown
facial disk

light gray

bright,
yellow-gold eyes,
gunmetal beak

clacks his beak
in warning

Owl studies; colored pencil

and bobs its head is to allow it to zero in on the source of an interesting sound. Correct identification means dinner. The great horned owl may not have hearing as accurate as the barn owl's, though. Barn owls are ghostly hunters which have been known to capture prey in total darkness.

I wonder how the Assassin will fit into the local ecosystem. Barred owls have already staked emphatic claim on our acreage; I find evidence of their skill as hunters in skulls and

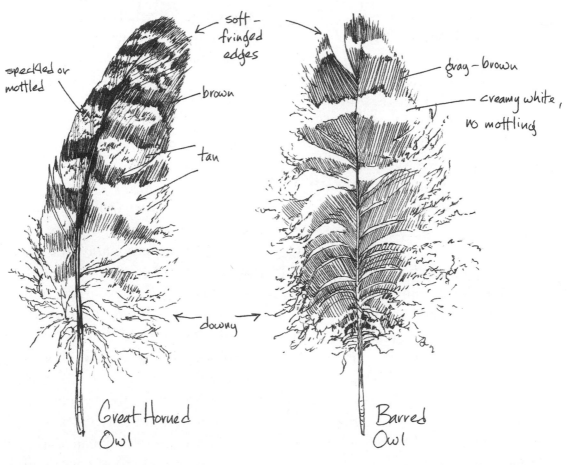

soft-fringed edges

speckled or mottled

brown

tan

downy

Great Horned Owl

gray-brown

creamy white, no mottling

Barred Owl

OWL FEATHERS; PEN AND INK

picked bones and hairy owl pellets as often as I find their shed feathers in the grove. These feathers are relatively simple, graphically; you see immediately why this creature was named as it was. Bands of creamy white alternate with unbroken gray-brown, like stripes on a convict's shirt. Even the relatively short feather on the right is striated with these simple divisions.

I will know if the Assassin does find a niche here. The molted feathers will be easy to spot; for all their typical owl similarities, they're very different from the barred owl's—a rich café au lait, rather than creamy white, with darker-colored bars. The tan is richly speckled with the same deep hue; drawing the feathers with pen and ink was a challenge.

A bird's quills are hollow (and so are its bones). The quill, or rachis, is lightweight, designed with air chambers; in flight feathers, the strong vanes that grow from it are designed to provide lift. The narrow leading vane helps cut the air; the curved back edge directs the flow. Vanes are made up of barbs and barbules that almost appear to be tiny feathers in themselves. Along the barbules are tiny hooks (hamuli or barbicels) that lock together to form a smooth flight surface. When you see a bird preening its feathers with its bill, it is straightening out these barbicels, relocking them for flight.

At the base of these particular feathers are down feathers which double as insulation when the bird is at rest. These lack barbicels, so the barbs do not interlock but float free, trapping air. Of course, making the downy feathers look soft with a solid black line was no picnic. I allowed my pen point to dance around erratically here, suggesting softness with a broken line. (Whether or not I pulled it off is up to the viewer to decide.)

Owl feathers are well engineered to their task, differentiating them from any other bird family; the edge is soft, fringed to muffle all sound; the owl doesn't make so much noise it can't hear itself hunt. I sketch a barred owl's flight feather to compare it with a Canada goose's quill of roughly the same size and position on the wing; the graphite pencil allowed for the subtlety I'm after, letting me capture the nuances of softness versus a kind of paper-stiff edge.

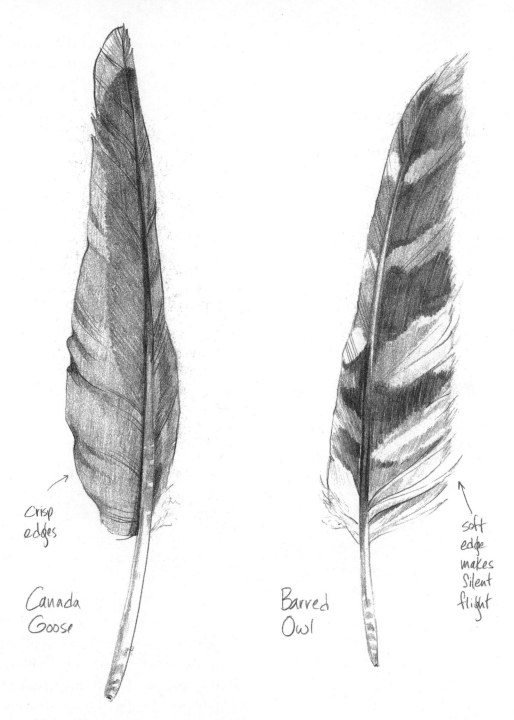

Crisp
edges

Canada
Goose

soft
edge
makes
silent
flight

Barred
Owl

OWL AND CANADA GOOSE FEATHERS; HB PENCIL

The goose doesn't care how much noise it makes. Silence is beside the point; it's not trying to avoid frightening prey. The goose's strong feathers are designed instead to propel it down the long miles of transcontinental migration from the mosquito-rich northern tundra to the Gulf of Mexico, and the sound of wing beats is punctuated by wild cries. The owl, on the other hand, favors stealth; it stays put on home territory and waits for food to come within range.

I put out food for the owl for two weeks after we let it go. I don't know if it has found the chicken parts and turkey necks I leave as blood offerings, but something surely has. I watch for owl pellets, clues that my friend has eaten nearby, but find nothing.

I'm not an owl-pellet expert. Whole armies of biologists have studied this phenomenon, wherein the owl liquifies the digestibles of its prey, expresses the liquid like an old-fashioned wringer washer and regurgitates what is left as a small, dry pellet—usually only one a day. The ones at left were collected in various locations; I have no idea what owl made them. I used a fine fiber-tipped pen and wet it with clear water for tone.

The study of owl pellets helps scientists to determine prey species, as they poke through the remains to identify tiny skulls and bits of bone. I do know that while the Assassin was in my care and I left the chicken parts inside his cage, nothing was left in the

OWL PELLETS—
undigested bits of roughage and bone

densely packed, darkish gray, an amalgam of feathers, hair, small bones and teeth

bits of bone

small black feather

bone

very bristly hairs — perhaps they are feather barbs

this one has a dense center but many stiff, bristly hairs

broken tooth— almost twice sized

If I knew more about biology, I might be able to identify these bits of bone and feather — all I can say with surety is that the owl has been eating rodents and small birds

OWL PELLETS; FIBER-TIPPED PEN AND WASH

morning—neither skin nor bone nor pellet—and hope that means my failure to find evidence of fine dining near the cage means nothing.

Tonight I listen for the Assassin's characteristic "hoo hoo HOO HOO hoo hoo" in the woods, so different from the barred owl's "who cooks for you, who cooks for you all-l-l?" With six hundred forty acres to choose from in one square mile, I won't be surprised if I don't hear him; the big owls are normally silent except during mating season in winter and early spring, besides. But if I do, I'll know the Assassin remembered how to catch his own dinner and doesn't need my help again. And I'll share the mix of feelings of surrogate parents everywhere: pride and relief, sadness and a touch of loneliness.

The extended, high note that pierces the night is the snowy tree cricket, a very delicate-appearing creature to make such a fine noise. This one is just a half-inch long— its acoustics must be sensational.

Action is slow in the early morning; Harris and I have spent the night at the cabin, and I've stocked the feeders while waiting for the coffee water to boil. The raccoons clean us out every night, and when we don't stay over the birds have to wait for fresh food until I arrive—whenever that is. This morning they are unused to such early service. I sketch the feeder and nearby table, and only one bird shows up for breakfast. But by full light the table is full, and I delight in watching here with my second cup of hot liquid.

SNOWY TREE CRICKET; FIBER-TIPPED PEN

at last a red-bellied woodpecker

only one small titmouse in all the time it took to draw feeder + table

lots of feeding birds by 8:30am

FEEDER ACTION

RED-BELLIED WOODPECKER AT PLATFORM FEEDER; FIBER-TIPPED PEN

GRAY SQUIRREL ON HANGING FEEDER; HB PENCIL

The hanging feeder is a source of exercise as well as food.

This fox squirrel was almost orange; when it turned its back I could sketch the lighter-edged hairs on the tail and the darker ticking along the margin. The fact that I've done so many squirrel sketches in my life helps me capture this one's anatomy; like the gray squirrel, it moves constantly.

The tails of these larger squirrels are much bushier than the gray squirrel's; they look as though they'd be good protection, winter or summer.

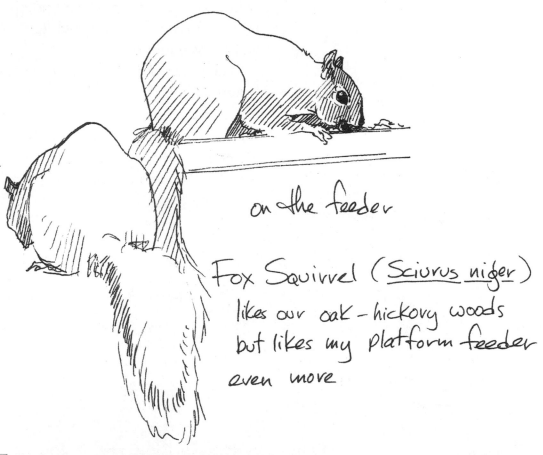

on the feeder

Fox Squirrel (*Sciurus niger*) likes our oak-hickory woods but likes my platform feeder even more

FOX SQUIRREL ON PLATFORM FEEDER; FIBER-TIPPED PEN

One day a pair of Northern bobwhites find an unexpected feast beneath the feeder; I often hear them up in the meadows, a more natural habitat with the brushy edges nearby for cover. Bobwhite numbers have increased somewhat from historic times when dense forests covered most of the East from the coast to the Mississippi, but they're on the decline again. Not, however, around here.

One flew before I could sketch, but the other continues to feed with a fine unconcern, talking softly to itself. I had heard them earlier, but they'd made a contraction of their normal call, and I couldn't quite make out what I was hearing. Instead of the normal "bob-*white*" with the

"white" on a strong ascendant note, these just repeated "white, white, white" over and over.

The little nuthatch works its way headfirst down the tree toward the feeder. I often see the bird on this walnut tree, which is just inches from the edge of the deck; I hear it first, making that metallic "beep-beep" like a kid's toy car.

NUTHATCH ON WALNUT TREE; COLORED PENCIL AND INK

BOBWHITE; PENCIL

THE VIEW THROUGH MY WINDOW; HB MECHANICAL PENCIL

Outside the window on the studio wall the nearest of the walnut trees stands, light from the sunstruck cedar wall reflected back into the shadowed side of the tree and warmed the shade to a ruddy glow. The poison ivy vine that wreathes the trunk from root to canopy is lit as well, its fall hues intensified by the reflected color until it seems as though I view the whole through tinted glass.

As indeed I may, if I so choose. Around this window are bright-

colored panes of glass that mirror the scene beyond as though designed as a proper frame for the autumn. It's an old window, the ten-dollar find from the flea market, a Victorian relic with a pane of wavy antique glass in the center. Down each side the smaller, stained-glass panes are strung like jeweled beads: red, then amber, then green, then amber and red again.

It's a good thing I no longer have such an irrational fear of spiders. This shed skin of a large wolf spider hangs from a loose network of silk on my favorite red-checked lumberjack shirt. That old shirt serves me as a jacket on cool mornings; I wore it only two days ago.

Spiders shed their skin when they grow, and I know that means the big spider must be nearby. I sketch the shirt and its new decorations, taking care not to disturb the spider I feel sure is hiding within. When I take the shirt out onto the deck before peering between the folds, I find the spider crouched there as though trying to make itself small and inconspicuous. Not a chance. It is *huge*, though not as large as one I found only inches from my bare ankle a few weeks ago. That one was on the leg of my desk, and I caught it in a cup and summarily banished it to the edge of the woods.

Sometimes memory drawings are all I have to go on. This bird was by the base of the feeder when I left the cabin to go home; I had no drawing equipment with me

strong strands of silk, apparently to anchor the spider as it wriggled out of its too-confining skin

I discovered this large exoskeleton — the spider's shed skin — on my plaid shirt on the hook in the cabin and knew the now-larger spider must be nearby. Sure enough, when I moved the folds of the fabric, it was there. Glad I didn't throw on the shirt to go outside at night.

SPIDER EXOSKELETON; FIBER-TIPPED PEN

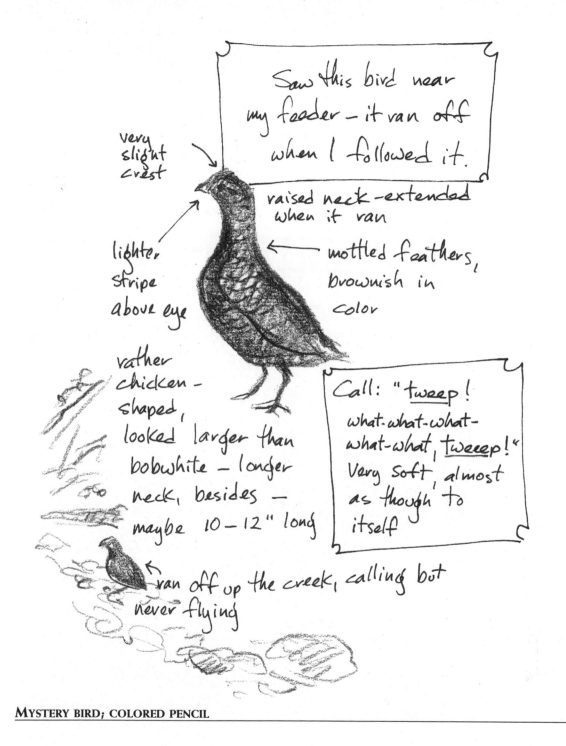

Saw this bird near my feeder — it ran off when I followed it.

very slight crest

raised neck — extended when it ran

lighter stripe above eye

mottled feathers, brownish in color

rather chicken-shaped, looked larger than bobwhite — longer neck, besides — maybe 10 — 12" long

Call: "tweep! what-what-what-what-what, tweeep!" Very soft, almost as though to itself

ran off up the creek, calling but never flying

MYSTERY BIRD; COLORED PENCIL

and didn't want to lose the bird while I went back in to fetch a drawing pad. Instead, I followed it, keeping it in sight as long as I could and trying to imprint details of what I saw in my mind's eye.

Hanging bird feeder; fiber-tipped pen

It was larger than a quail and had a longer neck, but still had a distinctive chickenlike shape—neither long and stilt-legged like a killdeer nor streamlined like a songbird. It didn't seem inclined to fly but preferred to run or walk quickly just ahead of me. It had mottled brownish feathers, and a light stripe above the eye, and appeared to have a bit of a crest, especially when it felt I approached too near—as though it bristled in alarm.

Still, it didn't seem panicked and called softly to itself as it went.

As soon as it was feasible, I sketched what I could remember and called George Hiser, with the Department of Conservation, who told me that given our brushy habitat and the bird's size, coloration, and actions, it sounded as though I might have a grouse in the grove—unusual, but not impossible.

Even in summer, chickadees and nuthatches find my feeder. I've hung it low on the railing to make it accessible to squirrels and raccoons. That may seem odd when most people are determined to keep these marauders *out* of their expensive birdseed, but my reasons are twofold. Not only do I like the mammals as much as I do birds and enjoy having them frequent the deck, but this way I avoid a bit of the damage they were wreaking on the cabin.

When the feeder hung from a hook on the soffit board by the big French windows, the view was great, and the antics of the squirrels were almost worth the cost—but not quite, when that cost was a great deal of damage to the cabin. One corner of a window's trim is eaten down to the nails, and the oily prints of the raccoons seem to attract or encourage even more gnawing. One raccoon managed to rip the window screen while trying to find a good position from which to feed. It was better to make it easy for them to get at the feeders, eight feet away from the cabin!

I had an audience for this sketch, a photographer from *Harrowsmith* magazine; I blame that for my slight inattention to perspective. It's hard to draw with someone watching over your shoulder, and not only watching but taking pictures.

Summer is the time to meet the family, as birds and mammals bring their young to share our offerings. These cardinals must be father and son; the youngster is just getting his

SUMMER CARDINALS

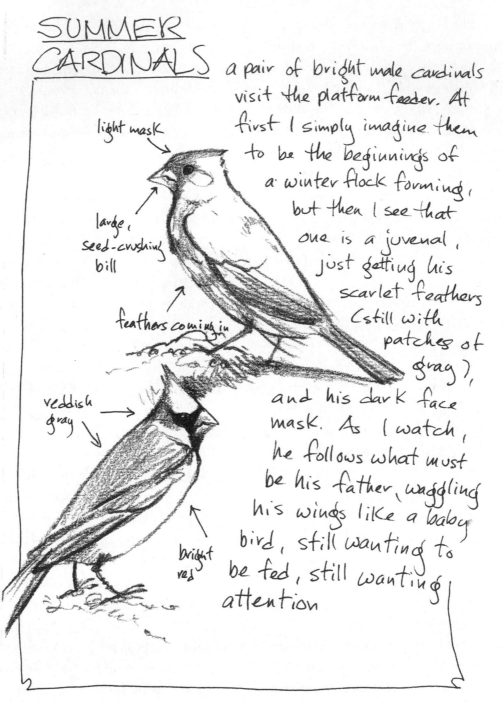

a pair of bright male cardinals visit the platform feeder. At first I simply imagine them to be the beginnings of a winter flock forming, but then I see that one is a juvenal, just getting his scarlet feathers (still with patches of gray), and his dark face mask. As I watch, he follows what must be his father, waggling his wings like a baby bird, still wanting to be fed, still wanting attention

light mask

large, seed-crushing bill

feathers coming in

reddish gray

bright red

SUMMER CARDINALS; COLORED PENCIL

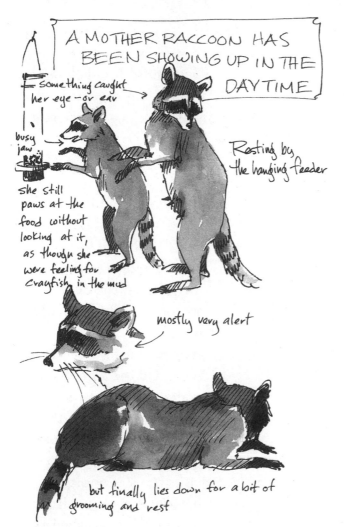

A MOTHER RACCOON HAS BEEN SHOWING UP IN THE DAYTIME

something caught her eye — or ear

busy jaw

she still paws at the food without looking at it, as though she were feeling for crayfish in the mud

Resting by the hanging feeder

mostly very alert

but finally lies down for a bit of grooming and rest

RACCOON AT FEEDER; PERMANENT INK AND WASH

hours. This female is a daily visitor; I can tell she has been nursing her brood by the enlarged black teats. Odd to think we mammals share this evolutionary oddity: at least two of our sweat glands have evolved into mammary glands.

She remains very alert, though she knows I am here. The moment she showed up, I stopped typing and positioned myself to sketch her. The only pen I could find quickly was a permanent "Sharpie," and when I stop with my point still in contact with the paper, the ink soaks into the paper with a rounded blob—so I keep it moving. The permanent ink is nice, though, in that it allows me to add a wash of lamp black to indicate her overall coloring. I am pleased when at last she relaxes enough to lie down and take a brief bath—she looks like one of my cats.

We never try to hand-feed them; I don't want the raccoons to get too used to people, not out here in the country where every other farm has

bright scarlet feathers. He is as large as his father, but he still wants to be fed like a baby.

Harris and I always see raccoons at the cabin, but normally only after dusk. This summer we've had a number of them in the daylight

its contingent of coonhounds. They need to remain wary. And then there's the possibility of rabies; raccoons are not tame and wouldn't hesitate to bite a friendly hand, especially if they confused it with food. These animals are among our most frequent carriers of rabies, so I leave her to her birdseed in peace.

The raccoons come less often in the winter months, or at least they come only at night. I find evidence of their activity in greasy little footprints on the deck after a rain; they've explored the rich scents of our barbecue grill and left their mark to show for it.

Up in the woods behind the cabin I find a raccoon skull, evidently there for some time. There are only two teeth left in the dental arcade. A soft black colored pencil seems to work well to suggest both the hardness of bone and the softness of fur; it all depends on the direction and strength behind the pencil strokes.

The little gray squirrel visits my feeder often, nervous and quick. It moves constantly, always alert to danger, imagined or real. Gesture sketches— those quick, less than five-second scribblings— work well here, letting me catch the overall shape or pose. Then, as the squirrel returns to the pose or a similar one, I can restate lines and add detail.

RACCOON SKULL AND HEAD; COLORED PENCIL

Quick Gesture Sketches developed further as the animal moved around

Squirrel at the bird feeder; the little flocking birds are jealous and territorial — they want to feed and are not taking well to the invader

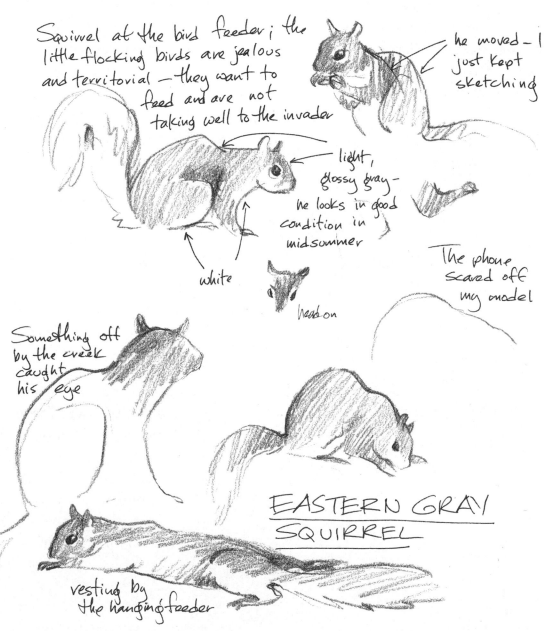

he moved — I just kept sketching

light, glossy gray — he looks in good condition in midsummer

white

head on

The phone scared off my model

Something off by the creek caught his eye

EASTERN GRAY SQUIRREL

resting by the hanging feeder

GRAY SQUIRREL AT FEEDER; COLORED PENCIL

A little shading to suggest pelt coloration and shadow, and the animal comes alive on my page.

I love the gray squirrels. They're life itself, packaged small. They are glossier than their larger cousins, the fox squirrels; their white or buffy underparts are a lovely, elegant contrast. I seldom see one of these small, dapper squirrels looking scruffy as the fox squirrels often do; they're sleek.

Healthy, too, from the look of it. They thrive on our offerings, winter and summer; it's as much squirrelseed as birdseed.

According to many sources, grays and fox squirrels don't inhabit the same territory—they're too competitive. But the squirrels on my square mile haven't read the rule book. I've got the sketches to prove it.

Skinks treat the cabin as though it were just another tree in the woods, climbing over the walls and scuttling away under the step. There's plenty for them to eat; I see them cadging a quick meal from one of the spider's webs that festoon the eaves or capturing a moth on the screen.

I've never seen such a tiny skink as this baby on the stone walk. It must have been a recent

SUMMER SKINKS

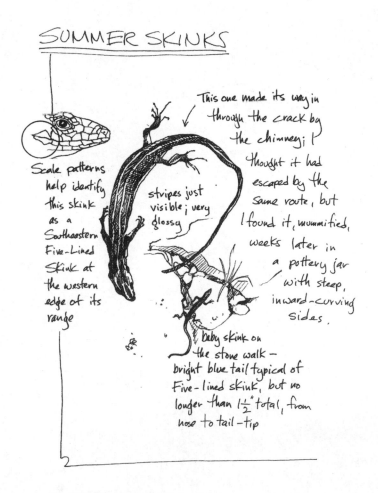

Scale patterns help identify this skink as a Southeastern Five-Lined Skink at the western edge of its range

stripes just visible; very glossy

This one made its way in through the crack by the chimney; I thought it had escaped by the same route, but I found it, mummified, weeks later in a pottery jar with steep, inward-curving sides.

baby skink on the stone walk — bright blue tail typical of Five-lined skink, but no longer than 1½" total, from nose to tail-tip

SKINKS; FIBER-TIPPED PEN

hatchling, and I wish I could have seen the egg it came from; the little creature seems as small as the baby walking sticks that were so plentiful in the woods this year.

Adults and subadults four or five inches long often skitter across the deck boards; I catch them momentarily and then let them go. One unfortunate skink got itself mummified in the still air of a pottery jug with vase-shaped sides, but at least I am able to closely study the scales under my hand lens (and at my leisure)—the best way to positively identify a skink.

Like all reptiles, skinks are cold-blooded, needing the warmth of the sun to allow them to hunt. When the weather begins to cool with the long slide into the chill season, I don't see them till spring. The first little blue-tailed juvenile signals the season as surely as the first wildflower.

At first the big woodpecker appears to be asleep, breast feathers fluffed to insulate in the deep cold, tail feathers spiked against the bark, neither moving nor giving voice to its characteristic harsh call. But at last it turns its head and appears to see me. I can't *help* but notice the bird. After weeks of gray overcast, the

RED-BELLIED WOODPECKER; PEN AND INK

neon-bright spot of feathers on its head is incandescent, much brighter than the male cardinal nearby.

The black and white markings on wings and back that identify this fellow as a ladderback are closely spaced; from a short distance they seem gray as the day itself. But that scarlet head looks wonderful against the dark woods. I sketch the woodpecker slowly and carefully—for once a bird has held still enough for me. No need for memory drawings here.

This flicker moves fast; as with the red-bellied woodpecker, the movements are jerky and nervous. The flicker alights on my window

screen for only a second before flying off with a loud *squawk*. For that reason, I must draw only the basic shapes, and that as quickly as possible. I fill in details after the bird has disappeared into the cover of woods, from memory and from photos.

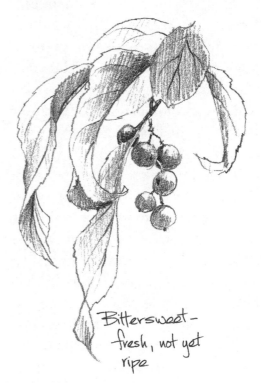

Bittersweet—
fresh, not yet
ripe

BITTERSWEET; PENCIL

Many kinds of vines entwine the trees of the walnut grove: catbrier, wild grape, Canada moonseed, Virginia creeper. But loveliest are the bittersweet, with bright orange

Quick Northern
Flicker
sketches

on the
screen—for
just a second

FLICKER; FIBER-TIPPED PEN

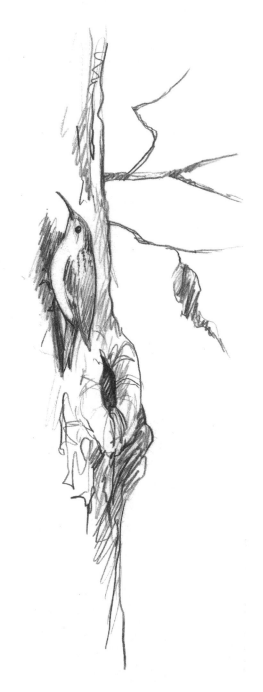

berries that catch the setting sun and fling the color back to the sky like the echo of a remembered dream.

This little creeper appears for only moments before spiraling on up the tree and out of sight as I sit sketching at my desk. It is as small as the dead leaf that hangs from a nearby twig, and if I hadn't seen the lateral movement I'd never have noticed the small bird. It's that camouflaged, brown and cryptically marked.

I capture the basic shape of bird and down-curving beak in a quick gesture sketch, then refer to my field guide for information about markings. The tree, of course, stays put, so that long after the bird is only a memory, it's easy to draw the background of the sketch.

The HB pencil works well on the smooth bristol paper, capable of a broad range of lights and darks; I like the creamy surface for detail work.

The fast-moving show at the feeder allows me to keep my gesture-sketching hand in fighting trim. The birds move so quickly that all I manage to do is scribble down a basic shape and perhaps suggest shading before moving on to the next one. This page of sketches took

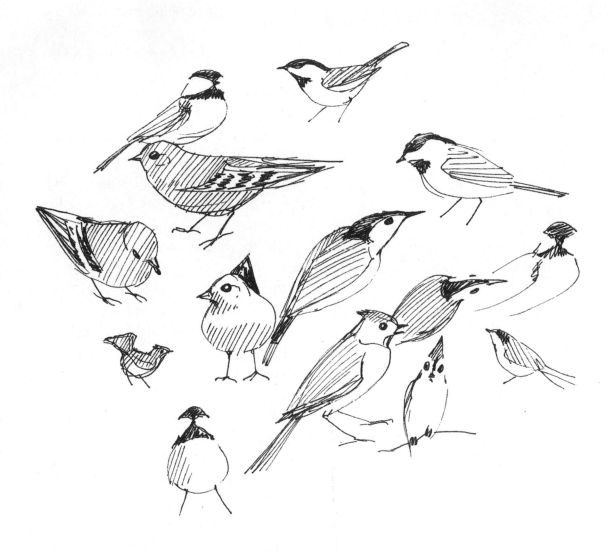

QUICK BIRD STUDIES; FIBER-TIPPED PEN

FIREWOOD UNDER THE DECK; FIBER-TIPPED PEN

no more than five minutes and included the season's first goldfinches in subdued winter drab among the titmice, nuthatches, and chickadees—the usual crew, in other words, except for the finches.

My husband, Harris, and I have yet to build a shed or lean-to to shelter the firewood, so I stack it under the edge of the deck to help keep it dry. We share the chore of cutting firewood; my chain saw is small and manageable, but I have trouble starting it. This little pile represents only a few minutes cutting of downed wood, but it will last the better part of two weeks.

For our needs here at the cabin, nature and our own labor supply all the wood we use; it isn't necessary to buy cordwood, only to expend a bit of energy. I never cut live wood. Nor do I cut standing dead wood—it's much too valuable to the birds as homesites. But once that dry wood hits the ground, it's mine.

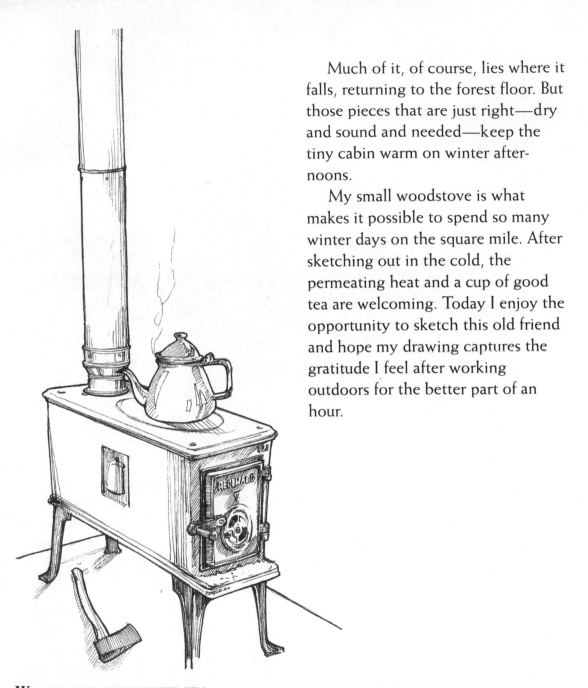

Much of it, of course, lies where it falls, returning to the forest floor. But those pieces that are just right—dry and sound and needed—keep the tiny cabin warm on winter afternoons.

My small woodstove is what makes it possible to spend so many winter days on the square mile. After sketching out in the cold, the permeating heat and a cup of good tea are welcoming. Today I enjoy the opportunity to sketch this old friend and hope my drawing captures the gratitude I feel after working outdoors for the better part of an hour.

WOODSTOVE; FIBER-TIPPED PEN

Appendix A
RESOURCES

A mile sounds like a relatively small area, easy to know. It is not. When I asked Joe Francka, entomologist with the Missouri State Agriculture Department, to check me on the insects that might inhabit my chosen mile, he laughed.

"Do you have any idea how many thousands of insects that might be?"

And indeed I did. My listing in Appendix B includes only those insects I know are here. I've not had the chance to find or identify everything that hops, flies, or crawls on this square mile. Add to that the wildflowers, grasses, vines, trees, understory plants, spiders, birds, mammals, reptiles, and amphibians, and you realize that *really* knowing such a place could take a lifetime. It's a most enjoyable way to spend a life. I am never bored.

There are resources available to help you know your own area. Contact your local college or university and its research library; a botanical garden, state conservation department, or soil conservation service— all of these can be invaluable resources. Those I called upon were:

The University of Missouri, Kansas City
The University of Missouri, Columbia
William Jewell College, Liberty
The Missouri Botanical Garden, St. Louis

Powell Gardens, near Kansas City
The Missouri Department of Conservation, both local agents and the home office in Jefferson City
The Missouri Department of Natural Resources, Jefferson City
The Missouri State Agricultural Service, Kansas City
The Missouri State Extension Service, Richmond office
United States Department of Agriculture, Soil Conservation Service, Kansas City
Mid-Continent Public Library, Excelsior Springs branch
Kansas City Public Library, Kansas City
St. Louis Public Library, St. Louis

ORGANIZATIONS

Outdoor-oriented groups may be of help to you as you learn about your area and about nature in general. The following are only a few of the largest organizations. Membership in most of the big organizations will put you in touch with the local chapter in most places. You will receive a newsletter that lets you know about meetings, conferences, field trips, and so on.

Defenders of Wildlife
1244 Nineteenth Street, NE
Washington, DC 20036

Ducks Unlimited
PO Box 66300
Chicago, IL 60666

Earthwatch (Research Expeditions)
Box 127
Belmont, MA 02178

Greenpeace
1436 U Street, NW
Washington, DC 20009

National Audubon Society
950 Third Avenue
New York, NY 10022

National Wildlife Federation
1412 Sixteenth Street, NW
Washington, DC 20036

Nature Conservancy
1815 North Lynn St.
Arlington, VA 22209

Sierra Club, Chapter Services
530 Bush Street
San Francisco, CA 94108

Appendix B
FAUNA, FLORA, AND GEOLOGY

FAUNA

VERTEBRATES

Birds: residents, migrants, and rare visitors

Ruby-throated hummingbird
Carolina wren
House wren
Winter wren
Black-capped chickadee
Tufted titmouse
Junco (also called snowbird)
Pine siskin
White-breasted nuthatch
Goldfinch
House finch
Purple finch
Brown creeper
Eastern wood pewee
Eastern kingbird
Eastern phoebe
Ruby-crowned kinglet
American tree sparrow
Field sparrow
Harris sparrow
House sparrow
Song sparrow
White-crowned sparrow
White-throated sparrow
Eastern bluebird

American robin
Wood thrush
Northern cardinal
Blue jay
Northern oriole
Blue grosbeak
Rose-breasted grosbeak
Yellow-billed cuckoo
Great crested flycatcher
Blue-gray gnatcatcher
Eastern meadowlark
Dickcissel
Rufous-sided towhee
Gray catbird
Mockingbird
Brown thrasher
Northern parula
Tennessee warbler
Warbling vireo
White-eyed vireo
Yellowrump warbler
American redstart
Common yellowthroat
Scarlet tanager
Summer tanager
Indigo bunting
Northern rough-wing swallow
Tree swallow
Mourning dove
Rock dove
Whip-poor-will

Chuck-will's widow
Nighthawk
Woodcock
Bobwhite
Wild turkey
Killdeer
Brown-headed cowbird
Common grackle
Red-wing blackbird
Rusty blackbird
Crow
Northern flicker
Downy woodpecker
Hairy woodpecker
Red-bellied woodpecker
Red-headed woodpecker
Yellow-bellied sapsucker
Broad-winged hawk
Cooper's hawk
Red-shouldered hawk
Red-tailed hawk (sometimes called chicken
 hawk)
Rough-legged hawk
Sharp-shinned hawk
Northern harrier
Prairie falcon
American kestrel
Barred owl
Great horned owl
Long-eared owl
Saw-whet owl
Screech owl
Short-eared owl
Turkey vulture
Black-crowned night heron
Great blue heron
Green heron
Belted kingfisher
American wigeon
Blue-wing teal
Bufflehead

Common goldeneye
Green-wing teal
Mallard
Wood duck
Canada goose
Snow goose
Plus mystery bird—looked like a grouse or
 prairie chicken; went "wheeeeeep, wht-
 wht-wht-wht-wht."

Mammals: residents, migrants, and rare visitors

Flying squirrel
Fox squirrel
Franklin's ground squirrel (maybe)
Gray squirrel
Thirteen-lined ground squirrel
Chipmunk
Prairie vole
Woodland vole
Mole
Pocket gopher
Beaver
Muskrat
Woodchuck (also called groundhog,
 whistle pig)
Eastern cottontail
Virginia opossum
Raccoon
Eastern spotted skunk (rare)
Striped skunk (also called woods
 kitty)
Deer mouse
Field mouse
Harvest mouse
Meadow jumping mouse
White-footed mouse
Least shrew
Short-tailed shrew
Big brown bat
Evening bat

Little brown bat
Red bat
Pipistrelle
Coyote (also called song dog)
Gray fox
Red fox
White-tail deer
And maybe bog lemming

Amphibians and Reptiles

Eastern American toad (also called common toad)
Woodhouse's toad
Blanchard's cricket frog
Bullfrog
Gray treefrog (also called tree toad)
Green frog
Plains leopard frog
Spring peeper
Western chorus frog
Eastern tiger salamander
Smallmouth salamander
Western slender glass lizard (also called glass snake)
Five-linked skink
Black rat snake (also called black snake)
Bullsnake
Eastern hognose snake (also called spreadhead)
Eastern yellowbelly racer (also called blue racer)
Great Plains rat snake
Northern water snake
Osage copperhead
Prairie king snake
Prairie ring-necked snake
Red milk snake
Red-sided garter snake (also called garden snake)
Rough green snake

Speckled king snake
Texas brown snake
Timber rattlesnake
Western earth snake
Western ribbon snake
Western worm snake
Common snapping turtle
Ornate box turtle
Red-eared slider
Three-toed box turtle
Western painted turtle

Fish

Catfish
Smallmouth bass
Largemouth bass
Bluegill
Crappie
Carp
Grass carp
Shiner
Minnow

INVERTEBRATES
Moths

Acorn
Ailanthus webworm
American copper underwing
Army worm
Banded woollybear
Bumblebee
Chickweed geometer
Codling
Corn earworm
Eastern tent caterpillar
Eight-spotted forester
European cornborer
Fall webworm
Funeral dagger
Locust underwing
Milkweed tussock

Peachtree borer
Plume
Salt marsh caterpillar
Cecropia
Luna
Polyphemus
Carolina sphinx
Striped morning sphinx
Walnut sphinx
Spring cankerworm
Underwing
And many more. According to J. Richard
Heitzman of the Idalia Society, given my
habitat and location, there are several
hundred native moths as well as strays
and migrants.

Butterflies
Alfalfa
Black swallowtail
Giant swallowtail
Tiger swallowtail
Zebra swallowtail
Buckeye
Cabbage
Checkered skipper
Eastern Dun skipper
Roadside skipper
Tawny-edged skipper
Zabulon skipper
Checkerspot
Clouded yellow sulphur
Cloudless sulphur
Dainty sulphur
Little sulphur
Comma
Gray comma
Questionmark
Copper
Dog face
Eastern tailed blue

Fiery skipper
Great spangled fritillary
Goatwing
Hackberry
Henry's elfin
Horace's dusky wing
Juvenal's dusky wing
Little wood satyr
Monarch
Mourning cloak
Painted lady
Red-spotted purple
Sachem
Sleepy dusky wing
Sleepy orange
Southern and Northern cloudwing
Spring azure
Tawny emperor
Viceroy
Wood nymph

Again, only a sample. Heitzman says,
"There are probably at least 75
butterflies, native or occurring as
consistent strays or migrants" in my
area—and 2,500 butterflies and moths
statewide.

Other insects
Mosquito
Ladybug
Damselfly
Dragonfly (various species)
Crane fly (also called galleynapper)
Robber fly
House fly
Green bottle fly
Deer fly
March fly
Horse fly
Horn fly

Face fly
Caddisfly
Mayfly
Dobsonfly
Scorpionfly
Black fly
Colorado potato beetle
Blister beetle
Tiger beetle (larva called doodlebugs)
Carrion beetle (also called doodlebug or
 tumblebug)
Click beetle
Whirligig beetle
Scarab beetle (also called dung beetle,
 tumblebug, skin beetle, May beetle,
 rhinocerous beetle, June beetle)
Unicorn beetle
Stag beetle
Asparagus beetle
Darkling beetle
Ground beetle
Shield bug
Stink bug
May beetle
June bug
Squash bug
Assassin bug
Chinch bug
Wheel bug
Toad bug
Thrip
Firefly (also called lightning bug)
Borers (long-horned borers, flat-headed
 borers)
Ichneumon wasp
Bald-faced hornet
Paper wasp
Potter wasp
Mud dauber
Cow killer
Cicada

Cicada killer
Yellow jacket
Bumble bee
Honey bee
Sweat bee (also called steady bee)
Leaf-cutting bee
Lacewing
Carpenter ant
Lined acrobatic ant
Red ant
Velvet ant
Midge (many species)
Buffalo gnat
Cockroach
Wood roach
Walkingstick (also called devil's darning
 needle)
Katydid
Camel cricket
Field cricket
Praying mantis
Grasshopper (several species)
Earwig
Treehopper
Leafhopper
Spittlebug (also called spit bug)
Aphid
Water strider
Giant water bug
Termite
Tomato hornworm (adult is sphinx moth)
Bagworm
Armyworm
Black fatworm
Wireworm (adult is click beetle)

Spiders and their kin
American house spider
Arboreal orb weaver
Spiny-bellied orb weaver
Triangulate orb weaver

Black widow
Brown recluse spider (also called violin
 spider)
Filmy dome spider
Foliage flower spider
Funnel web spider
Harvestman (also called Daddy-long-legs)
Orchard spider
Ridge-faced flower spider
Smooth flower spider
Spotted fishing spider
Tree trunk spider
White-backed garden spider
White-spotted jumping spider
Wolf spider
Xysticus crab spider
Yellow garden spider (also called writing
 spider)
Chigger
Mite
Centipede
Millipede (also called thousand-legger bug)
Woodlouse (also called roly-poly bug,
 pillbug, sowbug)
Tick (various species)
Scorpion
Crayfish (also called crawdad, mud bug)
Freshwater mussel
Snail
Slug
Leech
Earthworm
Horsehair worm

FLORA

FLOWERING PLANTS
Honewort (also called wild chervil)
Lopseed
Wingstem

Agrimony
Goldenrod (various species)
Summer poinsettia
Tickseed sunflower (also called beggar ticks
 or pickers)
Tickseed coreopsis (also called pickers)
Arrowhead
Lady's thumb
Smartweed
Jewelweed (both pale and spotted; also
 called touch-me-not, snapweed, lady's
 earrings, and by Native Americans,
 crowing cock)
Vining buckwheat (also called black
 bindweed)
New England aster
Small white aster
White heath aster
White woodland aster
Tall thoroughwort
Dandelion
False dandelion
Texas evening primrose
Wild lettuce (several)
Mountain mint
Wood sage
Heal-all
Bergamot (also called horsemint)
Nettle
Wood nettle
Dead nettle
Henbit
Indian blanket
Ragwort (also called squaw weed or
 groundsel)
Hawkweed
Thimbleweed
Wild geranium
Indian tobacco
Spring beauty
Potentilla (cinquefoil possibly the same)

False rue anemone
Pussytoes
Dutchmen's breeches
Jack-in-the-pulpit
Green dragon
Trout lily (also called dogtooth violet)
Dogbane
Virgin's bower
Trumpet vine
Whitlow grass
Pennycress
Shepherd's purse
White avens
Sheep sorrel
Three-seeded mercury
Fleabane daisy
Horse weed
Sow thistle
Blue-eyed grass
White snakeroot (also called boneset)
Hoary-leaved vervain
Blue vervain
Brown-eyed Susan
Black-eyed Susan
Annual sunflower
Maximillian's sunflower
Jerusalem artichoke
Cup plant
Wood sorrel
Ladies' tresses
Violet (yellow, green, purple, white)
Clammy cuphea
Milkweed
Climbing milkweed
Butterfly weed
Queen Anne's lace
Toothwort
Mayapple
Bloodroot
Peppergrass (also called poor man's pepper)
Wild gooseberry

Dewberry
White trillium
Bladdernut
Sweet cicely
Wild strawberry
English plantain
Common plantain
Pale Indian plantain
Solomon's seal
False Solomon's seal
Hedge parsely
Mullein (also called flannel plant)
Moth mullein
Elderberry
Blue lobelia
Spiked lobelia
Grape
Raccoon grape
Wild ginger
Rose verbena
Ground ivy (also called gill-over-the-ground)
Columbine
Deptford pink
Wild rose
Purple ironweed
Cleaver (also called bedstraw)
Wild petunia
Sensitive brier
Bull thistle
Wild onion
False garlic (also called crow poison)
Tick trefoil
Bluet
Sweet William
Jacob's ladder
Venus' looking glass
Wild crocus
Spiderwort
Dayflower
Water willow

American feverfew
Jimson weed
Narrow-leaved verbena
Yarrow
Fog fruit
Starry campion
Gaura
False buckwheat
Pale corydalis
Bellwort
Black mustard
Yellow rocket
Rough-fruited cinquefoil
Red clover
Yellow sweet clover
White clover
White sweet clover
Goatsbeard
Ground cherry
Pale touch-me-not
Spotted touch-me-not
Gray-headed coneflower
Partridge pea
Sneezeweed
Euphorbia
Cattail
Chicory
Tall bellflower
Prickly pear (also called opuntia)
Barnyard grass
Purpletop/grease grass
Sedge
Broomsedge
Buckbrush
Hedge bindweed
Canada moonseed
Virginia creeper
Poison ivy
Greenbrier (also called catbrier)
Hop
Bittersweet

Carrion vine
Plus several more sunflower species

Nonflowering Plants
Lichens
Blister lichen
British soldier lichen
Brown cap lichen
Fairy script lichen
Shield lichen
Rock tripe
Plus various other lichen species

Mosses
Apple
Bog
Common beard
Juniper hairy cap
Silver beard
Plus various other moss species

Liverworts
Various species

Ferns
Adder's tongue
Common woodsia
Ebony spleenwort
Lady fern
Rattlesnake fern
Smooth cliffbrake
Walking fern

Fungi
Agaricus spp.
Amanita spp.
Artist's fungus
Beefsteak
Boletes/cep spp.
Chanterelle
Chicken

Coral
Dead men's fingers
Earth star
Fairy-ring
Hen-of-the-woods
Horn of plenty
Horsehair fungus
Inky cap
Lepiota spp.
Lycoperdon (puffball family)
Morel
Polyporus spp.
Puffball
Rusty hoof fomes (tinder fungus)
Scarlet cup
Shaggy mane
Stinkhorn
Tricholoma spp.
Witches' butter
Wood ear

Trees
Black oak
Burr oak
Chestnut oak
Chinquapin oak
Northern red oak
Pin oak
Post oak
Shingle or laurel oak
White oak
Green ash
Prickly ash
White ash
Ohio buckeye
Sycamore
Cottonwood
Willow
Linden or basswood

Eastern red cedar
Redbud
River birch
Kentucky coffeetree
Wild plum
Black cherry
Osage orange (also called bow wood, bois
 d'arc, hedge)
Hawthorn
Black locust
Honey locust
Mockernut hickory
Shagbark hickory
Shellbark hickory
Silver maple
Sugar maple
Hazel nut
Box elder
Black walnut
Paper mulberry
Red mulberry
White mulberry
Gray dogwood
Red osier dogwood
Rough dogwood
Pawpaw
Hop hornbeam
Service berry
Hackberry
American elm
Slippery elm
Black haw
Crabapple
Buttonbush
Eastern wahoo
American bladdernut
Buckthorn
Smooth sumac
Staghorn sumac

GEOLOGY

ROCKS AND SOILS
Chert or flint
Glacial erratics—Sioux quartzite, quartz
Glacial till
Limestone (Pennsylvanian, largely
 Winterset and Bethany Falls)
Loess soils and riverbottom (according to
 the U.S. Department of Agriculture Soil
 Survey map, this is mostly Snead/rock
 and Ladoga soils, which are silt, clay, and
 loam, slowly permeable, and in some
 cases, badly eroded—fits my square mile
 to a T)

Fossils
Blastoid
Brachiopod
Bryozoa
Cephalopod
Chaetetes coral
Crinoid
Echinoid
Fusilinid
Gastropod; mostly ammonoid
Horn coral
Mollusk
Petrified wood
Pseudofossil
Trace fossil
Trilobyte (rare)
Shark teeth
Various plant fossils

Bibliography

Books are an invaluable resource. If you look for those that are specific to your area, you'll find them much more useful than generic field guides that cover half the United States.

Everyone knows the big guns in the field-guide game, the have-to-have ones: Peterson's, Audubon, Sierra Club, and the newer Stokes Series. What you may not realize is that there is a wealth of information on your state from which you can mine information on your own square mile. A few sources for these state-specific outlets include the National and State Parks, which have bookstores that usually include a section on the state they are in. (I bought five books at a Nevada site that provided me information on mammals, birds, wildflowers, geology, etc., for that state.)

Here in Missouri, the University of Missouri Press has a wonderful range of books. University Press of Kansas, in Lawrence, has a few books that cross state lines to cover my area, as well. The Missouri Department of Conservation, likewise, provides a wealth of information on the local wilderness. The Missouri Department of Natural Resources has its own line of informational books, as does the State Extension Service and the University Extension. While the list that follows is specific to *my* state, most things found here are common from the Eastern Seaboard to the Rockies. In other words, you'd find a woodcock in Vermont as well as in Missouri, though perhaps not in such abundance.

Beveridge, Thomas. *Geologic Wonders and Curiosities of Missouri*. Rolla, Mo.: Missouri Department of Natural Resources, Division of Geology and Land Survey, 1990.

Cliburn, Jerry, and Ginny Klomps. *A Key to Missouri Trees in Winter*. Jefferson City: Missouri Department of Conservation, 1980.

Cutright, Paul Russel. *Lewis and Clark: Pioneering Naturalists*. Lincoln and London: University of Nebraska Press, 1989.

Denison, Edgar. *Missouri Wildflowers*. Jefferson City: Missouri Department of Conservation, 1972, 1978.

Discover Natural Missouri: A Guide to Exploring The Nature Conservancy Preserves. Foreword by Peter H. Raven. St. Louis: The Nature Conservancy, Missouri Chapter, 1991.

Gass, Ramon D. *Missouri Hiking Trails*.

Jefferson City: Missouri Department of Conservation with the cooperation of the U.S. Forest Service and the Division of Parks and Historical Preservation, Department of Natural Resources, 1983.

Golden Guides (booklets on insects, insect pests, spiders, butterflies, moths, pond life, fossils, geology, weather, weeds, etc.). New York: Western Publishing Company, Inc.

Heitzman, J. Richard, and Joan E. Heitzman. *Butterflies and Moths of Missouri.* Jefferson City: Missouri Department of Conservation, 1987.

Johnson, Tom R. *The Amphibians and Reptiles of Missouri.* Jefferson City: Missouri Department of Conservation, 1987.

Kals, W. S. *Land Navigation Handbook: The Sierra Club Guide to Map and Compass.* San Francisco: Sierra Club Books, 1983.

Key, James S. *Field Guide to Missouri Ferns.* Drawings by Paul Nelson. Jefferson City: Missouri Department of Conservation, 1982.

Kucera, Clair L. *The Grasses of Missouri.* Columbia: University of Missouri Press, 1961.

Lafser, Jr., Fred A. *A Complete Guide to Hiking and Backpacking in Missouri.* Affton, Mo.: Fred A. Lafser, 1974.

Lincoln, R. J., and G. A. Boxshall. *The Cambridge Illustrated Dictionary of Natural History.* New York: Press Syndicate of the University of Cambridge, 1987.

Nelson, Paul W. *The Terrestrial Natural Communities of Missouri.* Jefferson City: Missouri Department of Natural Resources and Missouri Department of Conservation, 1987.

Oesch, Ronald D. *Missouri Naiades: A Guide to the Mussels of Missouri.* Jefferson City: Missouri Department of Conservation, 1984.

Pemberton, Mary Ann. *Canoeing in Northern Missouri.* Jefferson City: Missouri Department of Natural Resources, Division of Parks and Historic Preservation, 1982.

Pflieger, William L. *The Fishes of Missouri.* Jefferson City: Missouri Department of Conservation, 1975.

Phillips, Jan. *Wild Edibles of Missouri.* Jefferson City: Missouri Department of Conservation, 1979.

Pierce, Don. *Exploring Missouri River Country.* Jefferson City: Missouri Department of Natural Resources.

Ramsay, Robert L. *Our Storehouse of Missouri Place Names.* Columbia: University of Missouri Press, first edition 1952, current edition 1985.

Schwartz, Charles W., and Elizabeth R. Schwartz. *The Three-toed Box Turtle in Central Missouri: Its Population, Home Range and Movements.* Jefferson City: Missouri Department of Conservation, 1974.

———. *The Wild Mammals of Missouri.* Columbia: University of Missouri Press and Missouri Department of Conservation, 1959.

Schwartz, Charles W., Elizabeth R. Schwartz, and A. Ross Kiester. *The Three-toed Box Turtle in Central Missouri, Part II: Nineteen-Year Study of Home Range, Movements and Population.* Jefferson City: Missouri Department of Conservation, 1984.

Soil Survey of Clay and Ray Counties, Missouri. Washington, D.C.: U.S. Department of Agriculture, Soil Conservation Service, 1986.

Steyermark, Julian. *Flora of Missouri.* Ames:

Iowa State University Press, 1963.

Swain, Ralph B. *The Insect Guide*. New York: Doubleday.

Thomas, Lisa Potter, and James R. Jackson. *Walk Softly upon the Earth: a Pictorial Guide to Missouri Mosses, Liverworts and Lichens*. Jefferson City: Missouri Department of Conservation, 1985.

Unklesbay, A. G. *The Common Fossils of Missouri*. Columbia: University of Missouri Press, 1973.

Whitley, James R., Barbara Bassett, Joe G. Dillard, and Rebecca A. Haefner. *Water Plants for Missouri Ponds*. Jefferson City: Missouri Department of Conservation, 1990.

Zimmerman, John L., and Sebastian T. Patti. *A Guide to Bird Finding in Kansas and Western Missouri*. Lawrence: University Press of Kansas, 1988.

There are a number of books available to help you in the study of nature, including my own earlier books, *The Naturalist's Path* (New York: Walker and Company, 1991) and *The Sierra Club Guide to Sketching in Nature* (San Francisco: Sierra Club Books, 1991). In both of these, I tried to suggest ways to learn about nature, using a field journal and sketching as a tool.

And if you want to know more about botanical or scientific illustration, consider joining the *Guild of Natural Science Illustrators*, PO Box 652, Ben Franklin Station, Washington, DC 20044. Contact the guild for the latest information on dues, et cetera.

Index

Note: Page numbers in italics refer to illustrations.